D1037071

EXPLORING PAINTING

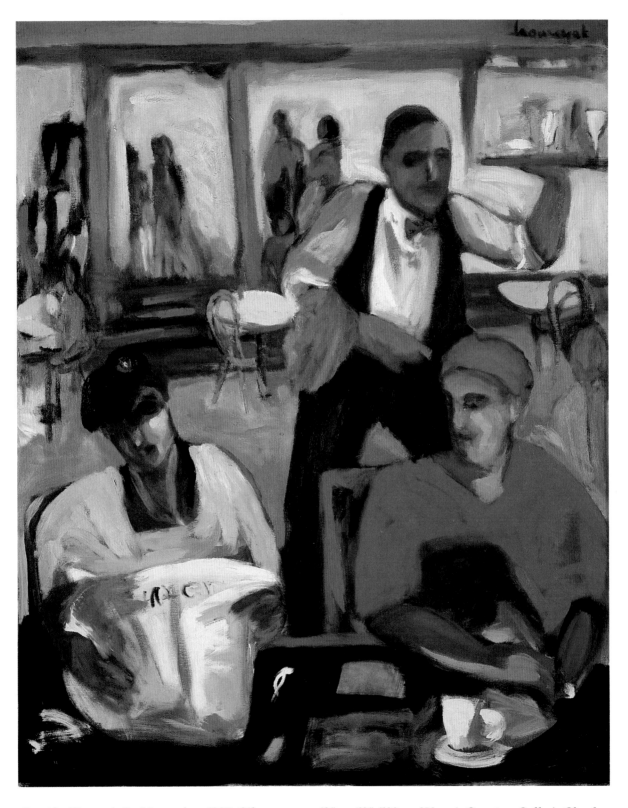

Jennifer Hornyak, La Mezzanine, *1987. Oil on canvas, 48″ × 60″ (122 × 152 cm). Courtesy Gallerie Claude Lafitte, Montréal.*

EXPLORING PAINTING

Gerald F. Brommer

Teacher, Artist, Author
North Hollywood, California

Nancy K. Kinne

Teacher, Artist
Boulder, Colorado

Davis Publications, Inc., Worcester, Massachusetts

To Ann Jones, Professor Emeritus, University of Colorado—educator, artist and friend—who quietly and effectively directed these two teachers and artists to walk a common path. Thank you.

Copyright 1988
Davis Publications, Inc.
Worcester, Massachusetts U.S.A.

Editor: Claire Mowbray Golding
Design: Greta D. Sibley
Printed in the United States of America
Library of Congress Catalog Card Number: 87-070838
ISBN: 0-87192-191-X
10 9 8 7 6 5 4

CONTENTS

INTRODUCTION

Painting is one of the most natural forms of human communication. Every day, color, shapes and lines flow from the tips of brushes held by hundreds of thousands of people all over the world. Three-year-old children and ninety-year-old adults enjoy using paint to record what they see, feel and imagine. That is how it has been since the earliest of times. While the quality and kinds of brushes, paint and surfaces have changed, the desire to communicate through painting has not!

The development of our culture and cultures around the world is recorded through paintings on walls, sheets of paper, wooden panels and canvas. Some of the creators of these "records" were masters, some were apprentices and some were beginners. But all were trying to improve their skills by exploring new techniques and better ways to present their messages.

You are continuing that search by learning as much as you can about making paintings. As you try new materials, new tools, new subjects, new painting experiences, keep in mind that growth in all art-related abilities comes only by challenging yourself. You'll learn by experimenting; you'll find that new methods give you new ideas, and new ideas suggest new methods.

You'll grow into your new abilities in art by exploring several important directions:

1) Learning something about the historical development of painting (art history);
2) Learning how paintings are constructed and how to expand your understanding of design, decoration and beauty (aesthetics);
3) Learning how to evaluate what other artists do and how to talk about art, artists and their work (art criticism);
4) Learning how to use tools and media to create your own kinds of visual expression (art production).

All of these areas are important. They will help you develop as an artist who is aware of the value of art in your own life, and in the world's cultural life. An understanding of these concepts will enrich your life in many ways.

A note about activities: At the end of chapters six through nineteen, you'll find a number of activities that will give you the opportunity to understand art and painting more fully—from the four different points of view discussed above.

Activities related to *art history* help us understand art of the past and how it influences the kind of art we make today. It also helps us understand artists and how they think and work.

Criticism (analysis) activities help us evaluate art and make judgements about it. By asking a few questions, we learn to look at a painting more carefully, analyzing its composition and quality.

The more we learn about *aesthetics* (the study of what is beautiful) the more we understand our personal responses to art. We learn why a painting makes us feel a certain way, why an artist's work sends us certain messages.

Production activities (studio art experiences) improve our ability to make art. Each chapter of *Exploring Painting* contains suggested activities, but there are many other projects that can help you make better paintings. The creative abilities at the end of each chapter will encourage you to practice and observe—and so improve your technical abilities.

part I

GETTING INTO PAINTING

Marilyn Groch, Paintbox, *1983. Oil on canvas, 36 × 48″ (91 × 122 cm).*

1. Pauline Eaton, Autumn Spectrum Square. *Watercolor, 30 × 30" (76 × 76 cm). "The painting is about color—with abstracted ideas. In the center the awakening seeds of autumn primaries reach out through the stems of various colors and then burst past the spectrum into the glorious array of autumn's leaves, pods and blossoms."*

chapter 1

PAINTING IS COMMUNICATION

Communication is a way of telling others about our thoughts, opinions, reactions and feelings. In our culture, most communication is done *verbally* — with words. But people can also communicate *visually* — with images.

What are the differences between communicating by using words — talking or writing — and communicating by using pictures? Think about that for a moment. When you read a sentence, where do you start? If you learned to read in the Western world, you'll start at the beginning — on the left — and move your eyes from word to word in a line until you reach the end. At the beginning of the sentence, you don't really know what the sentence will tell you. Only at the end do you discover its full meaning.

Now, where do you start when you look at a painting? Do you move your eyes along invisible lines from the upper left to the lower right of the painting, noting every brushstroke along the way? Probably not. Your eyes can take in many impressions at once. You recognize colors and shapes immediately; within seconds you can identify the painting's mood and subject and see how it is arranged. Often you don't need to wait until you've looked at the whole picture to figure out its meaning. Could you do the same with a typed page? In three seconds?

That is one thing that makes painting — or any one of the visual arts — a powerful way to communicate. With a painting you can show someone in a moment what it might take hours to describe in words. And often a painting can describe a mood or feeling or reveal beauty or ugliness much more clearly than words can. Have you ever heard the expression "A picture is worth a thousand words"? It means that a single picture says a lot in a simple, direct way. Do you think that's true?

While people speak and write in many different languages, visual images such as paintings are easily understood anywhere in the world. A painting done by the Flemish artist Peter Paul Rubens in 1615 can be understood by a twentieth century American who doesn't speak or read a word of Flemish. Painting is therefore a universal form of communication. One of your paintings could be appreciated by someone in India, China, France or Ghana, although

2

2. *Glenn Bradshaw,* Whitewater Maze. *Casein, 25 × 39" (64 × 99 cm). "Most of us see in similar ways, but we have many more options now than in the past. We can view the world from our shoe tops or from a satellite; we can see inside and outside simultaneously; we can express time, motion, feeling — things that are not generally visible. Whatever we paint should carry our own interpretation."*

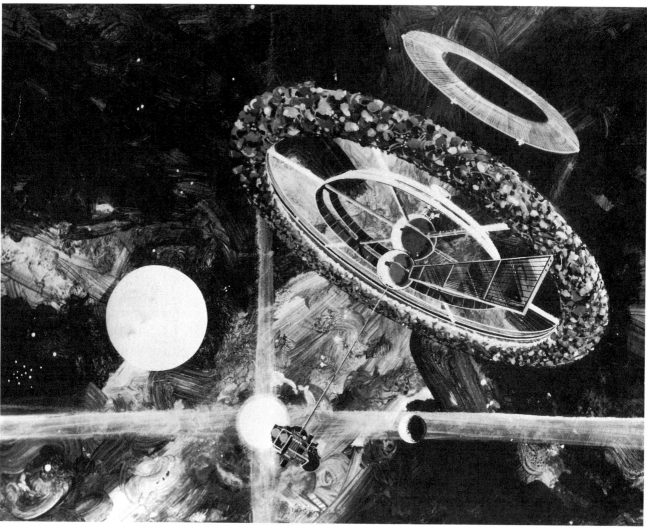

3

3. *After hours of study and research, an illustrator used acrylic paints to communicate his version of a future space colony, capable of handling ten thousand inhabitants. Painters can make visible the ideas of scientists and other technicians. Photograph courtesy NASA.*

that person might not understand you if you spoke.

So painting is a direct, immediate language that is understood everywhere. Does that explain why people paint? It's certainly part of the reason, but it's not the whole story. Just as you and your classmates have different reasons for playing a musical instrument, acting in plays or running for school offices, you'll each have different reasons for painting. Your paintings will look different, too, even when you paint the same subject. A painting expresses *your* point of view, your way of seeing the world, and no one sees the world in quite the same way you do.

Painting gives you a chance to reveal what you see — both outside and inside your mind — in all the colors you can create. You can change the world to suit your own ideas in a painting. You can paint what you think is unfair, unusual or unbelievable. You can make a dark day sunny, a brown horse purple, an old car new again. All you need is a brush, some paint and your imagination. And,

of course, this book, which will help you discover lots of new ways to express yourself.

You've probably seen paintings all your life, in museums and galleries, books and magazines and on cereal boxes and record albums. Some of the artists who painted those works wanted to communicate their emotions. Others wanted to make visible their outlook on religion, nature, politics, history or the people around them. Some painted objects; others painted ideas. Some explored color or shape alone, in works that contained no real objects at all. When you start to paint you'll be learning what they learned, and using the same basic information and techniques to create works that are entirely your own.

The following chapters will help you find ways to communicate your ideas through painting. Before any artist can communicate well, he or she must know how to use a variety of materials. Artists must also develop a "painting vocabulary," a way of talking and thinking about art that is similar to the grammar and vocabulary we use when speaking or writing. Through the art experiences waiting for you in *Exploring Painting,* you'll start to develop that vocabulary, and discover a new and powerful language.

PAINTING AND CAREERS IN ART

People used to assume that a student who was skilled in painting could only hope to struggle along as a painter throughout his or her life. While you still *can* decide to paint for a living, you should know that your skill in painting can be used in a wide variety of other careers, too. The knowledge and confidence you gain through the study of painting can help ready you for anything from department store display design to medical illustration to the creation of television's special effects. Keep that in mind as you improve your painting skills. You may find that your love of painting leads you to creative, fulfilling jobs you didn't know existed!

If you wish to develop your painting skills, learn all you possibly can about painting. People who are interested in art careers usually attend colleges, universities or art schools where they learn from experienced and often well-known artist-teachers. They can earn diplomas or bachelor's or master's degrees (BFA, MFA) that show that they have completed certain courses of study. However, some artists may develop the necessary skills by teaching themselves, or apprenticing themselves to someone skilled in a particular art.

Painters who wish to remain fine artists produce work which is sold to interested buyers through galleries or agents. Museums may exhibit the work of these painters, or acquire it for their collections. Painters often enter local or national shows or competitions to find out how their work compares to that of their peers.

Painters can also work for other people and businesses, of course.

4

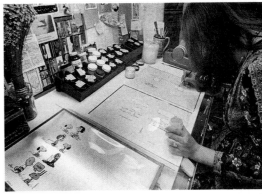

5

4. Interior designers are required to show clients how finished projects will look. These are Said Mahrinfar's ideas for a fashion boutique.

5. Artists who understand how to mix and use color are needed in the greeting card industry. After making drawings, this artist paints colors which will be photographed and printed on thousands of cards.

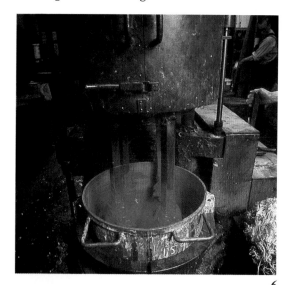

6

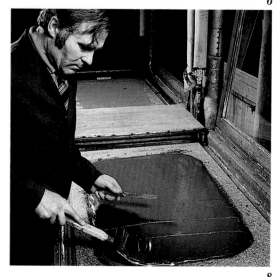

8

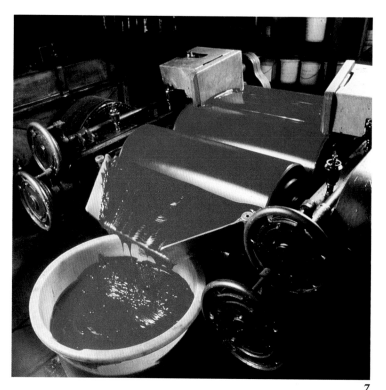

7

6. Early in the paintmaking process, ground pigment and water are mixed together to disperse the color particles evenly.

7. The color mixture is then ground with added liquid on a triple roll mill, which assures evenly sized particles and a smooth consistency. The evenly ground mixture is then sent to a mediums room, where the binder is added.

8. The paint mixture on the table is pan watercolor, drying on a warm granite slab. The amount of drying can be controlled by the length of time the mixture is allowed to remain on the slab.

Some are illustrators whose work may appear in books, advertisements or technical materials. Others draw detailed renderings of buildings before they are completed (they are known as architectural delineators). Artists paint murals, plan layouts for posters, use computer graphics to design cars and slot machines. Painted subjects are used in a variety of graphic design projects, from billboards to album covers.

Many television and film careers involve painters. Background or scenic artists are essential to films, and storyboard illustrators help produce what you see as a cartoon on TV. Stage and set designers are also skilled painters. Painters are also needed to teach painting at various academic levels, from elementary school through college.

It is easy to see that developing your painting skills will give you more than a few career opportunities. Remember, though, that one ingredient that is essential to successful painters cannot be taught in school. That is self-discipline. Many art careers require that you motivate yourself and work independently, according to your own time schedule. If you get used to working on your own now, you'll find it much easier later, when your job depends on it.

SOMETHING ABOUT THE PAINTS WE USE

Painting is the art of putting color on a surface. As you begin to color a variety of surfaces, you'll find you have many kinds of paint from which to choose. All paints are composed of three ingredients:

colored *pigment* particles; the *medium* or vehicle which carries the pigments; and a *solvent* or volatile liquid which makes the paint spreadable.

Pigments are dry powders made from both natural and manufactured materials. Some are permanent while others tend to fade a bit in bright sunlight. Some are made from the earth, some from minerals and some are completely synthetic. All are ground into fine powders in the first step toward paintmaking.

These colored powders are then added to liquid mediums (vehicles) which have two purposes: to carry the pigment particles in suspension so they cover the surface evenly; and to bind or stick the colored particles to a surface.

Solvents are used to thin the colored mixtures to an easy brushing consistency. After their task is accomplished, solvents evaporate, leaving the medium and pigment bound to the newly painted surface. The solvents must not change the quality of the color, must not have a strong odor and must not be toxic.

Other ingredients are often added to paint recipes. Driers, extenders, wetting agents and preservatives may be required. Generally, the pigments (colors) used in each type of paint are the same, with the recipes varying only in regard to mediums and solvents. A simple chart will help you see many of the painting media available to artists, and will help you compare the various media you will be using.

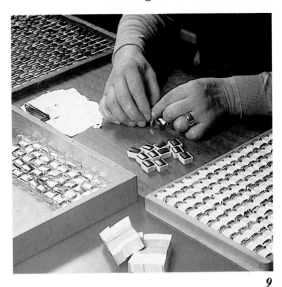

9

9. *The final step in paint preparation is packaging. Here, watercolor pans are being packaged by hand. All paintmaking photographs courtesy Winsor & Newton, Inc., England.*

NAME OF PAINT	MEDIUM/VEHICLE WATERBASED MEDIA	USUAL SOLVENT
Watercolor (transparent)	Gum Arabic Solution	Water
Acrylic	Acrylic Polymer Emulsion	Water/Acrylic Medium
Casein	Casein (Milk Protein)	Water
Gouache	Gum Arabic Solution	Water
Egg Tempera	Egg Yolk and Water Solution	Water
Designers' Colors	Gum Arabic Solution/Plastic	Water
Poster Colors	Vegetable Glue and Water	Water
Tempera Paint (schools)	Vegetable Glue and Water	Water
Pastel	Gum Tragicanth to hold pigment together	
	OTHER MEDIA	
Oil	Linseed Oil	Turpentine/Mineral Spirits
Alkyd	Linseed Oil/Synthetic Resin	Turpentine
Lacquer	Lacquer/Acrylic	Acetone/Lacquer Thinner
Oil Pastel	Linseed Oil to hold pigment together	Turpentine

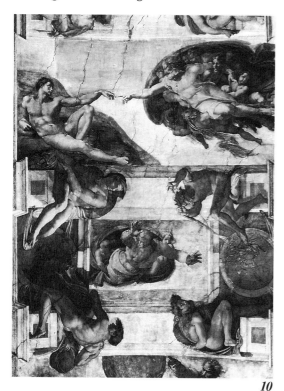

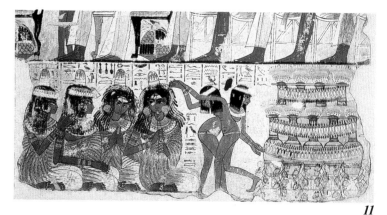

10. *Michelangelo used fresco techniques to paint the huge ceiling of the Sistine Chapel in the Vatican. Working mostly alone, he spent four years painting his visual interpretation of the history of Christian religion. The entire ceiling is over 125′ (40 m) long and contains over four hundred figures. It was painted from 1508–1512. Photograph courtesy ENIT.*

11. *This Egyptian artist used a common style to portray a banquet scene on the wall of a public building in Thebes. Such paintings help us understand the cultural activities of other peoples in other times. Wall painting, about 1400 B.C.; portion shown is 24″ (61 cm) high. British Museum, London.*

A LOOK BACK

Before you pick up a brush, dip it into a pool of vivid color and start a picture, take a few minutes to explore a bit about the history of painting. If you intend to paint, it helps to understand why and how other artists have made paintings, and how centuries of exploration and change in painting have led us to where we are now.

Your interest in painting makes you part of an ongoing art process that started with the ancient cave painters of Europe and Africa. And while the *reasons* for making paintings are varied and constantly changing, artists throughout history have used this means of visual expression. Their paintings document their cultural development and help us understand their lives, history, pleasures and religious convictions. This is as true in every part of the world as it is in our own culture.

If we look briefly at America's painting heritage, we can trace it from ancient Europe to contemporary times. Cave artists painted remarkably lifelike pictures of animals and people, probably as part of their hunting and fertility rituals. Later Egyptian artists, also painting on walls, used stylized forms and symbols to document historical events and everyday life. Greek and Roman artists painted realistically on walls and vases, and became adept at creating the illusion of depth, but most of their art was destroyed during wars and natural disasters.

The birth of Christianity influenced painting tremendously. The large walls of churches became huge "canvases" for artists to fill; they illustrated religious narratives and depicted the other worldiness of Heaven, Hell and their inhabitants. The Christian religion created a market for artists and abundant subject matter for painters.

Byzantine artists emphasized decorative gold backgrounds and a flat, symbolic style. Romanesque and Gothic artists concentrated primarily on architecture and sculpture, but Byzantine influences are visible in their painted images. Early Renaissance painting was also highly religious and symbolic, but painters began to rediscover and emphasize more naturalistic forms.

Gradually, the artists of the Renaissance turned their attention

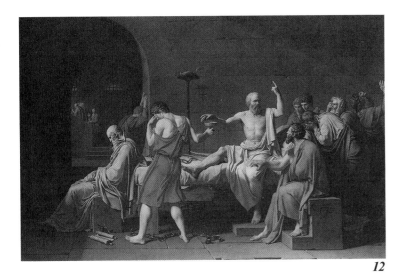

12

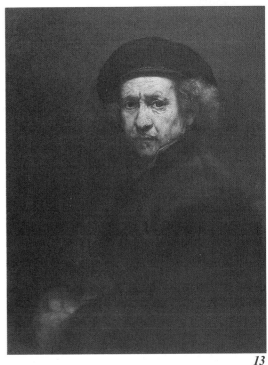

13

to subjects that were not strictly religious—to portraits, for example, and landscapes—and raised representational painting to new heights. Raphael, Michelangelo, Leonardo, Titian, Van Eyck and Dürer became the art heroes of their times. Because diversity of knowledge was important, Renaissance artists were often also writers, doctors or scientists—and an interest in the scientific aspects of art is visible in their work. Anatomy, perspective and proportion were considered vital aspects of painting by painters in Italy and Northern Europe, for example.

Baroque masters of the seventeenth and eighteenth centuries expanded the art of painting by working on huge canvases, developing swirling compositions that extended beyond the picture frame. Intense colors, dramatic use of light and shadow and an emphasis on emotion—rather than symbolism—characterized these works. Poussin, Rubens and Rembrandt inspired hundreds of other painters, and their collective talents pushed Northern Europe into international prominence in painting.

Europe's complex Baroque styles, compositions and painting techniques remained dominant until the early nineteenth century, when drastic changes in painting occurred. Three basic styles of painting—Neoclassicism, Romanticism and Realism—challenged artists in Europe and America, and vied with each other for popularity. *Neoclassicism* reflected renewed interest in ancient Greek and Roman ideas of morality, balance and restraint. It can be seen as a reaction against the exuberance and emotion of the Baroque, a return to visual order in a time of political and social upheaval. Subjects were balanced, carefully drawn and calm.

This controlled linear style was too stifling for many artists, who began to stress more romantic themes in narrative paintings. The term *Romanticism* came from the widespread popularity of romances—medieval stories of adventure and individual heroism. The Romantic style was much more painterly, emotional and expressive than sedate and controlled Neoclassical painting.

12. Jacques Louis David, leader of French Neoclassical painters, illustrated an ancient Greek story to influence French thought. Socrates would rather commit suicide than give up his political ideals. The French should do the same. Note the clean edges, smooth surfaces and controlled light. The Death of Socrates, *1787. Oil on canvas, 59 × 78" (150 × 198 cm). The Metropolitan Museum of Art, New York. Wolfe Fund.*

13. Although he painted many types of subjects, Rembrandt van Rijn is best known for his portraits. This self-portrait was painted when the artist was fifty-three years old. His use of light and shadow, his technique of brushing paint and his power of expression caused him to excel at a time when many popular painters were working in Holland. Self Portrait, *1659. Oil on canvas, 33 × 26" (84 × 66 cm). The National Gallery, Washington, DC. Mellon Collection.*

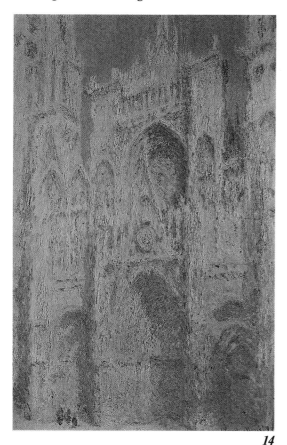

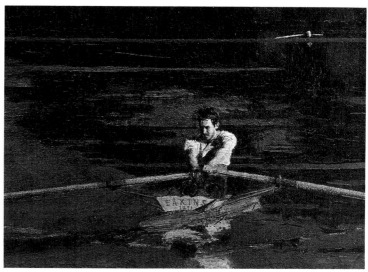

14

15

14. *French Impressionist Claude Monet made many paintings of the facade of this cathedral, studying the color and light reflected from its surfaces at various times. Compare Monet's soft edges with those of David. Monet was not painting a cathedral; he was painting the light and color on its stones.* Rouen Cathedral, West Facade, Sunlight, *1894. Oil on canvas; 39 × 26″ (100 × 66 cm). National Gallery of Art, Washington, DC. Chester Dale Collection.*

15. *American artist Thomas Eakins enjoyed painting realistic images of athletes participating in sports. Here he shows one of his friends rowing on a local river. Eakins was so interested in realism that he often made clay models of figures and placed them in sunlight so he could paint light and shadows accurately.* Max Schmitt in a Single Scull, *1871. Oil on canvas, 32 × 46″ (81 × 117 cm). The Metropolitan Museum of Art, New York.*

Still other painters felt they wanted to paint life as they saw it, rather than as a set of complex symbols or an exciting piece of fiction. These artists were called *Realists.* French Realist painter Gustave Courbet is said to have commented in response to criticism of his everyday scenes that he couldn't paint an angel because he had never seen one. His attitude reveals something of the philosophy of Realism: its artists found inspiration and significance in the commonplace, and felt no need to depict "grander" things. The Realists were also intensely interested in nature. English and American landscape artists began to paint outdoors, in natural light, with increasing frequency.

During the last third of the nineteenth century, outdoor painters became acutely aware of color and light as found in the sparkling landscapes of France. They attempted to paint their immediate responses to (or impressions of) this light, and their work became known as *Impressionism.* Impressionist artists such as Renoir, Monet and Pissarro were more interested in capturing the fleeting, everchanging qualities of light and color than they were in solid compositional structure. Their subjects had the feeling of an instantaneous glimpse of nature in bright sunlight. The invention of the camera in the early part of the nineteenth century helped them isolate and freeze natural scenes, and see and paint in this new and exciting way.

The casual approach of Impressionism was unsuitable to many artists who wished to emphasize form and structure or to express powerful personal feelings in their work. *Post-Impressionist* painters preferred to create images that appeared more solid and more emotional than the Impressionists' fleeting glimpses of light. Cézanne and Seurat, for example, emphasized structure in their paintings: for them the successful arrangement of shapes on the canvas was more important than the naturalness of the scene they created. Painters such as Van Gogh, Gauguin and Toulouse-Lautrec, also

rejecting the approach of the Impressionists, explored instead an intensely personal form of social commentary. Van Gogh's comments were primarily a reflection of his own inner vision and emotional turmoil. Gauguin implicitly criticized European society by glorifying more primitive cultures, while Toulouse-Lautrec commented on Parisian life through quick, sketchy glimpses of its night life.

By the close of the nineteenth century, other innovations were developing. Artists began to distort and fracture the forms in their work. Matisse simplified shapes and reduced complicated scenes to a series of expressive lines. Picasso, after experimenting with Expressionism and Fauvism, developed Cubism, a style that portrays its subjects as a collection of geometric shapes. Abstract and nonobjective painting gained importance. Painters known as Surrealists attempted to make visible the inner workings of the mind. The world had never known such a variety of expression before, and the public found many of these styles and movements difficult to understand or appreciate.

Following World War II, the United States became the focal point for a dynamic art explosion, as *Abstract Expressionist* artists (also known as Action Painters) spattered, flowed, dripped and splashed paint on canvas. As this powerful painting style ebbed in importance, some artists turned again to commonplace subjects, realistically portrayed. This style became known as Pop Art.

The decades since World War II have brought rapid changes to the art world in terms of style, technique and materials. Movements in art seldom last as long as they did during the Renaissance, for example, and there is rarely an overwhelming dominant force in painting. Minimal art and Expressionism are painted side by side, as are Superrealism and pure abstraction. Art critics call this contemporary phenomenon *Pluralism,* meaning that many different kinds of painting are being produced and accepted.

Look around you, in the window of a gallery or at a community art exhibit. Does one particular style (realistic, abstract, multicolored, monochromatic) dominate? Do all the artists seem to share a similar approach to form, light and shadow, subject matter? Probably not. Does that seem logical to you?

Style is a form of expression. Through their styles, painters reveal their personal vision. That purpose of art has not changed much over thousands of years.

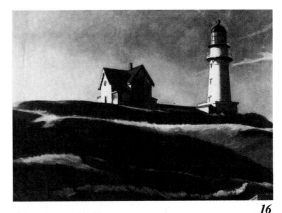

16

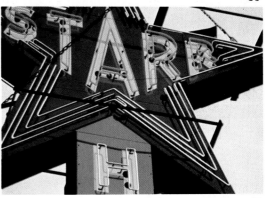

17

16. *Edward Hopper organized the space in his paintings with great care. He often used landscapes and city scenes as subject matter, but reduced them to simple forms by leaving out many of the details. He was able to combine his careful design and deep emotion to make powerful paintings.* Lighthouse Hill, *1927. Oil on canvas, 28 × 39" (72 × 100 cm). Dallas Museum of Fine Arts. Gift of Mr. and Mrs. Maurice Purnell.*

17. *Robert Cottingham is a realist painter. His attention to detail and awareness of color and texture are part of his style. He photographs his subjects (usually urban scenes) carefully, selects just the parts he wishes to use, and paints with extreme care and patience.* Starr, *1982. Acrylic on paper, 16.5 × 24.5" (40 × 63 cm).*

9

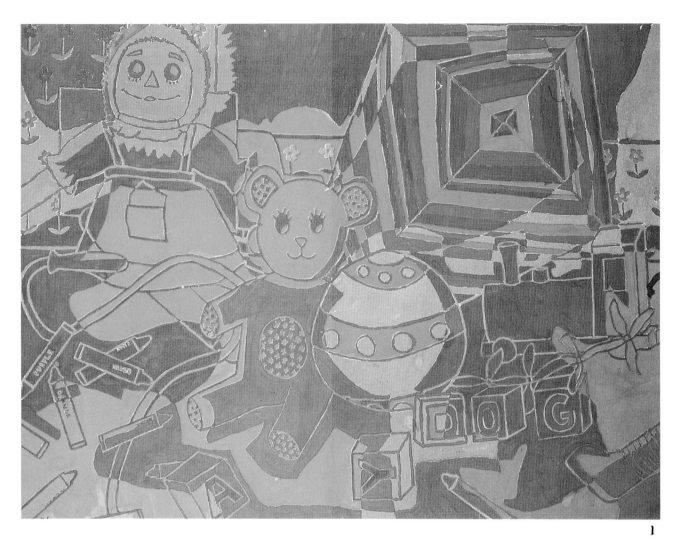

1

1. Color contrast creates interest in this glowing tempera painting. The carefully chosen colors seem brilliant when placed next to each other. Note the way your eye moves around the picture, jumping from one green shape to another.

chapter 2

WORKING WITH COLOR

Color is everywhere. The vibrant hues or subtle tones of nature delight us again and again. Trees, flowers, sky and water create a colorful background wherever we go.

Color influences us, too. Bright clothes in shop windows attract our attention; billboards sometimes make us look twice. Fabric, neon signs, posters and video machines bombard us with statements in color.

There are literally thousands of different colors—brilliant, dull, pastel and dark. Variations of reds, oranges, yellows, greens, blues and violets make up almost everything we see. An artist notices all these magical hues, selects a few and combines them to create an impression or evoke a certain mood.

As a painter, you will need to choose, eliminate, mix and combine colors. In this chapter you will learn how to select color schemes that "work." You will also learn that color is powerful: it can make objects in a picture seem to glow, to come forward or recede, to appear bigger or smaller, heavier or lighter.

Your knowledge of color theory will enable you to use color to create the effects you want in a painting.

COLOR THEORY

Color, as you probably know, is a property of light. When we say an object is red, for example, we mean that its surface absorbs certain wavelengths of light and reflects others. If our eyes see only the long wavelengths that we call red, we identify it as a red object. If all wavelengths of light are absorbed, we see a black object; if all are reflected, we see a white one.

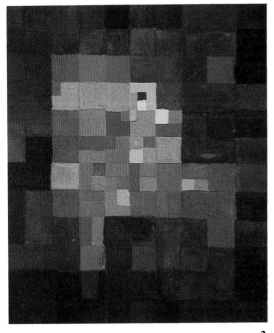

2

2. In this tempera color study done in the style of Paul Klee, bright colors advance and dull ones recede, creating movement and depth.

11

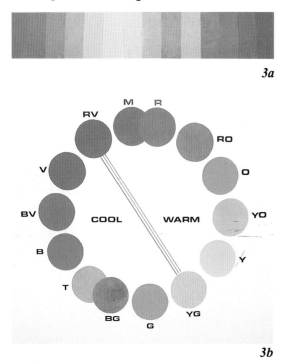

3a

3b

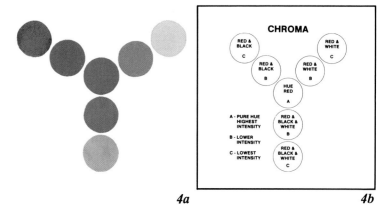

4a *4b*

3a and 3b. *The colors of the spectrum or rainbow, arranged in a row. When they are curved into a circle, they form a color wheel.*

4a and 4b. *This chart shows the difference between value and chroma. At the center is the hue red, as you can see in the labeled diagram. The lowest circle in this "y" is a light value of red. Can you see how the red circle in the center is darker in value, yet brighter in chroma, than the lowest circle?*

When we talk about color, we are concerned with three basic variables, or characteristics, of each color: *hue, value* and *chroma. Hue* is the color we see—red, for example. *Value* is the relative lightness or darkness of that color; maroon is a dark value of red, and pink is a light value. *Chroma* is the brightness or intensity of the color, and is difficult to describe in words. Some reds are bright and clear, while others appear muddy or dull. You'll know an intense red when you see one. But try not to confuse intensity with value, or lightness and darkness with brightness and dullness. A light value of red can be less intense, less bright than a dark one, and vice versa. Value and intensity are completely independent of one another.

Words like hue, value and chroma make talking about color easier and clearer. And knowing how a color's value or chroma affects the look of other colors will help you paint more effectively.

THE COLOR WHEEL

In other art classes you may have encountered the color wheel, a system of organizing and classifying colors. The color wheel bends the colors of the visible spectrum (red, orange, yellow, green, blue, violet) into a circle. The colors around the rim of this wheel are hues. Red, yellow and blue are the *primary colors* and are used to mix all of the other hues. Mix two primary colors—red and yellow, for example—and you'll create what is known as a *secondary color,* in this case orange. Mix a primary color (red) with a secondary color (orange) and you'll create red-orange, an *intermediate color.*

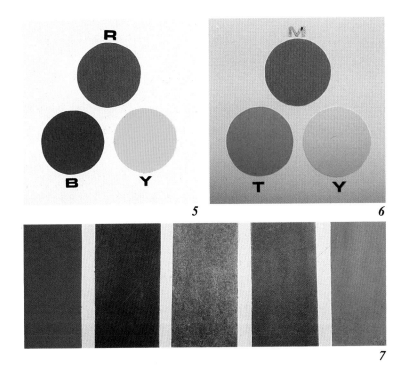

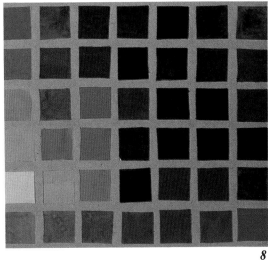

Magenta (a bright, pinkish red), yellow and turquoise can serve as the primary colors for an alternative color wheel, if you wish to experiment with them. Even though the results are theoretically the same, the secondary colors (orange, green and violet) produced from this wheel are often brighter.

Colors located across from each other on the color wheel are called *complementary colors*. Red and green are complementary colors, as are blue and orange. Mixing complements together gives you a neutral grayish tone. You can lower the chroma (intensity) of a color by adding a small amount of its complement to it.

5. Red, yellow and blue are traditionally thought of as the primary colors—colors that are mixed to produce the other colors of the color wheel. The primary colors cannot produce turquoise or magenta.

6. With magenta, yellow and turquoise, you can also mix all of the colors on the color wheel, although mixing magenta and turquoise will yield a less intense blue.

7. A scale of complementary colors showing the hue red, red mixed with a little green, a mixture of equal parts of red and green, green with a bit of red added, and pure green.

8. A chart composed of six sets of complements and the mixtures created from them. It is valuable for a painter to make a chart like this and discover ways to mix complementary colors.

13

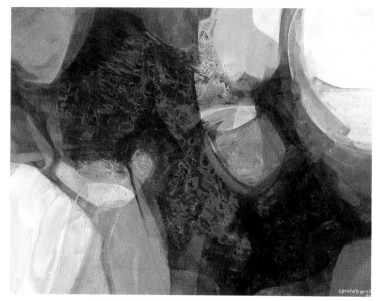

9

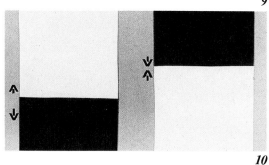

10

11

9. *Any set of complementary colors contains both warm and cool colors. Paint a small picture using only one pair of complements plus black and white. Mix twenty-five different hues, tints and shades. Note the different ways you can change the intensity of the colors.*

10. *These images illustrate some characteristics of light and dark colors. In the image on the left, the black band is heavy and appears to sink, while the white floats on top, creating stability. In the righthand image, the black wants to sink while the white seems to want to rise, creating vertical action, tension or movement.*

11. *Carole Barnes has used both warm and cool colors in her acrylic collage entitled* Hawaii (Ke'e Beach). *The red shapes seem to come forward while the cool greens and turquoise recede. Can you find a set of complementary colors in her painting?*

WARM AND COOL COLORS

Color has temperature—have you noticed that? Red, red-orange, orange, yellow-orange and yellow are *warm colors*. They remind us of fire or the sun and bring excitement and boldness to a painting. Warm colors make objects seem larger and appear to come forward.

Greens, blues and violet are *cool colors* reminiscent of lakes, distant mountains, sky and foliage. They are calm and restful. Cool colors recede into the distance and make objects seem smaller.

Yellow-green and red-violet can function as either warm or cool colors because they contain elements of both. In a blue and green painting, yellow-green or red-violet would add some warmth, while in a color scheme of warm reds and yellows, they would act as a cooler accent.

Putting both warm and cool colors in a painting—or an interior design, or an outfit of clothes—gives it balance. Add a small area of turquoise to a painting in warm oranges, rust, pink and coral, or an accent of cool green plants to a room with rose walls and reddish brown furniture and you will be combining warm and cool colors for contrast and balance.

TINTS AND SHADES

When white is added to a hue the resulting color is called a *tint*. For example, pink is the resulting tint when white is mixed with red, and peach is the result of adding white to orange. Adding white also lowers the chroma (intensity) of the hue.

Adding black to a hue produces a *shade*. Navy blue is a shade of blue, maroon is a shade of red.

14

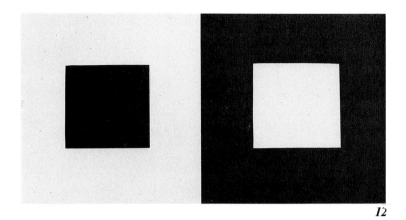

12

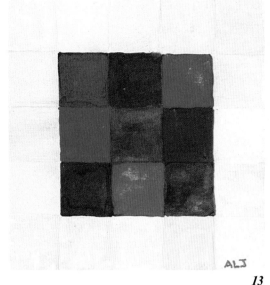

ALJ

13

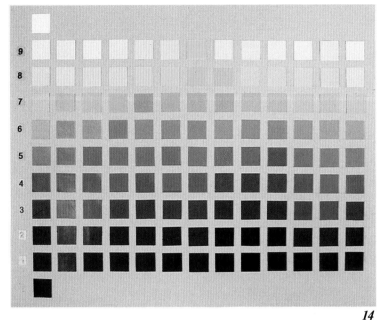

14

12. Colors are affected by the other colors that surround them. The black square on the left appears smaller than the white square on the right because light colors pop forward and seem larger, while dark colors recede.

13. Surround nine different shades of equal value by sixteen tints of the same value. A black and white photograph or photocopy of your painting will help you decide if your values are accurate.

14. Black and white and color value scales. Each hue is placed on the scale according to its value (its lightness or darkness). The paler the tint, the higher its number, and the darker the shade, the lower its number. For example, yellow has a value of #9 and violet has a value of #4. If you wanted violet and yellow to have the same value, you would either have to choose a pale lavender to match yellow or a deep tan to match violet. Red and green are about at the middle of their value scales.

Tints tend to come forward in a picture. They tend to make objects look bigger and appear to float or rise up in space. Shades, on the other hand, make shapes appear heavy and sink, to seem smaller and to recede or go back.

Altering a hue in this way, making it lighter or darker by adding white or black, is called changing its value. As you'll recall, value is the relative lightness or darkness of a color. In order to compare values, it can be helpful to look at a black and white *value scale,* which ranges from white (high value or high key) to black (low value or low key), with gray values in the middle. A *color value scale* is a column of colors produced from one hue: tints appear above the hue and shades appear below.

How can you identify colors of the same value? Try to imagine how the colors would look if you photographed them in black and white. Would they be a similar shade of gray? Squint at the colors. Do they seem to have a similar amount of light reflected from them?

To practice matching values, mix tints and shades of black and

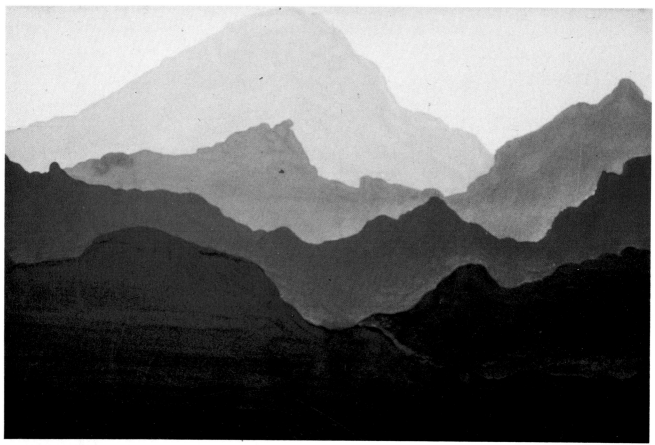

15

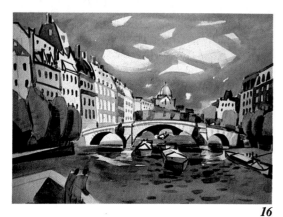

16

15. *Try using mountain ranges or a series of buildings as subject matter for a monochromatic value study. For best results, paint from light to dark.*

16. *George Post's watercolor,* Paris, *is a painting that contains much value contrast—the use of dark values against light ones.*

white on a piece of heavy white paper. Then mix tints and shades of each of six hues from the color wheel. Cut out these painted areas and arrange them into value scales of any length you like. This exercise will also give you practice mixing paint.

VALUE CONTRAST

Value contrast means using light colors next to dark ones. When all the colors in a painting are of the same or similar value, the painting is said to have little or no value contrast. This can be visually monotonous, but in some cases the effect is pleasing, because colors of the same value glow when placed next to each other.

When you choose to use colors of widely different values, your painting will have much value contrast. Color becomes of secondary importance in such a painting; what gives the painting its impact is the contrast of light against dark.

Remember that you can have color contrast in a painting without having value contrast, just as you can have value contrast without color contrast. A red and a green of the same value have color contrast, but no value contrast. Pink and maroon have more value contrast than color contrast. Pink and black have both value *and* color contrast.

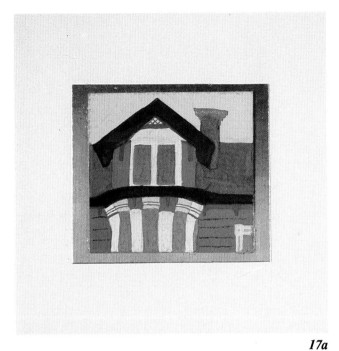

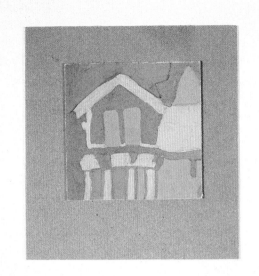

17a

17b

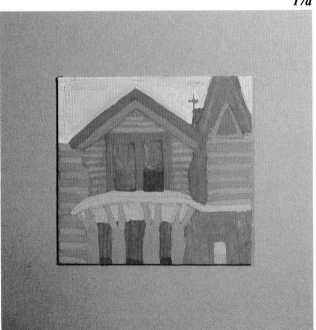

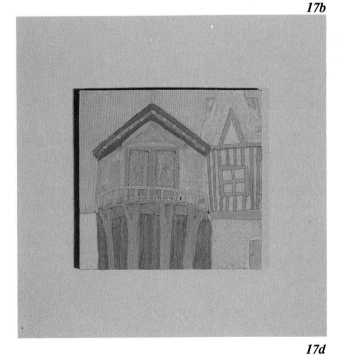

17c

17d

These house studies show varying degrees of color and value contrast. In 17a, value contrast predominates, while in 17b you see both value and color contrast between the violets and yellows. In 17c, color contrast of complementary oranges and blues is more significant than value contrast. In 17d, there is almost no value contrast between the glowing reds and complementary blue-greens. Notice how the color of the mat enhances each picture. Try several small house paintings of your own, selecting complementary color schemes. Keep in mind both color contrast and value contrast.

18a

18b

18c

18d

18e

18f

This spot of red-orange glows because (on the top row) it is surrounded by: its complement (turquoise); a dull turquoise; and a dulled shade of red-orange. On the bottom the same spot is surrounded by: another hue of the same value; gray of the same value; and black. Pick a hue yourself and make it glow by surrounding it with six different colors. Do the same with other hues, tints or shades.

COLOR IN CONTEXT

Obviously, a color is affected by the colors that surround it. A dull pink will look brighter if surrounded by a dull greenish-gray of the same value, but it will look grayish if surrounded by a brilliant red-orange. Similarly, a color can appear dark or light depending on its environment. For instance, dull pink painted near white will appear darker than when it is painted near black or red-orange.

There are also ways to make colors glow. One way, as we have said, is to surround a color with its complement of the same value. Another way is to surround a color — say, blue — with any color of the same value, by black, gray, a duller blue or a duller complementary color, such as orange. Remember, you can dull a color by adding black or by adding its complement to it.

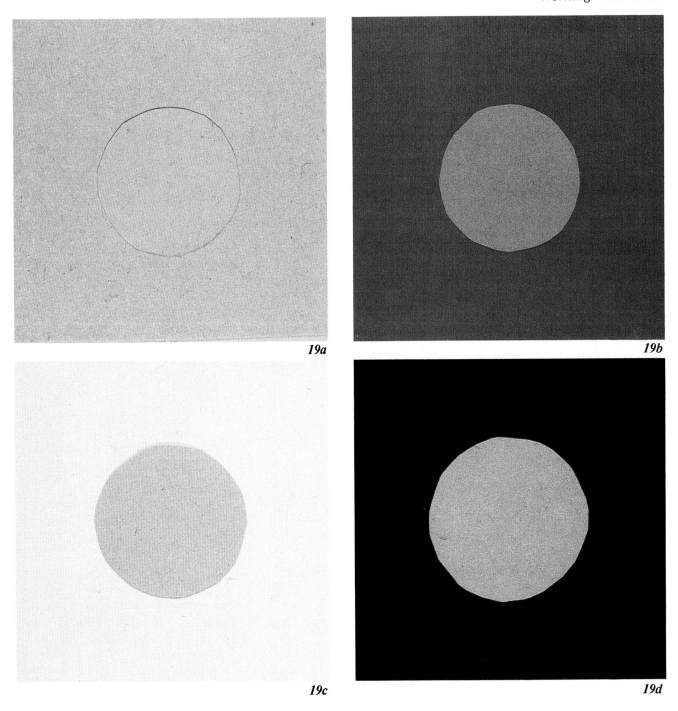

19a

19b

19c

19d

The brightness and value of a dull pink appear to change when it is placed upon gray-green, red-orange, white and black. Choose a dull color and make it look brighter, duller, lighter or darker by surrounding it with the appropriate colors.

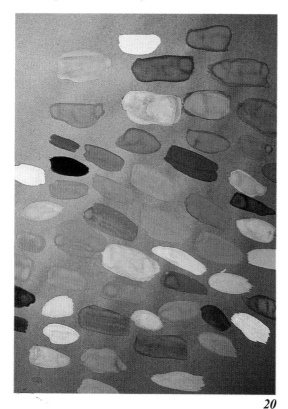

20

20. *When planning a color scheme, try it out on a sample paint chart. Here, a set of complementary colors is combined with black and white. Gray paper of a middle value was chosen for the sample chart because the painting was to be done on gray paper.*

21. *A monochromatic scheme, using one hue with tints and shades, relies heavily on value contrast to create interest, depth and movement. A monochromatic scheme is one of the most effective color schemes for the beginning painter.* Napali Cliffs, *by Ande Lau Chen, is an acrylic and rice paper collage with many values of blue-green, and touches of yellow-green for warmth.*

22. *More variety is possible in an analogous color scheme, which uses several hues next to each other on the color wheel. Red-violet warms the cool greens and blues in this student tempera painting. The colors glow because there is little value contrast.*

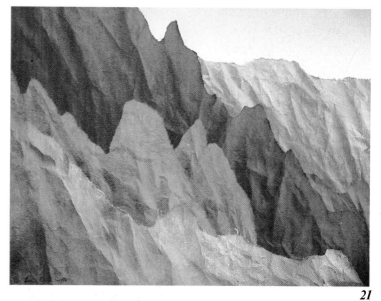

21

22

CHOOSING COLORS AND COLOR SCHEMES

Now that you have a grasp of how colors can be mixed and how they work together, you can begin to choose color schemes for your paintings with some expertise.

First, consider the mood or feeling you wish to express. Do you want hot, bright, bold colors that make an exciting or happy statement? Or do you prefer a soft, delicate, airy ambience? Perhaps you'll want to use dark, dull shades to convey an aura of mystery or cool colors to produce a peaceful and calm painting. It is important to decide upon the atmosphere or mood you want to create before you choose specific colors.

Once you know the mood you want to convey, think about colors that suggest that mood. If you used all the hues on the color wheel in one painting, the result would probably be confusing. Just as a chef chooses a few seasonings for a dish and does not use every spice on the rack, so a painter must select a few colors and eliminate many others. In painting, sometimes "less is more."

There are many ways to choose and eliminate colors systematically. A *monochromatic* color scheme makes use of only one hue

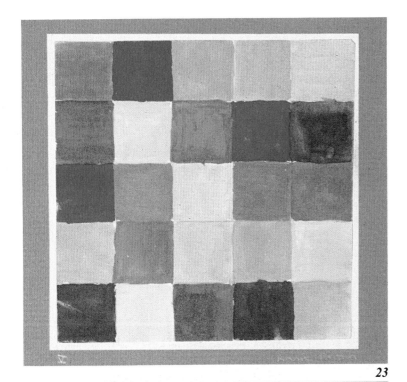

23

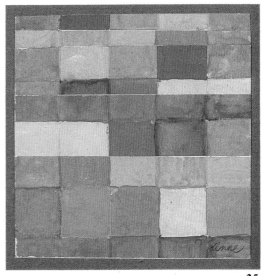

25

23. *On a five-inch square of heavy paper or mat board, using a format of twenty-five one-inch squares, paint a modified monochromatic scheme with much value contrast. Then try an analogous scheme, but limit the value contrast.*

24. *One set of complementary colors, yellow-orange and blue-violet, plus black and white were used in this neutral toned architectural painting. Shadows are shades, and add interest and value contrast.*

25. *Try several small paintings of your own using these complementary systems. Choose your colors and add black and white. Paint some with value contrast, some without. Geometric squares or simple architectural drawings work well. Use fairly thick paint, and don't paint wet areas next to each other or colors will run together.*

24

and its tints or shades. This may seem monotonous, but it can produce surprisingly appealing pictures. A similar but more colorful approach is an *analogous* color scheme, made up of three touching colors on the color wheel, such as green, yellow-green and yellow.

A set of complementary colors plus black and white, or two colors next to each other on the wheel plus their complements, with all the resultant tints and shades, make attractive schemes.

21

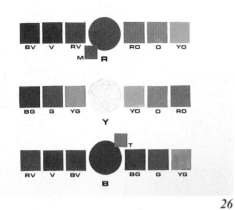

26

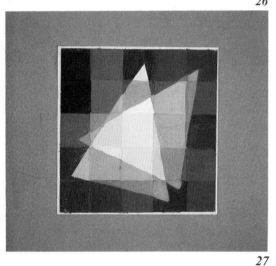

27

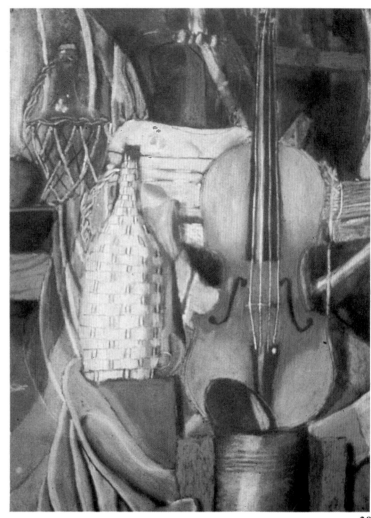

28

26. *The red, yellow and blue color families. Each family is made up of one primary color plus all the other colors in the color wheel that contain that primary color.*

27. *Can you tell which color family the student used in this tempera painting?*

28. *The warm glow of the yellow color family permeates this pastel still life. The student emphasized value contrast.*

29

30

You can also use *color families* to determine your color scheme. There are three color families, created from each of the three primary colors. The red color family, for example, includes all the colors on the color wheel that have red in them: red-violet, blue-violet, red, red-orange, orange and yellow-orange. The yellow color family is made up of all the colors that have yellow in them, and the blue family includes all colors with blue in them. Using all or part of a color family, plus black and white, will result in a painting that glows with one dominant hue. Notice, however, that each family contains both warm and cool colors.

One of the most exciting color schemes can be created by eliminating four analogous colors (colors next to each other on the color wheel). You will find that the eight remaining colors, plus black and white, give you a very complete palette. For example, if you eliminate blue, blue-violet, violet and red-violet, you can still create wonderfully harmonizing colors, including a soft blue obtained by mixing magenta and blue-green (or turquoise). Eliminating colors teaches you to improvise and experiment — and you'll probably be surprised at the results.

29. *In Carolyn Lord's sparkling watercolor,* Spring Breezes, *all the colors that appear could be mixed by eliminating the four analogous (or touching) colors, blue, blue-violet, violet and red-violet, from the palette. Intermixing the remaining colors of the color wheel with black or white creates a wide array of colors.*

30. *It is worthwhile to spend some time painting charts like this one. After eliminating four analogous colors (colors next to each other on the color wheel), make a chart that shows every possible combination of the eight remaining colors and their tints and shades. Make another chart by eliminating four other analogous colors, and so on, until you've made twelve charts. Tempera paints in an egg carton (See the chapter on tempera) are easy to mix, and gray construction paper of a middle value gives best results. You can refer to your paint charts again and again to devise color schemes for your paintings.*

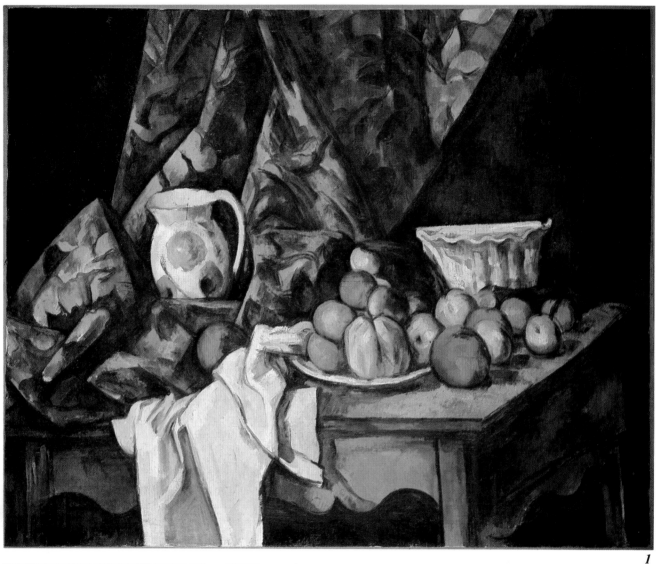

1

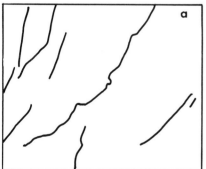

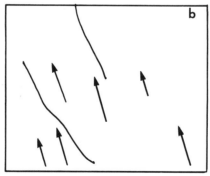

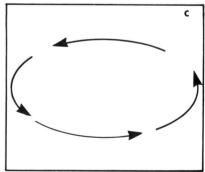

2

chapter 3

ELEMENTS AND PRINCIPLES OF DESIGN

To paint, it helps to understand the structure of art. To understand the structure of art—and use that structure in your own artwork—you must know its basic elements and the main ideas that form its foundation. Like the color wheel, the elements and principles of design help you simplify and talk about complicated concepts; like a road map, they show you what you need to get where you're going, but do not include every pebble along the way.

The *elements* of design—line, shape, space, texture, color and value—are the fundamental tools of the artist, the building blocks of art. When you look at the world around you, you'll notice that these elements never appear by themselves. When you look at a geranium, you see color (red and green), shape (the outline of leaves, stem and flower), line (the stem, the veins of the leaves) and space (the area around the plant and between its parts, also called *negative space*).

The *principles* of design are the guidelines you use when you combine the various elements into a composition. They are: balance, unity, contrast, pattern, emphasis, movement and rhythm. Just like the elements, examples of the principles are found everywhere, and never in isolation. For example, you remember learning to balance a painting with warm and cool colors, or creating a contrast, emphasis or movement with them. You were already using the principles as you worked.

Understanding these elements and principles helps you organize your paintings and gives you a special vocabulary you can use to talk about your art and your visual environment.

LINE

Everywhere you look there are lines. In nature you can see the lines of tree branches, the curving path etched by a stream of water, a spider's web. The industrial world furnishes more examples: lines formed by railings, window panes, edges of buildings.

Lines can have many qualities. They can be curved or straight, vertical, horizontal or diagonal, thick or thin, smooth or fuzzy, light or dark, continuous or broken, real or implied.

1 and 2. *This painting looks simple enough, but like all of Cézanne's work, it is carefully controlled and ordered. The color is rich and almost seems to glow, but there is little detail and brushstrokes are controlled. Warm tones of the fruit and table contrast with the cool tones of the pitcher, vase and tablecloth. Although there is color and value contrast, long, flowing lines unite the parts of the painting. The lines (See A, line drawing) weave through the picture from left to right, forming rhythms that give the composition unity. Balance is provided by the countermovement (B) of several lines, and most importantly by the way all the objects lean toward the left. Cézanne left no objects in a vertical position. Your eye probably moves (C) up the white cloth and along the fruit to the bowl, which leans and points back to the left. Your eye then skips to the pitcher, around the curved edge of the cloth and back to the fruit, continuing in a circle. The painting's design is carefully balanced. Why might Cézanne have wanted to create such precise movement? How does that movement help you appreciate the painting's subject?* Still Life with Apples and Peaches, *Paul Cézanne, 1905. Collection, The National Gallery of Art, Washington, DC. Gift of Eugene and Agnes Meyer.*

3. Real and implied line. Real lines (left) are lines you can see. Implied lines (right) are created by the contrasting background you see behind an object.

4. Linda L. Stevens painted the massive rounded shapes of boulders in Winterlight #36. *These organic shapes are molded by light and shadow and covered with complex textural patterns. Color, here, is less important than the rough, heavy feeling of the forms she has created in her 40 × 60" (102 × 152 cm) watercolor.*

5. Edith Bergstrom's painting, Palm Patterns #118, *emphasizes the use of line. Lines of all sizes and values are woven together to produce a unified composition. Vertical and horizontal lines give stability, while the diagonal ones, which balance each other, lend excitement. The watercolor is 38 × 30" (97 × 76 cm).*

In a painting, straight lines generally suggest directness and clarity, while curves imply gentleness and create circular movement. Vertical and horizontal lines provide structure: vertical lines give a painting strength and horizontal ones convey calmness and tranquility. Diagonal lines lend action and energy, as would a lightning bolt or a falling tree. When a line is very thick, it is strong and can almost be thought of as a shape. A thin line generally looks weak or delicate. Fuzzy lines have a softness about them; smooth ones denote harder surfaces.

A real line is one you can see. An implied line exists when you see an object against a contrasting background. Its edges produce a contrast which we "read" as line. And sometimes line is suggested by a string of objects—a series of footprints in the sand, for example.

Lines can lead your eye around a painting as a pathway leads you through a park. Lines can be used to add decoration to a plain surface. Repeated lines can form patterns and set up rhythms. Lines can create perspective by leading the eye deep into the picture plane.

SHAPE

Shapes can be *geometric* or *organic*. Geometric shapes such as squares, circles and triangles are found in nature in a snowflake, the full moon, a rock crystal and a half grapefruit. In the human world they appear in architecture and machines. Organic shapes, on the other hand, are irregular. Many leaves, seashells and manufactured objects—light bulbs, for example—have organic shapes.

Shapes in painting or drawing are two-dimensional (flat) but may be given the appearance of three-dimensional form through shading or by showing surface and depth.

Shapes, like lines, can be curved or straight, primarily vertical, horizontal or diagonal, opaque or transparent, smooth or fuzzy. Real shape is the shape of an object itself; implied shape is the negative shapes formed by space around the object. As lines do, shapes can portray strength, calm or action. Their edges can be arranged to form a linear pathway guiding the viewer from one object in a painting to another. The way the artist handles a shape's surface quality (color, value and texture) gives it interest and importance.

SPACE

Space is literally all around us. In a painting, however, space is limited to the two-dimensional picture plane, and the way you fill it determines the overall effect of your work. You can fill that space with shapes, colors, lines and textures, making it busy and full of movement, with little or no background or negative space. Or, just the opposite, the objects may be few and small, dwarfed by empty space surrounding them, and the painting may have a lonely or tranquil feeling.

You can manipulate space in other ways, too. By the use of color or value, you can make objects come forward or recede in space, and thus produce the illusion of depth. Shapes with clear surface detail seem more in focus and appear nearer to the observer than fuzzy, plain shapes. When objects overlap in space, those that are partially blocked seem farther back, as do objects placed higher up in the picture plane, farther from the bottom of the paper. Pattern over the entire painting surface creates a flat look.

Before you start to paint, think about the space you'll have to work with (the size of the painting surface) and the illusion of space you want to create in it. Planning your use of space beforehand will make it easier for you once you actually begin.

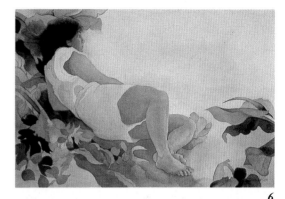

6

7

6. *Diane LaCom uses empty space to emphasize the reclining figure in her painting* Morning Shadows. *The warm flesh tones come forward and the cool greens move back, creating a feeling of three-dimensional space. The acrylic painting is 24 × 36″ (61 × 91 cm) in size.*

7. *Ann T. Pierce fills the painting surface with a delightful tangle of branches and leaves. Notice the balance between negative space (the background) and positive space (the leaves, branches and flower). The pink blossom moves forward in space because of its warm color and because it is the only shape not partially covered by another shape.* Beauty and the Beast *is a transparent watercolor.*

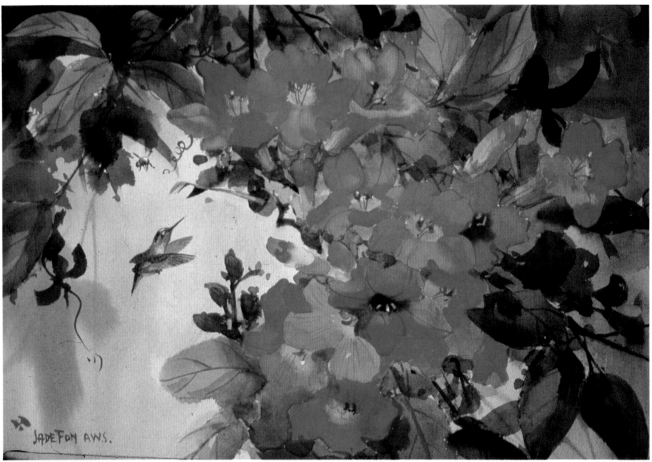

8

8. *Artist Jade Fon uses bright reds, which seem to pop forward, against cool dull greens for maximum color contrast in his watercolor* Trumpet Vine. *Subtle value contrast adds interest in the large negative space of the 18 × 21″ (46 × 53 cm) watercolor.*

THE SURFACE QUALITIES OF COLOR, VALUE AND TEXTURE

Color and value have already been discussed in Working with Color, Chapter 2. Now you can see that they can be combined with the elements of line, shape and space to make things recede or come forward, sink or rise, seem bigger or smaller, dominant or weak. Just as line and the placement of shapes lead your eye around a painting, so spots of color set up a pathway the viewer can follow from one place to another.

Texture is the tactile quality of a surface — rough, smooth, sticky, soft, fuzzy, slick. It can be real or implied. A real texture is one that can be felt, such as a piece of sandpaper, a woven straw mat or a kitten's fur. Implied texture in a painting is created by the artist: the surface only *appears* to be textured.

Artists create texture through the use of light and shadow, or with lines, dots or detailed designs. Sometimes the painter puts a textured object under the painting surface and rubs over it with a crayon to achieve a look of texture, or dips the surface of the object in paint and prints the wet texture on the paper or canvas. A fairly dry brush or rough paper can also create a textured effect

9

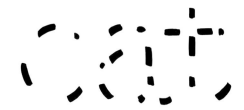

10

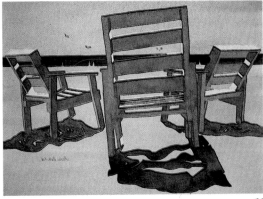

11

in a painting. A toothbrush dipped in paint can be rubbed and made to splatter paint to produce a textured pattern.

Now that you are aware of the elements of art and design, can you spot their use and interaction in the illustrations throughout this book?

UNITY

Unity is a sense of cohesiveness, a feeling that all of the parts of something belong or work together. The human eye seeks unity in the environment. When parts of things are missing or obscure — when part of a neon sign is burned out, for example — a person often imagines the missing parts and sees the complete form. This is called *forming closure.*

Unity can be important in a painting. A unified painting looks complete, orderly; its meaning seems clear. There are several ways to create unity as you paint. A dominant theme, idea or design element can unify a painting. A repeated color or colors can be the main attraction; texture or subject matter can be used to pull many elements together. Repeating or overlapping lines or shapes, or creating linear pathways leading from object to object can add to a work's unity. Shadows underlying objects can also tie them together. Finally, a border around a painting holds the focus of attention on the center area and is another unifying concept.

9. *Patterns of darks and lights create movement in Charles Sheeler's abstract cityscape. The contrasts in value lend three-dimensional quality to the plain flat shapes. Can you tell which direction the light is coming from?* Skyline, *oil on canvas, 25 × 40" (64 × 102 cm). The Wichita Art Museum, Kansas.*

10. *When parts of something are missing, it is natural to imagine the missing parts in order to* form closure. *Many pieces of the letters are missing here, but we tend to be able to read the word* cat *by forming closure.*

11. *One theme (chairs), monochromatic color, and one main idea (light and shadow) work together to produce this unified picture by Linda Doll. Overlapping and repeated shapes and shadow and the horizontal line in the background also tie the units together.* Sunshine Series #3 *is a 20 × 28" (51 × 71 cm) watercolor.*

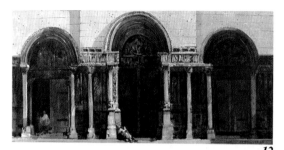

12

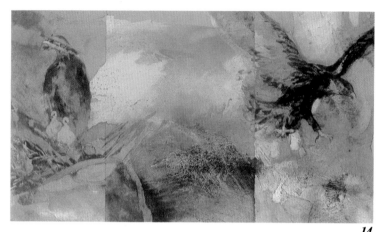

14

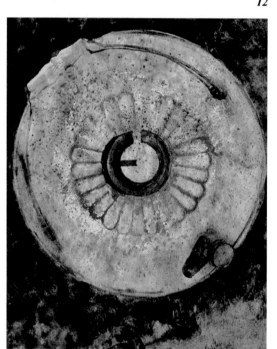

13

12. *Gerald F. Brommer's* Facade, St. Gille *is an example of symmetrical or formal balance with almost perfect symmetry of arches and columns. The emphasis on light and shadow gives depth to this 15 × 30″ (38 × 76 cm) watercolor.*

13. *Larry Webster uses radial balance in his painting,* Kerosene Can: Top View. *He creates interest by using detail of texture on the can as well as in the background of the 21 × 14″ (53 × 36 cm) painting.*

14. *Sue Wise has achieved asymmetrical or informal balance in her water media painting* The Eyrie. *The birds, although different in size, balance each other almost like two people on a see-saw. Acrylic and dry pigment, 24 × 42″ (61 × 107 cm).*

BALANCE

Imagine you are walking a tightrope, high in the air. If you sense you are slipping, your arms stretch out and move up and down to restore your balance. Remember how you balanced on a see-saw when you were small? If you and your friend were not the same weight, you had to change positions to create balance. We have a built-in feeling for our own balance and an innate sense of balance in the arrangement of elements around us and in paintings. When things seem unbalanced, we want to restore equilibrium.

There are three kinds of balance: symmetrical, asymmetrical and radial. *Symmetrical* or formal balance is the most obvious way to achieve balance. It occurs when one side of an object or painting is identical (or nearly so) to the other side. A human face, a butterfly, a spruce tree, an ink blot test or the pattern on an Oriental rug are examples of symmetrical balance. This symmetry creates calmness, formality, even boredom sometimes. One type of formal balance is created in a painting when the underlying structure is a vertical cross.

In *asymmetrical* or informal balance, small objects farther from the center balance large objects, nearer to the middle, on the other side of the picture. You'll find that asymmetrical balance can be both exciting and subtle.

Radial balance comes out from the center of a picture, like spokes on a wheel or rays of the sun. Radial balance is formal and symmetrical, but it often produces a graceful rhythm.

When planning a painting, it is a good idea to place bits of colored paper on a piece of paper and move them around until you create a pleasing visual balance. Keep in mind the balance of big and small, dark and light, warm and cool, smooth and textured, geometric and organic, bright and dull.

Take a look at some of the illustrations in this book. How have some artists created a sense of balance in their paintings?

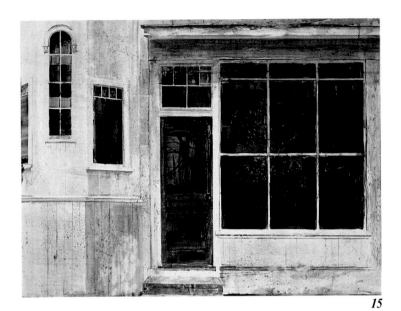

15

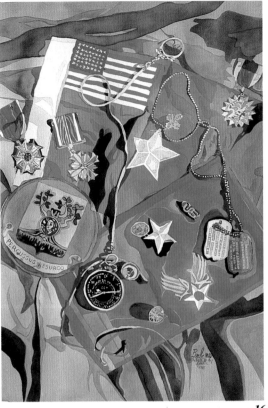

16

CONTRAST

Contrast creates interest. If everything in a room were one color, it would be a boring place. If every food in a meal were sweet, the taste experience would lack variety. The visual world is full of contrasts: a vertical tree trunk against the horizontal horizon, a red flower on a green plant, a smooth pond surrounded by a textured shoreline or a fragile spider web attached to a sturdy fence post.

There are contrasts of light and dark, rough and smooth, bold and timid, warm and cool, straight and curved, geometric and organic, shiny and dull, plain and patterned. Almost every visual entity has its opposite.

When you find that your painting lacks variety, sometimes introducing a small source of contrast will give it interest. A painting done mostly in reds will take on a new life when a spot of turquoise blue is placed in it. Look for contrast in the rooms and spaces around you, and then see how often it appears in the paintings in this book. How does contrast help a painting?

EMPHASIS

Every successful painting emphasizes something. It may be a central idea, technique or mood, or a visual element or design principle. An artist may feel that colors working together are most important in his or her work. Another may value rhythmic movement above all, and try to make that stand out. In any painting, many elements and principles work together, but they are usually less important than the one special impact that the artist wants to make.

15. *The most obvious element of contrast is dark against light in Larry Webster's watercolor,* Reflections. *Other important but more subtle contrasts can be found in the variation in the sizes of the rectangular windows, the organic branch shapes inside geometric shapes and rough textures played off against smooth surfaces.*

16. *Sandra Beebe's color choice of red, white and blue, her selection of military memorabilia and use of the American flag all emphasize the central theme of patriotism in this striking watercolor. Notice how her use of shadow creates further unity in* Tribute to My Father, *30 × 22" (76 × 56 cm).*

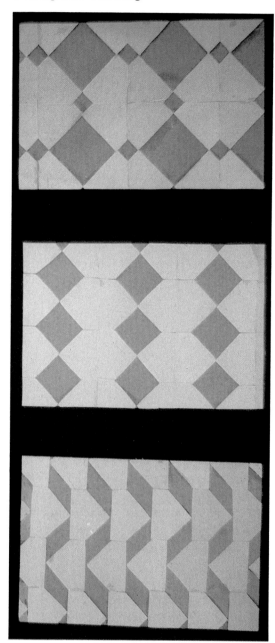

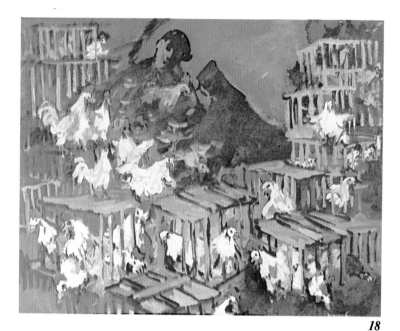

18

PATTERN

Elements or motifs repeated again and again produce a pattern. In nature, the octagonal shapes in a beehive, the lines on a zebra and stalks of corn in a field all form patterns.

In the human world, patterns are formed by rows of windows on a building, a checkered shirt, the seats in a concert hall.

Patterns may be as planned and precise as the geometric tread on a tire. They may be as random as scattered stars in the sky or freckles on a face.

Use pattern to decorate shapes or lend texture to a painting. It can appear in a few areas only or can be used to enrich the entire visual surface.

Look for the patterns around you. When you begin to notice them regularly, look for the patterns on paintings. What messages do patterns give you? How does it work differently in the works of different artists.

MOVEMENT AND RHYTHM

Movement in a painting is the action the viewer's eye makes as it follows a pathway. Moving from color to color, shape to shape, value to value, the eye traces suggested lines around a picture. The elements in a composition can be arranged to keep the focus of attention in the picture plane, but they can also lure the viewer off the edge of the paper.

Rhythm is the organized repetition of visual movement. It is a pattern of movement set up by colors, shapes, values and lines occurring again and again. If the size, shape and color of these repeated units remain the same and the distance between them re-

17

17. Many identical five-sided shapes have been arranged to produce three different patterns on a background. Do any of these patterns look familiar to you?

18. The shapes and colors of a chicken, and the lines of a wooden cage are repeated many times to form an interesting pattern in this casein painting by Dorothy Sklar. Where is the center of interest?

32

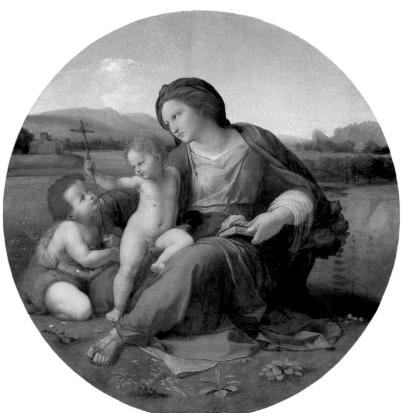

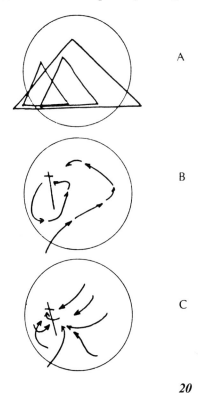

19

20

mains constant, the rhythm is predictable, stable and may be monotonous. To add excitement, an artist sometimes changes the size, color or shape of the repeated units and varies the intervals between them. A row of trees, for example, could become smaller and appear closer together in the distance.

Both movement and rhythm are the principles of design that cause your eyes to dance around a painting, from object to object. They also can help you find the center of interest. When you look at a painting, pay attention to how and where your eyes move. You may find yourself stopping abruptly or gliding smoothly, depending upon how the artist has arranged the painting. When might an artist want eye movement to be smooth? When would jerky movement be appropriate? What kind of statement can an artist make with each? Think of movement as the pathway you follow, and rhythm as the tune you hum along the way. That may help you decide how and why an artist uses rhythm and movement in a painting. It may also help you work rhythmically when you start your own paintings.

You will find that as you search for and work with the elements and principles of design, good composition will become second nature to you. You will learn to recognize it in the work of others and in your own work.

19 and 20. Raphael, like most Renaissance painters, was a master of design, and this tondo (circular painting) demonstrates his ability. Round paintings must be very balanced and stable or they tend to "roll" one way or the other. Raphael uses the pyramid composition (See line drawing A), the most stable of all arrangements. Your eye probably enters the painting at Mary's exposed foot (B) and moves up the leg to forearm, shoulder and face. You skip to John (in coat), move along his back and leg to Jesus' foot, leg, face and arm. You eventually end up at the little cross. There are other countermovements (C), but all lead to the cross. Now look at the eyes of the people. Where are they looking? Raphael leaves nothing to chance, but directs your eye in several ways to his center of interest: the cross. The Alba Madonna, *Raphael Sanzio, 1509. The National Gallery of Art, Washington, DC. The Andrew W. Mellon Collection.*

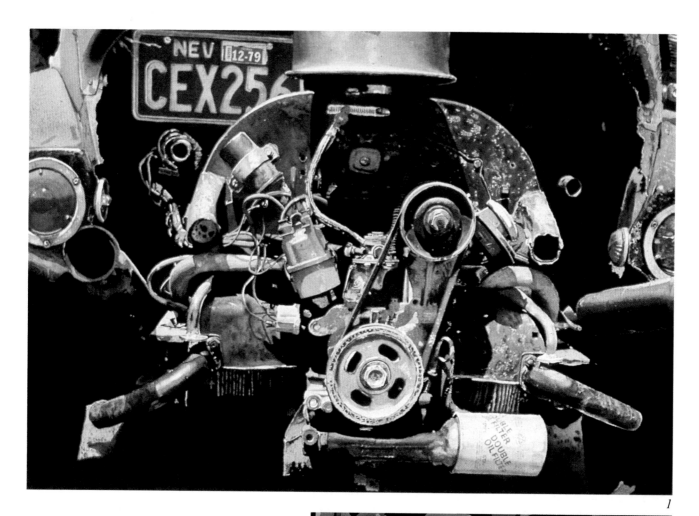

1. Alex Guthrie has turned the common mechanical innards of an old automobile engine into a dynamic interplay of round and tubular shapes in his detailed study, Happy Wanderer #6. Notice how the shadows strengthen the feeling of form in this 22 × 30" (56 × 76 cm) watercolor.

2. Sandra Beebe turns a pile of pretzels into a lyrical study of color and pattern in this close-up view of a familiar subject. Pretzels is a watercolor, 22 × 30" (56 × 76 cm).

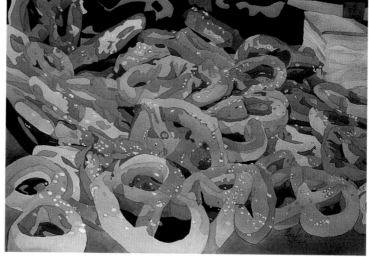

chapter 4

THE SEARCH FOR IDEAS

WHAT TO PAINT?

As important as the elements and principles of design are in painting, they are not art in themselves. Art begins with *ideas*, and ideas do not always come easily. Before you start painting, you should have a plan—an idea, subject or theme—something you wish to portray, explore, express or create. In this chapter you will learn to search for ideas—to see things in your everyday world from a new viewpoint. You will discover new ways to perceive and select subject matter and different approaches to painting it.

LEARNING TO SEE

When searching for subject matter for a painting, it helps to be able to see your environment in new and fresh ways—to forget what you *think* things look like, and really experience colors, shapes, textures and pattern. Observe things around you in a sensitive and direct way. Look carefully to increase your *visual sensitivity*—the necessary ingredient for effective creation, evaluation and aesthetic appreciation of art.

How do you do this? How do you train yourself to see and perceive in this new manner? The first thing to do is relax and just enjoy looking. See what is before you and note its unique qualities. Don't dismiss a visual impression by instantly attaching an old label to it. For instance, if you were to describe a tree in words, you could say that trees have brown trunks and branches and green leaves; that a tree can be an apple or oak; that furniture can be made from some trees. How different is this verbal description from direct observation where you would note blue-greens, silver-greens, yellow-greens and dark-greens, and dancing shapes creating spots of pattern against a pale blue background. The verbal description produces a common, stereotyped image; the visual impression captures the unique aspects of the subject.

Look, really look, as if for the first time, at things you may have passed by or never even noticed before. Look at everyday, simple things like a pattern of cracks on a wall or chipped paint on a door.

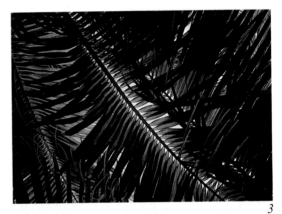

3

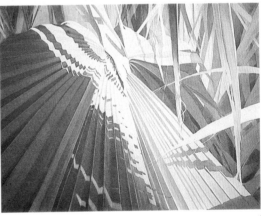

4

3 and 4. When you really look at a tree (such as the palm tree, above), you notice that the leaves are the positive *space. However, equally important is the* negative *space—the shapes formed by the spaces between and around the leaves. Artists learn to recognize these negative shapes as pleasing elements in themselves. Notice how Edith Bergstrom has used positive and negative space for example, in* Palm Patterns #85, *a transparent watercolor* **below.**

35

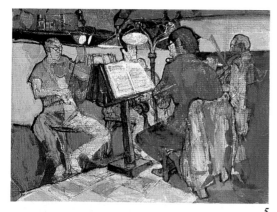

5

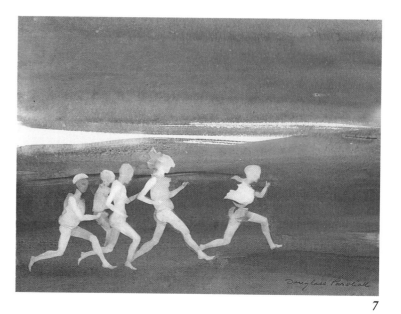

7

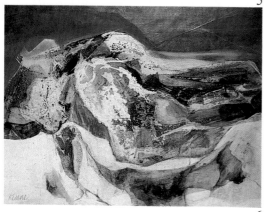

6

5. *John Brooks Miller usually selects friends and members of his family as subjects for his paintings. In painting* Quartet, *he used collage, watercolor, acrylic and ink to complete a painting made from an on-the-spot sketch of four of his musician friends.*

6. *Nancy Kinne's landscape reflects the ruggedness of the Rocky Mountains softened by patches of snow. She created the snow patterns in the center by overpainting dry pigmented areas with white and later washing it off.* Mountainscape #6 *is an acrylic painting, 26 × 40" (66 × 102 cm).*

7. *Douglass Parshall defines his running figures in* Race *by surrounding them with negative spaces painted with a luminous watercolor wash. The spaces between the runners form interesting shapes of varying sizes and contours. 15 × 22" (38 × 56 cm).*

With your eyes, trace the linear shadows cast on snow or a house by brittle tree branches. Look closely at a flower petal with a drop of water on it. Examine an old, decayed tree stump. Notice a row of steps and a painted door in a busy downtown area.

Try to respond to the mood that a scene evokes in you. Does something strike you as exciting, or awe you with its beauty? Is something interesting because of unusual circumstances, a pleasing repeated pattern or a startling color combination? Be constantly aware. Keep a mental diary, a notebook or sketchbook of such ideas. Take slides or photographs to remind you of things you have observed with your "new eyes." The time you spend just looking — before you even pick up a brush — is an important part of painting.

TRADITIONAL SUBJECT MATTER

It may help you think of ideas if you divide all subject matter into three main categories: landscapes, still lifes and figures. These categories may help you organize your thoughts, or allow you to choose a general subject with which to begin.

A *landscape* is a painting that emphasizes features of the natural environment, such as mountains, trees, fields and lakes. Paintings of cities, architectural forms, the sea, the surfaces of other planets and the like can also be considered landscapes.

A *still life* is an arrangement of inanimate (lacking the power to move) objects. A guitar, a bowl of fruit, an armchair, an old lantern or any object that appeals to you can serve as the main element in a still life. Often the objects included in a still life painting have special meaning for the artist, or have special relationships to each other that help unify the composition.

Human or animal forms are the center of interest in a *figure* painting. You've probably seen portraits of famous people or groups

36

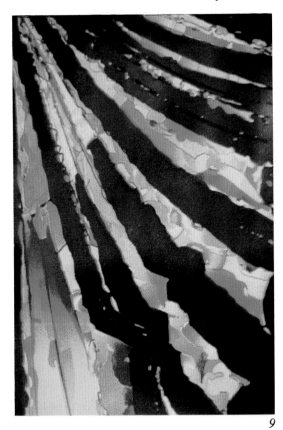

9

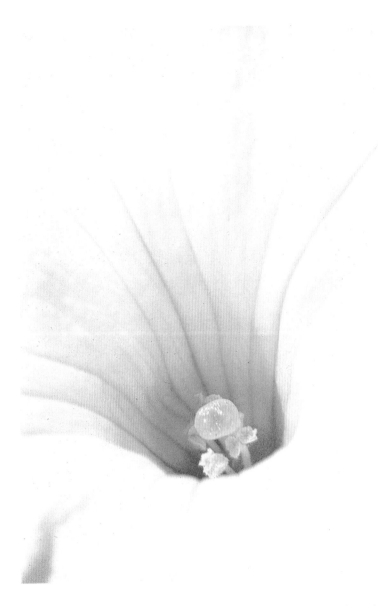

8

8. *A magnified view of a white petunia shows an interesting pattern which could be used in a painting. Lines leading to the center of the flower create radial balance.*

9. *An electron microscope captures jewel-like splashes of color in a mineral crystal and could be of interest to an artist in search of subject matter.*

of people, or studies of the human figure in motion. For the sake of simple classification, paintings of animals may also fall into this category.

Classifications like these are very broad and general, and many paintings—such as a man on the beach, a cat in a window, a church in a mountain meadow—are combinations of them, rather than simply one or the other.

Look through a museum or gallery, or the pages of an art magazine. Find paintings that fit into these three categories. Which of these subjects appeal to you most? As you consider the paintings that attract you, start thinking about how you could use such subject matter in your own work.

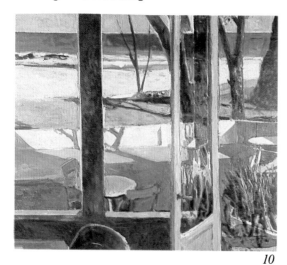

10

10. *Fragments of a beach scene are viewed through rectangular windows in Robert Frame's* Beach Terrace. *He has selected several sets of complementary colors and has used value contrast and diagonal lines to create excitement in his 50 × 60" (128 × 152 cm) oil painting.*

CHANGING YOUR POINT OF VIEW

Even if you have a general idea about what subject you'd like to paint, you're probably still searching for ways to make your treatment of that subject unique. One rewarding approach is to try to look at subject matter from an unusual point of view.

New Perspectives

Change your perspective. Look at a farm landscape from an airplane, and notice how it turns into a patchwork quilt of fields, with rivers tracing branch-like patterns through it. A person perched on a ladder looks quite different from someone you view at eye level—his or her size seems to change, and some body parts may be distorted. Look at a landscape through the arch of a tunnel, or a house through the window of another house—chances are these new views will give you new ideas for paintings.

Peer through a magnifying glass at some small object you find—how does it change? Magnify part of a cartoon—can you see how it was printed, what colors were used, what shapes make up those colors? What does a mineral crystal look like under a microscope? Is it something you might like to paint? Slice a cabbage in half, look through a kaleidoscope, set up a still life on a glass-topped table and stare at it from underneath. The world looks different when you change your ordinary approach to it.

New Ways of Thinking

Next try changing the way you *think* about familiar things. Sure, your shoe is exactly that—your shoe—but what other uses might it have? Could it provide shelter for someone or something? What can clichés tell you about shoes? What do they mean when they talk about "the old soft shoe"? What happens when someone gets his "foot in the door"? Playing with phrases or double meanings can spark ideas for unusual paintings.

Or consider similarities between familiar objects. Can you see any resemblance between an ear of corn, for instance, and a tall office building? Between a mushroom and an umbrella? What ideas do these similarities give you?

Contrasts can also give you food for thought. Think about contrasts—between a growing tree (natural) and a bulldozer (mechanical), for example—and how they can help you communicate your thoughts. Suppose you want to create a painting that expresses your love of the outdoors, and you fear that human technology may make the outdoors impossible to live in. You might paint a beautiful mountain scene in soft blues and greens, but add a hard-edged black factory in the foreground, with smoke from its smokestacks almost blotting out the view. You'll have used several forms of contrast to get your point across.

As you look for ideas for paintings, remember that your outlook

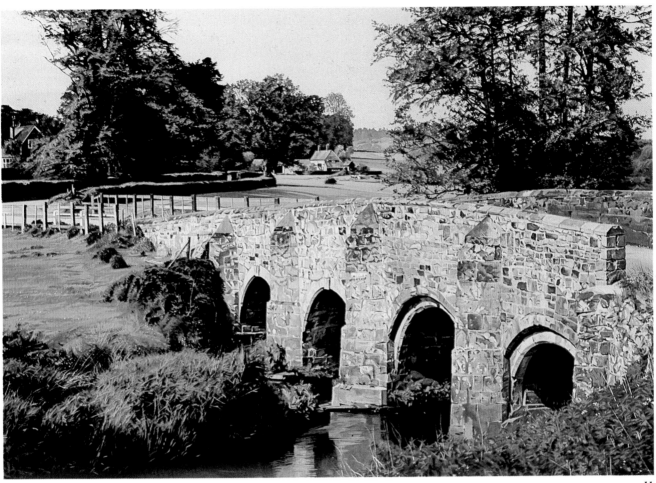

11

is unique, that no one else sees things in exactly the same way you do. Don't be afraid to try unusual things. Listen to your own thoughts, and trust them. It may take time to develop your special way of seeing, but with practice you'll probably find that it gets easier to think of new ways to look at the familiar things around you.

11. Dale Peché likes to work in a very realistic style, capturing details, lighting and shadow, and using local color. His gouache painting, Near Petersfield, Sussex, *sets up a rhythmic pattern by the repetition of arches and the spacing of fence posts. 18 × 22" (46 × 56 cm).*

OTHER SOURCES OF SUBJECT MATTER

In addition to working on the visual exercises we've described, you can look for ideas in the work of other artists and craftspeople. Visit galleries and museums and study the paintings and sculpture there. Look at pottery, weaving, works in glass, paper and bronze and notice their textures and colors. Glance through magazines and books on painting, photography or any subject that interests you, and pay special attention to the many different ways one subject can be handled. How many different ways are there to look at a car, for example?

Browse through a record store. How many albums use paintings on their covers? Which paintings? Are they modern or old? Are

12

12. *Alex Nepote uses color and shape to lead your eye deep into the center of his painting,* Hidden Nook. *As an abstract landscape, this 30 × 40″ (76 × 102 cm) acrylic collage creates a mood rather than a realistic portrayal.*

the paintings used to emphasize some idea the recording artist has, or to provide contrast to that idea?

Notice the many different styles of wallpaper, wrapping paper, greeting cards and posters. How do these styles express different moods through their use of color and pattern? Which ones attract you most? Why?

To generate ideas for paintings and plan a composition all at once, cut a number of colored shapes out of paper or fabric and experiment with them. Arrange them in various ways on a sheet of paper, and think about which arrangements please you most. Why? How can you use those arrangements, or that combination of colors and shapes, in a painting?

Did you create a painting that you no longer like, or that you feel was unsuccessful? Cut it up and rearrange the pieces. Perhaps you can see some new possibilities for it in this new form.

And, last but not least, close your eyes and let your ideas for paintings come from your imagination. Can you see shapes "behind" your eyelids when your eyes are closed? When you daydream, where do your thoughts go, and what images do you create? Have you ever thought of painting them?

One word of caution, as your head fills with ideas. Beginning painters sometimes find they want to include everything they think of in one painting. Try to avoid that. Be selective, narrow your field of vision and remove things that might make your painting confusing. Try to zero in on one main idea, one aspect of a scene, one unusual element. Keep in mind that you will be doing many paintings in the future. Save some ideas for later. Sometimes more can be said with a few well-chosen statements than with many less carefully selected ones.

CHOOSING A STYLE

An artist's style is like his or her voice—recognizable, individual, unique. Artists develop a particular style after many years of painting. If you look over the work of an artist who has been working in one medium for some time, you'll probably see some similarities between the works. They may be similarities of subject matter, use of color or line or expression of opinion. Style can be difficult to describe, but you'll begin to see it the more you look at paintings and other works of art.

Developing your own style will take a long time. As a beginning painter you'll probably be most concerned with learning how to organize your composition, mix and combine colors and get used to the materials you have to work with. But you'll find that the longer you paint, the more obvious your strengths and preferences become.

You decide, perhaps, that you're fascinated by the effect of light—especially winter light—on your subjects. Your paintings take

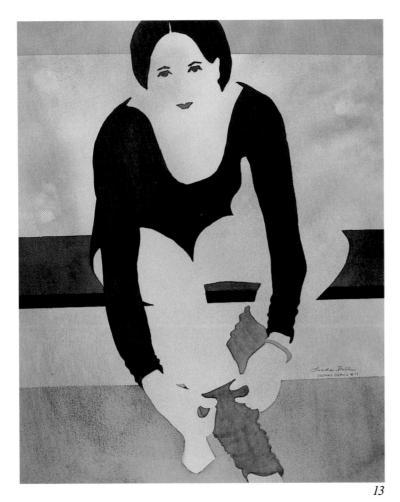

13

13. *Linda Doll makes strong statements in her paintings by eliminating everything that detracts from her central idea or theme. In* Leotard Series #19, *she chooses to emphasize shape, value contrast, movement and balance. Can you name some of the elements or principles of design she has eliminated in her watercolor?*

on a pale bluish cast; you find yourself using grays and browns and thin washes of muted colors. Or perhaps you begin to distort your subjects so that shapes and spaces are much more abstract. Your paintings may eventually be made up only of geometric shapes or bands of color. Or you may decide that you want to depict the world realistically, creating an almost photographic copy of it. Whatever form it takes, your style will develop if you continue to paint.

In the meantime, experiment with a wide range of styles. Try to capture all the realism of some of your subjects, including every visible detail. In other paintings, leave out some detail, change some of the colors you see and alter the composition to suit your needs and ideas. Try distorting your subject matter from time to time: make some objects larger or smaller than usual, or change their shape in some obvious way. Add bands of color across your works, or reduce a still life to its most simple shapes and colors. Work in the styles of other artists. You'll learn how they produce the effects that make their work special.

1 and 2. To draw objects convincingly, you must learn to see both positive and negative shapes. Here is a chair, first drawn by making the negative shapes black, and then drawn by making an outline in black of the positive shapes.

chapter 5

PLANNING AND ORGANIZING

DRAWING FOR PAINTING

Your head is full of ideas for paintings. Shapes and colors have begun to attract your attention, and you want to start putting them on paper. How should you start? If you're like most artists, you start with a pencil. While an experienced painter may sometimes sketch only a few pencil lines and then proceed to work immediately with paint, most painters find it very helpful—and usually necessary—to make a series of small sketches and then a large, detailed drawing before they start to paint.

Sketches and Working Drawings
A good way to begin to sharpen your focus and make your ideas clearer is to use a *viewfinder*, a piece of sturdy paper or cardboard with a square or rectangle cut out of it. Look through the viewfinder to "zero in" on an interesting area or group of shapes or colors. Viewfinders eliminate some of the surrounding space and remove things that might distract you.

When you have chosen a view that interests you, draw some mini-drawings or *thumbnail sketches*. These will help you familiarize yourself with the subject matter and experiment with composition. Instead of just thinking about your painting, you'll be using pencil and paper to plan it. Look intently through the viewfinder. Search for the negative shapes created by the edges of the viewfinder and the outside edges of the objects.

Next, enlarge your favorite sketch directly on your painting surface, or make a working drawing on manila paper or newsprint the same size the finished painting will be. If you decide to copy or enlarge your sketch, try turning it upside down. That way, you'll copy the shapes you see without worrying about how "right" they look. This is good practice.

If your working drawing is made directly from what you see, try drawing like this: Pretend your drawing arm is very long and you can touch your subject matter with your pencil. Imagine running your pencil over the edges of each object as you look at it. When drawing, look mostly at your subject. Only glance down at your

3

3. *Drawings of plants fill the sketchbook of an artist trying to decide on a good composition for a painting. Sketching helps artists organize their thoughts and record ideas quickly.*

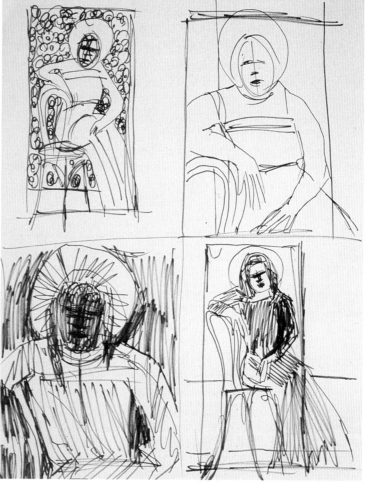

4. A model poses in a white dress and chair. The multicolored background adds interest and contrast.

5. Students stare intently at a model while doing preliminary drawings for a large figure painting. The room is partially darkened and the model is spotlighted to create a sense of drama.

6. Students use viewfinders to select areas they want to draw. Quick sketches help them organize ideas for composition.

7

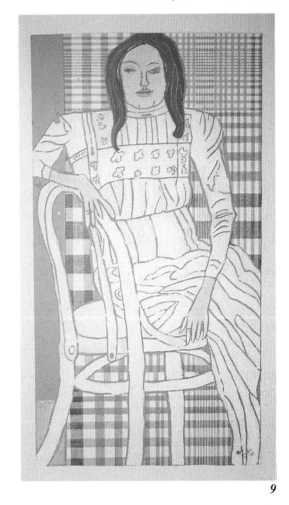

8

9

paper about one quarter of the time. You can add details later.

If this full-sized drawing pleases you, you may transfer it to your painting surface using carbon paper or by chalking the back of the working drawing and tracing over it. Make as few changes as possible on your final painting surface and it will remain smooth and clean. It is recommended that you use a middle value gray paper, instead of white, for most of your paintings (except transparent watercolor). Gray paper gives you a truer idea of the relationships between colors while you are painting.

If you find that you tend to draw too small and have trouble filling your paper, draw on even larger paper and cut it down to normal size when your drawing is finished. A drawing of any size may be *cropped* (cut off on any or all sides) to improve the composition, before it is traced onto your final paper.

You may want to experiment with your composition but want more flexibility in arranging the objects than drawing allows you. Try this: Draw each object on a separate piece of paper, cut each one out and place all of them on your drawing surface. When you achieve a good composition, trace around the objects. You'll probably spend less time erasing than usual.

As you work through various sections of this book, you will find several approaches to drawing for a painting. Experiment with them, and with other procedures that you see or discover on your own. The drawing style you choose may depend upon the kind of painting you want to create, or the amount of time you have. You may draw differently for every painting you produce. But drawing is an important first step toward a finished painting, and it is always good practice for an artist.

7. *A working drawing, carefully drawn to the size of the finished painting. A drawing like this can be transferred to gray or pale blue paper using chalk or carbon paper.*

8 and 9. *Two student tempera paintings of the same subject. How did each treat the background differently? Can you see contrast at work in either? Both students left some areas of gray paper showing. How do these areas contribute to each work?*

Getting into Painting

10

11

10. *If you look closely at this painting, you can see three magnified circles. This is one subtle way to add interest to a painting. The student used two sets of complementary colors (red-green and yellow-violet) for a brightly contrasting color scheme.*

11. *You can just barely notice the circular miniatures in this vibrant tempera jungle painting. Much care was taken in painting the dark background and negative spaces to produce crisp, precise leaf and flower shapes.*

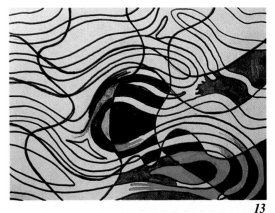

12

13

14

More Drawing Ideas

While you draw, think about how powerful your drawing is, and how well it conveys your feelings about your subject. If you feel it needs more visual interest, or a stronger composition, consider adding some unique touches.

For example, draw several circles inside your composition and enlarge everything within them, as if they were magnifying glasses. Or distort the objects as if the circles were drops of water.

Draw borders, rays, circles or ovals over the drawing and plan to paint them in transparent tints or shades. These areas will add interest to the finished painting.

In a small circle or rectangle, draw a miniature copy of your drawing and position it somewhere on the larger drawing. This will create a kind of echo effect, and can draw attention to parts of the work you'd like to emphasize.

Another unique treatment is to draw additional lines over a finished or near-finished drawing. Divide the drawing with a grid of horizontal and vertical lines, spaced in any way you please. These lines can form a rhythmic pattern or they can echo the shapes of other objects in the drawing. When painting, change color or value at every division line. This technique can create patterns of color and value throughout the painting.

These drawing ideas may add uniqueness to your finished painting as well as contribute to the overall composition. Can you think of any other ideas which might work well?

12. First, a simple line drawing in pencil.

13. The artist then adds wavy division lines, three vertical and three horizontal, in green ink. At each division line the artist uses a different color.

14. The finished watercolor painting (only 4½ × 6″ — 11.5 × 15 cm) has a rhythmic quality. This technique distributes colors in an interesting pattern over the entire surface of the painting.

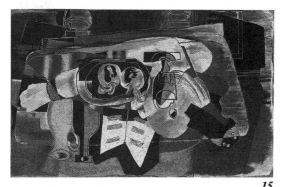

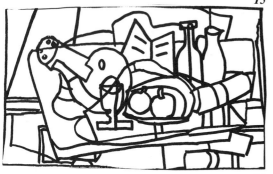

15

16

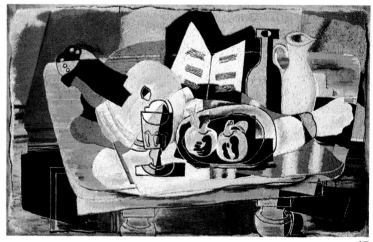

17

15. *By turning Georges Braque's still life upside down, you notice design elements and principles without being distracted by subject matter. Notice the value contrast and the pattern made by dark and light shapes. The painting seems equally balanced on either side of the pointed shape at bottom center.*

16. *A line drawing of Braque's painting shows that diagonal lines are balanced: when a line slopes one direction, another elsewhere in the picture slopes in the opposite direction. Lines also serve as barriers to keep your eye from drifting off the edge of the picture.*

17. *In* Still Life: The Table, *painted in 1928, Braque has distorted his objects in the style of Cubism. The limited earth tone colors, the combination of geometric and organic shapes and the contrast of light and dark make this an interesting composition. Note the many ways shapes and lines lead you to the center of the picture. Oil on canvas, 32 × 52" (81 × 132 cm). National Gallery of Art, Washington, DC. Chester Dale Collection.*

ANALYZING A PAINTING

You've found a subject that interests you, done some sketches and begun to paint. But while you work you wonder: How will I know when the composition is right? Have I chosen the best possible arrangement of objects? How much detail should I include? And what if I find that the painting doesn't seem to work? Is there something I can do to change it? Here are some ways to analyze the organization or composition of a painting—yours or someone else's.

Turn the drawing or painting upside down or on its side and study it. When you cannot rely on subject matter to hold it together, you will be more aware of the painting's other strengths and weaknesses. Does it seem well organized even upside down? Does it seem *better* organized upside down?

Some Solutions

Make a line drawing of your painting. Analyze the main shapes and lines—do they create a strong composition?

Is the painting structurally weak? Compositions seem most stable when most of the shapes and lines tend to be vertical or horizontal. If something leans diagonally to the right, balance it with something leaning to the left.

Do the objects in the painting seem unrelated to one another? Try unifying them with a shadow underneath them. In a still life, a cloth under the grouping will help unite all the objects. A fence in a landscape or a ribbon flowing from object to object will tie separate things together. Giving all the objects similar values will also help weave them together.

Is the painting too confusing, too busy? Is there too much pattern? Try introducing some plain areas. Lessen some of the contrasts. Choose one element or principle to emphasize, and try to make other elements less important in the painting. This will help

18

20

19

18. The plants in this student's tempera painting are held together by the pale window and the linear leaves that lead your eye rhythmically from one plant to the next. The white cloth unifies the objects on the table. The dark stone surrounds the painting and holds it together like a fence around a pasture.

19. You can zero in on a small area of a picture or a painting using a small shape as a pattern to draw around. Use the selected area as the nucleus or center of a new composition.

20. A streamer of ribbon, a strand of yarn, stripes on the drapery, the lines of the chair and dried weeds all tend to lead your eye around this pastel painting on black paper. Can you find any lines that counter the diagonal lines formed by the cloth from upper left to bottom right?

21

22

23

21. *Darkening the corners of this tempera painting makes your eye move in a circle around the picture. The dark corners serve as barriers to keep your focus in the center.*

22. *Katherine Chang Liu has used a light band across the top and a dark one at the bottom to enclose her luminous painted collage. The dark area also serves to give visual weight to the bottom of* Ancient Walls #6, *a 30 × 40″ (76 × 102 cm) mixed media painting.*

23. *An asymmetrical arrangement of bubbles sets up a rhythm and forms a pathway as the eye moves from one part of this tempera painting to another.*

give viewers fewer things to concentrate on. If you think too many colors make your painting too busy, consider eliminating some.

Does your eye wander off the paper and out of the painting? If so, figure out why. If an arrow-like shape or a line leads you off the paper's edge, place a "road-block" in its way. Put a line or shape perpendicular (at a right angle) to it at its end to keep your eye from straying out of the picture, or gray the colors near the outside edge of the painting. Darken the corner areas to keep the focus of attention in the center. Enclosing the painting with a darker transparent border all around, either an oval or a rectangular shape, also helps highlight the center of the picture plane.

If your painting is too top heavy, a shadow, a dark shape or a dark transparent band at the bottom will help balance it by adding visual "weight."

Superimposing pale shapes on your painting — such as light rays or bubbles — or adding some transparent colored areas can create movement and direction in the composition.

SUMMING UP

Now that you have some knowledge of the basics of painting, and can use some of these compositional ideas to make your paintings better, you're ready to explore further. What media can you use? Does watercolor express your ideas best, or do you find that collage inspires you? Will you try oils or acrylics? And how do other artists approach different kinds of subject matter? How does an architectural painting differ from a seascape? Why do so many artists paint portraits? How can you learn to paint human figures naturally? All these and many other questions will be explored in the upcoming chapters. Enjoy the trip.

26

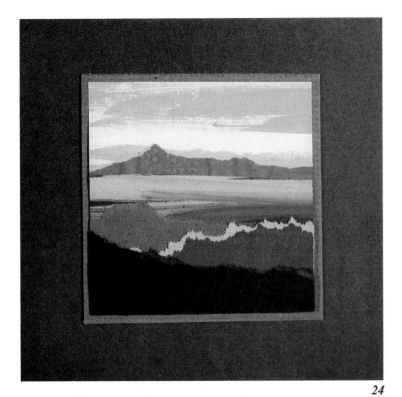

24

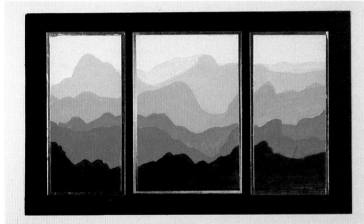

25

24. Tiny collages of painted paper or magazine shapes may help you come up with a composition that could be enlarged into a painting. Try to copy your collage exactly, duplicating size and shapes and matching colors.

25. Cutting some paintings into vertical strips and spacing them on a new background can add interest to a painting. (A composition composed of three pieces is called a triptych.)

26. Sometimes cutting a painting up into many rectangles and reassembling them produces an interesting composition. Repainting areas after they have been reassembled improves the finished painting. See if you can come up with other ways to manipulate materials to achieve a composition that works.

part II

MEDIA AND TECHNIQUES

1. *Fra Filippo Lippi painted delicate and sensitive paintings using real people as models as he did in* Madonna and Child, *finished around 1445 in Florence, Italy. Like other Renaissance painters, he paid much attention to light, shadow and perspective to give volume and depth to his paintings. Tempera on panel, 20 × 32″ (51 × 81 cm). National Gallery of Art, Washington, DC. Samuel H. Kress Collection.*

1

chapter 6 # TEMPERA

Literally, the word *tempera* means any substance used to bind powdered pigment. As early as the tenth century, altar pieces and gessoed panels were painted with a mixture of egg yolk and water added to pigment. Egg white tempera was used on parchment for medieval manuscript illustration. The tempera or poster paint produced today comes in both powder and liquid form, and is much easier to work with than its medieval counterpart.

Powdered paint or powdered tempera is mixed with water until it has a thick, creamy consistency. The paint is opaque, dries to a smooth matte finish and will cover a previously painted area if the new coat is applied gently. Powdered tempera colors are easy to mix. Roll a damp brush into the tops of small piles of dry paint and then mix the colors on a palette of aluminum foil. Egg cartons make convenient containers for powdered tempera.

Mixing the powder with liquid starch or acrylic gel medium instead of water will produce a more durable paint surface. This allows the artist to build up transparent layers of paint without smearing the undercoats. If using acrylic gel, make sure you wash your brushes thoroughly before they dry, as acrylic gel will ruin them.

Powdered tempera is available in all the key colors of the color wheel plus black, brown, white, silver and gold. Some companies offer only a few colors; in those cases, knowledge of color mixing can be very valuable.

Liquid tempera poster paint is made from finely ground pigments and comes in many brilliant colors, including fluorescent colors. Designers and artists use this paint because of its versatility: The permanently plasticized starch base makes it easy to work with and creates a dry film that does not chip. Its adhesive ability allows application to almost any surface, including glass.

Both powder and liquid tempera paintings can be sprayed with fixative when dry to make their surfaces more durable.

2

2. *Medieval monks were excellent illustrators of manuscripts. This multicolor page from the Lindisfarne Gospel Book, 698–721, is an example of their intricate work. Hidden in the swirls of the calligraphy are serpents, dragons and other fantastic animals. Egg tempera and gold on parchment, 9.6 × 8" (24 × 20 cm). British Museum, London.*

3

4

3. *Tempera powder and liquid tempera. Water, liquid starch, polymer medium or acrylic gel may be mixed with powdered tempera. Baby food jars work well for storing mixed paint; egg cartons are perfect containers for the powder.*

4. *A variety of brushes, including an Oriental brush (far left), toothbrush and stipple brushes, as well as a sponge, can be used to apply tempera paint. Various colors and weights of paper are suitable. Spraying clear or tinted water on a tempera painting can produce interesting effects.*

PAINTING SURFACES

Papers of various textures, weights and colors are suitable for tempera paint. Artists concerned with maximum durability look for high rag content in a paper, which may cost several dollars a sheet. However, most painters find that a heavy grade construction paper works well. Mat board or any heavy paper with a non-shiny surface also gives good results.

Paper in a neutral gray color of a middle value is best for work with tempera. The artist will not be "blinded" by a glaring white surface while the painting is being worked on, and so can judge color relationships more accurately. Colored paper can produce interesting effects. If you plan to leave some of it exposed in the finished painting, make sure that you purchase a fade-resistant colored paper whose color will not change over time.

It's a good idea to apply masking tape around all sides of the back of the paper to keep it from becoming tattered on the edges while you are working on it.

TOOLS AND EQUIPMENT

Most of the brushes used for watercolor painting are suitable for painting with tempera.

Round brushes of synthetic combinations retain a fine point and carry much paint. Use the largest brush you are comfortable with; large brushes hold more paint and do not need to be loaded with paint so frequently. An assortment of sizes—#3 or #4 for detail work, and #8 and #12 for larger areas—is recommended. Avoid brushes that lack resilience or are too limp: they will allow you less control. Oriental brushes in various sizes are excellent. They have very fine points, hold a lot of paint and let you create interesting shapes with a single stroke.

Use bristle brushes if you want a painterly effect. The brushstrokes will usually remain visible, and edges will not be sharp or crisp.

Sponges may be used to impart texture to a painted area or to apply one color on top of another. Coat a rough textured sponge with a light layer of paint and superimpose its imprint on top of another color.

Load a toothbrush or a stiff stencil brush with paint, and flick it with your thumb to produce a spatter or textured effect.

Mist from a spray bottle can be used to impart texture or to apply dots of color to a painting. Be sure to mask off all areas that you don't want sprayed.

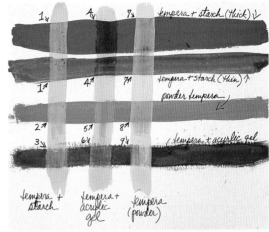

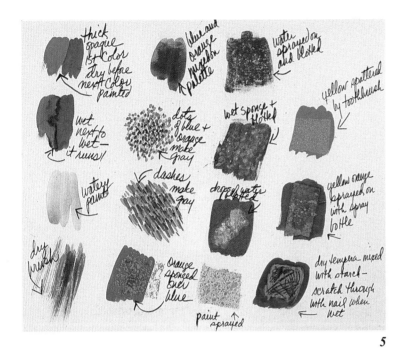

5

6

7

WAYS TO WORK

Tempera is usually applied when it is thick and creamy to produce a smooth, opaque matte finish. Although it dries quickly, colors will run together if you paint next to a wet area. To retain crisp shapes, be sure an area is dry before you paint close to it.

If you plan to cover a painted area, apply the second coat gently and thickly, using a darker color to prevent the undercoat from bleeding through. You can also minimize bleeding by mixing the undercoat with liquid starch instead of water and letting it dry before applying paint over it. Sometimes two overcoatings will cover a darker color.

If you wish to *imply* transparency (make colors look as though other colors show through them) but are using opaque paints, mix the two (or more) colors you intend to overlap. The resulting color will appear to be a combination of two transparent colors.

Thinning the tempera with more than the usual amount of water or starch will make it transparent and dilute the intensity of the color.

You may also forego mixing colors smoothly on your palette. Instead, paint dashes or dots of color directly on your painting, in the manner of the Impressionists or Pointillists, and let the viewer's eye mix the color. Layering paints with a "dry" brush (a brush with little color or water on it) also produces an interesting effect.

Spraying a finished painting with a fine mist of water and letting it dry increases the brilliance of the colors. It also tends to blend them, and to create a tiny pebbled pattern on the surface. Experiment with a simple painting before trying this on one of your better pieces.

5. Tempera is a very versatile medium, and there are many ways to apply it. What other techniques can you think of?

6. This chart shows that if you use an undercoat of powder tempera mixed with either liquid starch or acrylic gel, and paint over it with thinned paint, real transparency results without smearing (1, 3, 4, 6, 7, 9). If you mix the tempera only with water, it will smear if painted over with a thin layer of paint (2, 5, 8).

7. Implied transparency can be achieved with opaque paint by overlapping shapes. Paint the overlapping areas by mixing the colors together.

8

9

8. *To prepare to paint an exotic jungle scene, many small sketches are made of floral motifs. The artist draws directly in felt-tipped pen. She will use these sketches as sources of information for a larger felt-tipped pen drawing.*

9. *The drawing is transferred to heavy gray paper using carbon paper. Corrections can be made at this time and the drawing can be trimmed down if desired.*

10. *Circles are superimposed on the drawing to be painted in pale colors later. Here a student consults her paint chart for help in choosing a color scheme. Paint is mixed on a wax paper palette.*

10

DEMONSTRATION/TEMPERA PAINTING

Tempera paintings should be well planned and approached in a step-by-step manner. This series of demonstration pictures shows you one way to approach painting with tempera.

13

11

12

11. Experiment with painting techniques and color combinations on a sheet of glass placed over the painting.

12. Here the artist chooses a deep blue-black as the background color. She has painted the objects first, including some details. Final details can be painted after the background is finished. An Oriental brush, which holds a lot of paint and has a fine point, works well to define shapes precisely.

13. The finished painting is lightly sprayed with a fine mist of water to blend the colors and to create an interesting surface texture. Charcoal shadows may be added.

14

14. *Andrew Wyeth's* Christina's World, *1948, is an example of the detail and precision possible with egg tempera. Through effective use of space and his realistic style, he creates a mood of loneliness. Wyeth painted the landscape first and then superimposed the figure on it. Tempera on gesso panel, 32¼ × 47¾" (81 × 122 cm). Collection, The Museum of Modern Art, New York Purchase.*

15. *Claude Buck's* Shepherd Family, *with its soft, rounded shapes and lack of detail, has a look of great peace and gentleness. Can you see how the forms of sheep and hills lead your eye smoothly from left to right to the family group? Oil and tempera on plywood, 1915, 6 × 8" (15 × 20 cm). Courtesy Sid Deutsch Gallery, New York.*

16. *Robert Vickrey chooses egg tempera for his precise and detailed paintings. His powerful personal style is exemplified in* Kim From Above, *30 × 40" (76 × 102 cm) on gessoed panel. Note the way he has used shadows as important design elements (line and shape).*

LOOKING AND LEARNING: A GALLERY OF TEMPERA PAINTINGS

Examining other artists' tempera paintings will teach you to appreciate tempera's special qualities: its clear, bright colors and matte finish.

As you study each picture, notice how the artist has used the elements of design. Look for the use of color, value, line, texture, shape and space. Review the principles of design and note instances where balance, unity, contrast, emphasis, pattern, rhythm and movement play an important part in a painting.

15

16

19

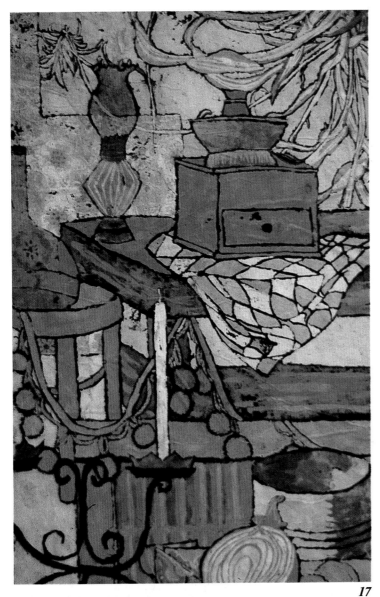

17

18

17. This paint resist on rice paper was painted with a limited color scheme of two sets of complementary colors (red-green and yellow-violet). Note the balance created by the use of both straight and curved lines in the 18 × 24" (61 × 46 cm) work.

18. The entire surface of this painting is covered with repeated rhythmic shapes and luminous color. The artist mixed gold metallic tempera with the colors in the small circles. Gray shadows were painted in last as a soft middle tone of value to unite the dark and light colors.

19. Mark Tobey's Broadway is an abstract painting of a big city at night. The overall textured appearance was achieved by sketching details with white paint. For a soft effect, the artist used a dry brush technique in some places. Tempera on masonite, 19³⁄₁₆ × 26" (49 × 66 cm). The Metropolitan Museum of Art, New York. Arthur H. Hearn Fund.

20

21

22

20. *Tempera permits sharp edges and fine detailing. This still life was painted on black paper which was left showing in the grillwork. All of the colors in this painting were mixed from red, green, blue, black and white.*

21. *This tempera paint resist of a figure shows the subtle effects of shading this process can yield. Many layers of paint in different tones were applied before the ink wash-off. The curve of the chair keeps your eye from wandering off the top of the page. (More wash-off techniques, chapter 12.)*

22. *Little dabs of tempera give the textured effect of grass in this large resist painting. The artist drew each quarter of this picture on 18 × 24" (46 × 61 cm) gray paper and carefully fit the pieces together before he painted. He finished each resist section separately and later glued them together. The overall finished size is 36 × 48" (91 × 122 cm). (More resist techniques, chapter 12.)*

ACTIVITIES

ART HISTORY

☐ The tempera paint that you use is an opaque, water soluble medium, and is related to the egg tempera used many hundreds of years ago. Do some research in encyclopedias or art materials books and write a brief history of *egg tempera.* Include the kinds of grounds on which the paint was applied. List several early Italian artists who used tempera in their work. Why have so many of these early artists remained unknown in art history?

☐ Several contemporary artists still use egg tempera in their work. Research the work of one or two of them, such as Andrew Wyeth and Robert Vickrey. Present a report on how their work differs from the work of Fra Filippo Lippi or Jan van Eyck. Use slides or illustrations whenever possible, and discuss: subject matter, size, technique, grounds, concept and purpose. Perhaps you could narrate a video presentation on the subject with a classmate.

CRITICISM / ANALYSIS

☐ Study Robert Vickrey's painting *Kim from Above* on page 60. Then analyze it by discussing or writing answers to these questions.

What medium is used, and what is the size of the work? (Cut a piece of kraft paper the same size as the painting, so you have a way of comparison.) What geometric shapes can you find? How are shadows used to tie parts of the work together? What type of balance is used? Why might the artist have placed the partial wheel in the upper right corner? How would you describe the artist's style? What effect does the change in color and value of the ground have on the painting? Where is the center of interest? How has the artist taken you there? Analyze how and why circles or ovals are used.

☐ Compare and contrast the tempera paintings of Andrew Wyeth (page 56) and Mark Tobey (page 61). Discuss texture, subject, style, use of line, concept, color, detail, mood, etc. How has each artist communicated his goals as stated in the titles *Christina's World* and *Broadway?*

AESTHETICS

☐ Study Robert Vickrey's painting on page 60. Write several sentences in response to these questions.

How does the artist use perspective to attract our attention? How does this approach differ from the approach taken in most paintings? What might have happened seconds before the scene you see? What do you think was the artist's concept in arranging and designing the space? What other title could you give the painting? Imagine the painting at 30 × 40″ (76 × 102 cm), or project the image at that size on the wall. How can size change the way a painting affects you? Do you like the painting? Why?

☐ Study Andrew Wyeth's painting of *Christina's World* on page 60. Write a description of what you see in the painting, and tell how it makes you feel. What mood has the artist set? How did he establish the mood? How do you feel about Christina? How has the artist emphasized Christina's plight in the painting? Christina was the artist's neighbor and was a crippled girl. How has he made you aware of this? Does the painting make you feel comfortable or uncomfortable? Why?

PRODUCTION / STUDIO

☐ To emphasize the opaque quality of tempera color, paint a still life on black paper, leaving the paper unpainted where you want to form black lines or shapes. The resulting painting may resemble a stained glass window, and the colors will seem to glow. Use the paint directly from the bottle, and do not dilute with water. Why will the addition of water defeat the purpose of this project?

☐ Use tempera colors to make a painting in the style and technique of Vincent van Gogh (dashes of color) or Georges Seurat (pointillist dots). Study examples of the work of these artists and note the way they applied paint. Work in small sizes and use simple subjects for your project: three apples, two flowers, a doll or stuffed toy, for example.

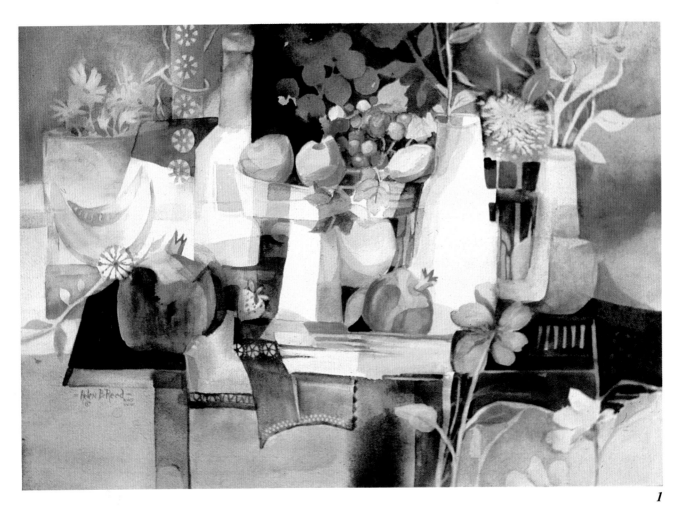

1. Helen B. Reed's Still Life Mosaic *shows the transparency of the watercolor medium. Overlapping washes produce a variety of color combinations. Note the careful structuring of the parts of the painting and the excellent use of warm and cool hues to control visual movement in the painting.*

Note: Most watercolor paints are non-toxic; however some pigments can cause allergic reactions. Read labels carefully, wash your hands often, wipe up spills immediately, and *never* put your brush in your mouth.

chapter 7

WATERCOLOR

Among professional artists, transparent watercolor is the most popular water-based medium. Although types of watercolor have been used for several thousand years, the transparent medium (also called *aquarelle*) became popular in England in the eighteenth century. Previously, it had been a tinting medium used to color ink drawings and to make sketches for oil paintings.

Although English artists popularized watercolor, it is in America that it first became a major painting medium. Around 1880, Winslow Homer made watercolor his prime means of expression, exhibiting his finished works for public viewing. John Marin emphasized his personal feelings, Edward Hopper stressed structure and mood and Charles Burchfield changed the way we think about nature. In recent years, the medium has gained enormous popularity, and artists now displaying dazzling arrays of techniques and countless styles, from nonobjective to superrealistic.

THE WATERCOLOR MEDIUM

Transparent watercolors are not *purely* transparent, but they differ greatly in their texture, covering quality and luminosity from tempera paint and other opaque watermedia. White paint is generally not necessary in watercolor painting. Degrees of color intensity and tints are determined by the amount of water mixed with the colored pigment—the more water, the less intense the color. Color mixed with water is called a wash, and applying washes to white paper allows the white to glow through the color, producing the variety of intensities that characterize the medium.

Watercolor comes in tubes, cakes and pans. Tube colors are the most moist and the most intense in hue—most watercolorists prefer them. Pan colors require vigorous brushwork to pick up color, but the colors become softer if you put a few drops of water on them before you begin to paint.

2

2. Winslow Homer explored many ways of using the watercolor medium to show us the world of nature that he loved. Palm Trees, Florida was painted at his favorite fishing location. The painting, done in 1904, is 20 × 14" (51 × 36 cm). Museum of Fine Arts, Boston.

3

5

6

4

3. *Most watercolorists prefer tube paints, because they remain moist and are more intense in hue than other kinds of watercolor.*

4. *Several types of plastic palettes are used for arranging moist paints and mixing washes. Students and artists often recycle common household items, such as plastic plates or frozen food trays, for these purposes. Palettes of any type must have mixing spaces large enough to hold large quantities of water for making washes.*

5 and 6. *Try several ways to make marks with your brushes. Use the tip; press a bit to make broader lines; release pressure; use the sides; twist the brush as you draw it across the paper. Note the kinds of marks you create, and use them when you begin to paint.*

PAINTING SURFACES

Because the artist relies on white paper to produce watercolor's values and intensities, papers must be chosen carefully. The best papers are expensive and usually made in Europe. The thickness and weight of paper is determined by how much a ream (500 sheets) weighs. Heavy watercolor papers can weigh 400 pounds per ream, and are identified by their weight, such as "300 pound rough."

Surface qualities of papers also vary, with some being rough and others smooth. Hot press papers are smooth; cold press papers are rough, and rough papers are extremely textured. The more texture a paper has, the more apparent that texture will be in a finished watercolor painting, so it is wise to try several different surfaces before you begin to paint in earnest. Artists select their favorite weights and surfaces after much experimentation and trial.

There are many professional papers that you can experiment with. "Student grade" watercolor paper, heavy white drawing paper, oatmeal, charcoal and some rice papers provide a variety of excellent surfaces. Thin papers buckle when wet, but can later be flattened under weighted boards. Some artists make such papers more usable by coating them *thinly* with gesso, acrylic gesso or acrylic medium. Try a number of different papers to determine the most suitable surfaces for your watercolor work.

TOOLS AND EQUIPMENT

Brushes are made in almost infinite variety. Most are useful, but no one brush will serve all your painting needs. Experiment with several before choosing the ones that work best for you. It is important to remember that a few good tools are more useful in the long run than many mediocre ones.

All types of brushes come in several sizes. They are usually

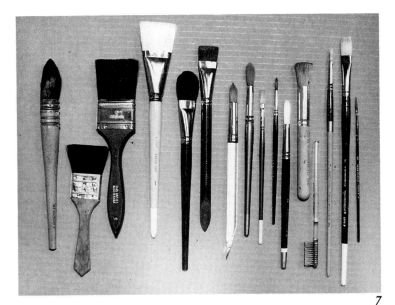

7

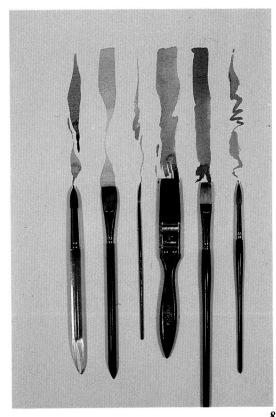

8

9

numbered, with the larger ones having higher numbers. For example, round brushes range from number 000 to number 16 (the largest), with numbers 10 or 12 making good all-purpose tools. Flat brushes are sometimes numbered, but often are sized by their width 1/8″ to 2″ wide. Generally, watercolorists use the largest brushes possible for each part of their working processes.

Watercolor brushes are usually made of animal hair (sable, ox or squirrel), synthetic fibers or combinations of them. Red sable brushes are very expensive and favored by many professional artists. Natural/synthetic combinations are extremely popular and produce excellent strokes, carry much water and retain fine points. Try also bristle or nylon brushes (generally made for oil, acrylic or tempera painting), Oriental brushes, stencil brushes, toothbrushes and varnish brushes to see what kinds of marks or strokes they make.

Fill several sheets of white drawing paper with practice marks, made with a variety of brushes. Try using a very wet brush or a brush that is just damp, and note the difference. Hold your brushes in several ways (across yor palm; near the tip; at the end) while you make your practice strokes.

7. Try some brushes that are not made specifically for watercolor painting. Here is a variety of brushes, all acceptable for use with watercolors.

8. Five brushes, with the marks they make when stroked, twisted and turned. From left: synthetic hair, #12; flat sable, 1″; sable striper, #2; varnish brush, 1″; bristle brush, flat #7; round sable, #8.

9. This student experiments by using a bamboo pen to draw with ink into a watercolor painting. Note the equipment: slanted Masonite board; water supply in a plastic bottle; half-pan watercolor sets; mess trays used for washes; sticks and a variety of brushes. Learn to use any tools available that will help you make better paintings.

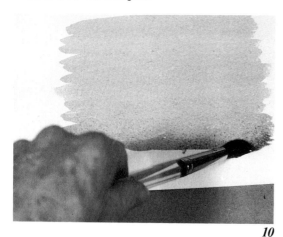

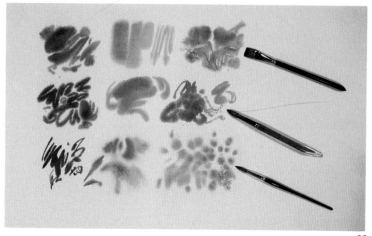

10

11

10. *Washes can evenly cover large areas of paper if they are applied carefully. Slant your paper slightly. Mix large amounts of wash. Begin at the top by brushing a horizontal stroke with a large, loaded brush, leaving a "bead" of moist color (an accumulation of water and color that occurs on a slanted painting surface) at the bottom of the stroke. Load the brush again and lay down another stroke just touching the bead at the bottom of the previous stroke. Continue until the area is covered. Do not go back and touch up wet areas. Finish the wash by picking up the last bead of color with a squeezed-out brush. Practice this technique on several kinds of paper.*

11. *Three different brushes were used to apply color to the wet surface. As the paper dries, edges of strokes become more crisp. Soft edges are typical of this wet-into-wet process.*

You may try other kinds of tools for watercolor as you become more familiar with the medium. Make thin lines with sticks and broad lines with pieces of cardboard; cover large areas with sponges dipped in paint. Dip your fingers, hands, crumpled paper or facial tissue in colored washes.

Containers for water should be as large as possible. Quart containers, bowls or small plastic buckets are fine. Large amounts of water will help you keep your brushes clean and will make washes easier to mix.

Drawing boards (1/2″ plywood, or 1/4″ Masonite) are excellent supports for papers, because they can be slanted (on a book or two, for example) to any desired angle. Simple table easels make it easier to control the amount of slant. Use masking tape to hold papers in place.

WAYS TO WORK WITH WATERCOLOR

As recently as twenty-five years ago, most watercolor paintings had a similar and distinctive look, determined by the technique and use of the medium. Today, however, watercolors are used in an ever-widening range of techniques and styles, and are often combined with other media. Before you begin to paint with transparent watercolor, it is important to learn about its unique characteristics.

Watercolor can be applied to both wet and dry surfaces with vastly different results. Evenly wet a sheet of paper with a sponge, and apply watercolor with a large brush loaded with water and color. Next, try painting with a relatively dry brush (use only a little water) and note the differences. Use round brushes and flat brushes. Spatter color on the wet surface. Scratch the painted area lightly with a stick or brush handle. Use a bristle brush to move color and water on the surface. In some areas, keep adding color as the surface dries to see what happens. Use only two closely related colors (red and orange, for example) on one sheet; then repeat the experiment with complementary colors or split complementary harmonies.

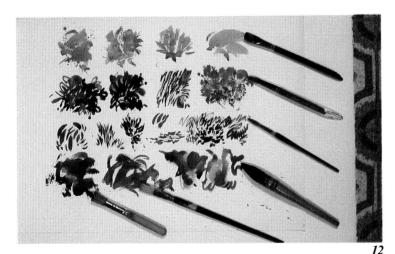

12

14

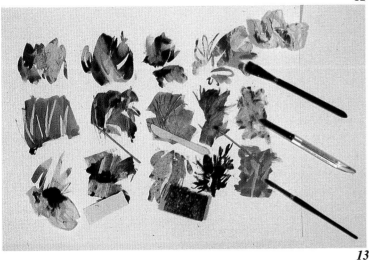

13

12. *Six different kinds of brushes made these marks on dry paper. Try varying amounts of water and color in your brushes, and experiment by using all parts of each brush.*

13. *In addition to the three brushes, splintered sticks, a plastic knife, facial tissue and sponges were used in this series of experiments.*

14. *Roger Armstrong painted* Beginning of Fall *on an 8 × 11½″ (20 × 29 cm) sheet. He brushed color onto dampened paper and allowed it to flow. The small, star-like spaces were made by sprinkling table salt onto the wet color and letting it dry. Can you see where color was lifted with a squeezed-out brush? Can you tell where the paper was wet and where it was dryer when color was applied? Can you see where color was spattered? Try painting abstracted tree forms on a dampened sheet of paper.*

Slant your work surface at several different angles. Sometimes a flat surface works best, although the colors may puddle. A slant allows colors to run, and helps produce even washes.

Work through similar exercises (using several kinds of brushes, spattering, scratching, etc.) on dry paper. Try several kinds of paper, from smooth to rough, to see how surfaces affect the results. Paint some sheets with light values and light-valued (high keyed) colors; others with dark values and dark-valued (low keyed) colors.

Before you even attempt to paint actual objects, learn what the medium will do under many different conditions. Draw into a wet surface with a small brush loaded with intense color. Blot color with a crumpled facial tissue or a squeezed-dry brush. Draw on a damp surface with a stick and intense wash, or ink. Experiment with ways to make exciting and interesting textures, bleeds, washes, swirls and so on.

Notice that as the papers dry, the lines and edges you paint become sharper. Color put into a wet surface will dry much lighter; the same color applied to a dry surface will retain much of its intensity.

BARN - TREES - FENCE POSTS - PATHWAY - BUSHES

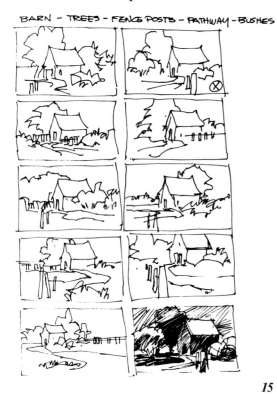

15

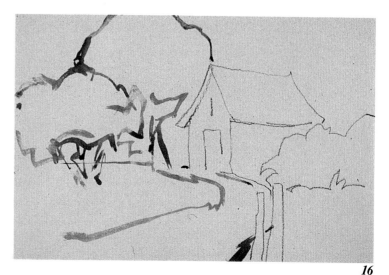

16

15. *On an 8½ × 11″ (22 × 28 cm) sheet of typing paper, the artist draws a number of trial arrangements of five elements. The barn is the center of interest. Note how it is moved to various locations in the sketches, and how each sketch is a little different from the others. After studying the various arrangements, the upper right one is chosen, and a small black and white value study is done at the lower right to help determine the color values to be used in the final painting.*

16. *The major elements are placed on an 11 × 15″ (28 × 38 cm) sheet of white drawing paper. For the sake of the demonstration, part of the outline is done with pencil, part with brush and a neutral wash. This outline is only a rough sketch; some artists prefer to make a very careful beginning drawing. This arrangement of the parts of the subject should fill the sheet and appear comfortable and well designed.*

DEMONSTRATION/ HOW TO START A WATERCOLOR

After you have chosen your subject (still life, landscape, flowers, figure, abstraction, etc.), it is often valuable to make a series of quick thumbnail sketches, about 2 × 3″ in size. Try several arrangements of the main elements in the composition and choose the one you wish to use.

Regardless of subject, basic watercolor painting techniques remain generally constant: 1) Make a light outline of major elements; 2) Determine white areas and apply light-valued washes to the rest of the surface; 3) Add darker over-washes, called glazes; 4) Add darkest darks (accents, deep values); and 5) Add intermediate value glazes, textures, and finishing details.

No two artists paint exactly alike from the beginning to end. Some like to begin with line drawings in pencil, pen or brush. Others like to start by painting large shapes, then adding necessary lines. Try several ways to see which works best for you. Do not be concerned with details in the beginning. Whether starting with line or shapes, work from large shapes (generalizations) to smaller details (specifics).

In transparent watercolor paintings, white is obtained by leaving parts of the paper unpainted. Therefore, you must first determine where whites (if any) will be left. Next, start adding washes of the lightest values of the "local colors" (actual colors of objects). Light-valued washes are made with much water and little color. Fill the sheet as quickly as possible, so that you won't be tempted to add too much detail too soon. Use a large, soft brush to wash in the sky, background and other large shapes.

When the paper is dry, add some darker value washes over the others, still working in large areas and shapes, not details. Let areas dry before adding more washes.

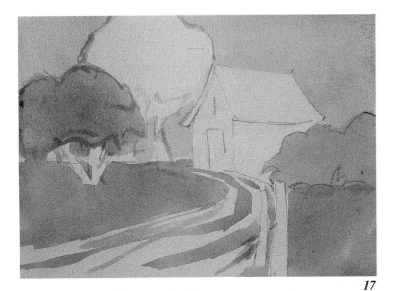

17

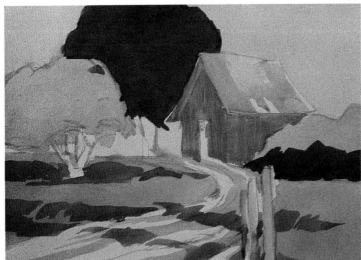

18

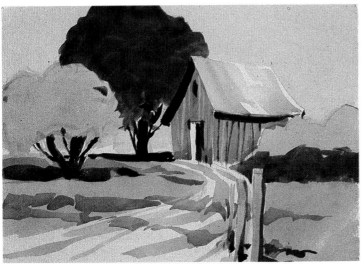

19

17. *Light values of local colors (blue, greens, light brown) are brushed on in large washes with a large, flat brush. These wash areas are purposely kept flat and even.*

18. *When dry, darker washes (medium green, red and medium browns) are added, roughly following the value study. Notice the darker color brushed over the light bushes in front of the barn.*

19. *When these colors dry, the very darkest values are brushed in. Refer to the value sketch. Tree trunks and shadows in the barn and under the trees are brushed on with a large, pointed brush. This sets the overall value arrangement from light to dark.*

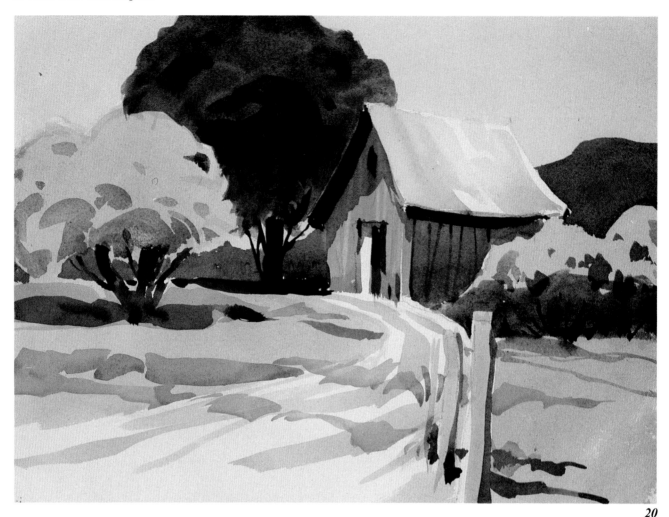

20

20. *Only now are the final but limited details added. Note the darker colors applied to trees and bushes; the details in the barn; the extra dark values added to tree trunks, fenceposts and shadows. Bright sunlight is indicated by the contrasting, cool shadows on the barn and under the trees. These washes are brushed over existing color areas.*

At this point the various elements need to be tied together, so a medium green hill-shape is added in the background. Some artists might feel more details are required, but for others this painting is finished. It has a directness and freshness which is typical of one style and approach to watercolor painting. Notice how some light-valued wash areas are not touched once they are put down on paper.

Most watercolorists work from light to dark, because overlays of several washes produce darker and darker values. Leave the lightest areas alone, once they are put down, and continue to add color in the darker value areas.

A few very dark areas can be painted in (squint your eyes to locate the darkest values) and then the necessary details and textures can be added. Begin the details at the center of interest, keeping them to a minimum. Keep the painting simple.

Transparent, cool washes (blue or bluish-purple) can be pulled over warm areas to suggest shadows or to unify the surface of the painting.

Some artists enjoy working on each part of the painting separately, finishing one at a time. Others (as in this demonstration) prefer to allow the parts of the painting to be developed at the same time so the painting grows as a unified entity.

This demonstration involves a few simple landscape elements: barn, trees, fenceposts, path and bushes.

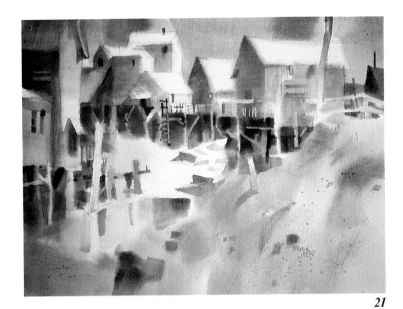

21

CONTINUE TO EXPLORE WATERCOLOR'S POSSIBILITIES

With thousands of watercolorists working in the United States, and dozens of books explaining how various artists use the medium, it is easy to see that there are many ways to make watercolor paintings. This is only one of them. It is important that you try many directions, but always let your own feelings come through in your work.

Artists have reasons for painting the way they do, and often can tell you why their paintings have certain colors, values, brushstrokes, textures or other characteristics.

Examples of student and professional work will show you some of the major features of watercolor painting. You may wish to try similar subjects, painting them in your own way. Be sure you simplify the subjects of your sketches before you start. Determine three, four or five major elements, and place them on your paper to make your arrangement interesting.

22

21. Frank Webb soaked his paper before beginning this wet-into-wet painting. He used large, flat brushes to apply thicker color than is usual in washes, because much water is already in the paper. As the sheet dried, the edges of newly applied color became more crisp. Note the contrast between some very soft shapes and others that are sharper. Also note some of the pencil lines that outlined the major shapes before the first color was applied. Dock Square, 1984. Watercolor, 22 × 30" (56 × 76 cm).

22. After carefully simplifying and drawing her model, this student used washes of varying intensities to finish the painting. Her technique involved leaving thin white lines between the colored areas. Watercolor, 24 × 18" (61 × 41 cm).

Media and Techniques

23. *Morris J. Shubin left large areas of white and worked mostly in negative space, emphasizing texture and pattern. The painting was made after studying, sketching and making other studies of a diving bell on the Monterey, California fishing pier. This simplified shape creates a powerful and dramatic impact.* Diving Bell, *1984. Watercolor, 11 × 15" (28 × 38 cm).*

24. *After sketching from slides of Mexico in class, this student zeroed in on a few major areas of this Mexican cathedral, rather than paint the entire building. He used washes and glazes (overwashes) effectively to create shadows and imply dimensional form. Note the complete range of values, and the textured washes made by blotting with facial tissue. Watercolor, 18 × 24" (46 × 61 cm).*

23

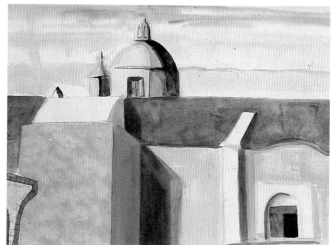

24

74

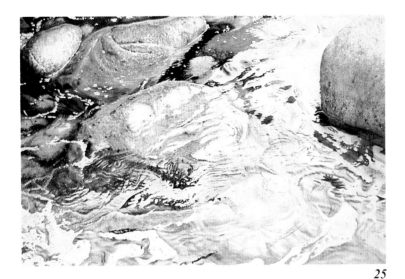

25

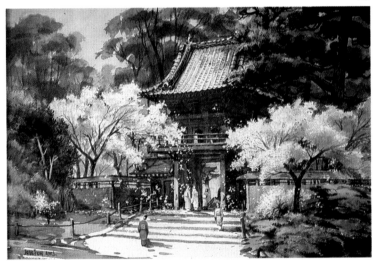

26

25. *Linda Stevens enjoys working in series, and* Water Light #33 *is one of a group of paintings dealing with California tide pools. The large (30 × 40" – (676 × 102 cm), dynamic image toys with our senses, as we cannot tell how large the original rocks are. We see light both absorbed by and reflected off water surfaces. The artist studies these complex light patterns by taking photographs and using them as visual information when she paints in her studio. She works with traditional techniques, using many color overlays to achieve luminous effects.*

26. *Jade Fon employs a complete range of values in this dramatic watercolor of a Chinese temple. After drawing carefully to position all the elements, he applied a block-out medium (similar to rubber cement) to preserve the white and light-valued parts of the cherry trees and the wind-blown petals. This allowed him to apply many overlapping washes and still retain the lights in certain areas. Note the careful use of varying color intensities, and how grayed colors indicate spatial depth in this 22 × 30" (56 × 76 cm) painting.*

LOOKING AND LEARNING: A GALLERY OF WATERCOLOR PAINTINGS

All these transparent watercolor paintings illustrate possible techniques and styles. By studying the work of professional artists, you can learn how they handle subject matter, use the medium and express a personal vision in their work. Some of the artists' comments are included to help you understand their reasons for painting the way they do.

27. *Rolland Golden uses his title,* Angles and Beer, *to help explain his subject.* "The top of the table with the beer can is the dynamic point of emphasis. Perspective creates an angular table top which is surrounded by angles throughout the picture plane. Changes in the real scene were introduced to emphasize the angular motif. Selective seeing is an important part of an artist's creative work." *The painting is 22 × 30" (56 × 76 cm).*

28. *Phil Dike has been working with images of the sea for most of his life.* Wave Echo *(22 × 30" — 57 × 76 cm) is a carefully abstracted image tht involves the basic elements of shore, sea and sky. The artist searches for certain shapes, patterns and colors, and then simplifies and arranges them to suit his design requirements. Compare this coastal view with that of Linda Stevens to see how artists' individual expressions are the result of their desire to communicate personal ideas.*

29. *Morris Shubin started painting* Bikers *by brushing random shapes of color onto the paper. He did not have a definite subject or style in mind, but designed the surface to emphasize form. After these abstract shapes were dry, the artist began to develop the subject, allowing the original shapes, colors and patterns to suggest bikers and their vehicles.*

27

28

29

ACTIVITIES

ART HISTORY

☐ Winslow Homer (See page 65) was the first American artist to use watercolor to make major painting statements. He also worked in other media, as was common at his time (1836–1910). Research the artist and write a short paper discussing his use of transparent watercolor. When did he begin to use the medium? What were his favorite subjects? Why is watercolor a good medium for working outdoors—on location? In what parts of America did he do his paintings? What things of interest did you find about his work? Name the titles of five of his watercolors.

☐ Some research into the history of English painting (or the history of watercolor) will tell you the traditional role of watercolor. It was used as a sketching medium—watercolor sketches were the basis for oil paintings created in the studio. This led people to think that watercolor was not a major painting medium, but rather a drawing medium. Write a short essay either defending (agreeing with) this idea or disagreeing with it.

CRITICISM / ANALYSIS

☐ George Post used his unique watercolor style in painting *Watermelon,* in 1972 (18 × 23″ — 46 × 58 cm). Describe what you see in the painting. How would you describe the major shapes? How is line used? Is it always an outline? Use words to describe the lines.

Describe the artist's use of major shapes, detail, balance and composition. Describe his brushing technique. Is it loose or tight? Free or restricted? Do you like his approach to watercolor painting? Why? Look up his name in the index and study his other paintings in the text. Note his consistent style, regardless of subject matter. How would you describe his style?

☐ Study Helen B. Reed's watercolor, *Still Life Mosaic,* on page 64. How would you describe her composition? Why is *mosaic* a fitting word in her title? (Look the word up in a dictionary if necessary.) How does she use line and shape to arrange parts of her work? Is the painting realistic, representational or nonobjective? Why? Is it naturalistic or designed? Can you call it abstracted? Why? How has she used the characteristics of warm and cool colors to advantage? How many ways has she used design to control visual movement? What contrasts do you see? How has she emphasized the transparency of the watercolor medium?

AESTHETICS

☐ Both Phil Dike (page 76) and Linda Stevens (page 75) have painted their impressions of coastal images. Write a paper or prepare a television script that describes: 1) what you see in each work; 2) the difference between realism and personal interpretation; 3) different approaches to the same subject; 4) other similarities and/or differences; 5) your personal reaction to each work; 6) your reasons for your feelings.

☐ Study Sandra Beebe's watercolor on the cover of this book, and discuss or write about it, describing: 1) her painting style; 2) her use of line, shape and edges; 3) her use of color; 4) her treatment of subject matter; 5) her control of the medium; 6) her brushwork; 7) your own reaction to the painting; 8) the reasons for your feelings about it.

PRODUCTION / STUDIO

☐ Cut scraps of various white papers (drawing, watercolor, newsprint, typing, slick, textured, etc.) about six inches square. Use watercolors and any tools available (brushes, fingers, sticks, sponges, wadded paper) to color them in as many different ways as possible. Select *parts* of a dozen samples and trim them to the same or different sizes and arrange them on a black background (cardboard, large construction paper, etc.) as a display chart.

☐ Make a series of six paintings of one simple subject (still life, clown's face, landscape, barn, etc.). Paint on small sheets (4 × 6″) with a large brush. Use different color schemes with each painting. After drawing and painting several times, try painting directly, without drawing first.

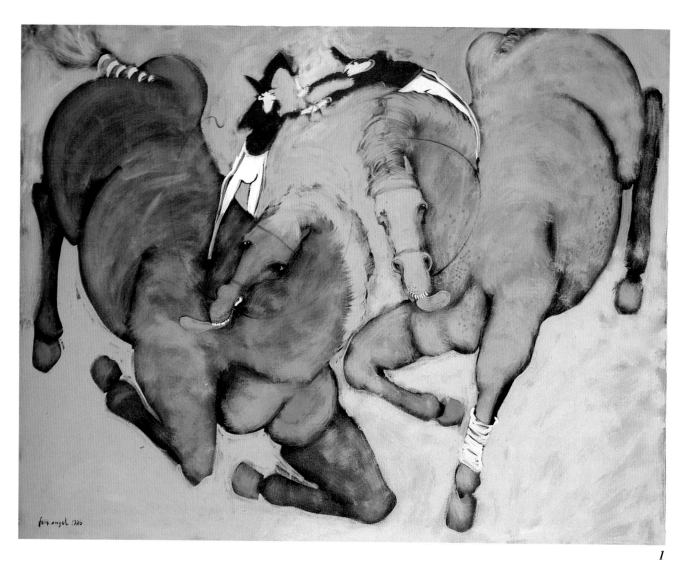

1. *Swirling brushstrokes create a feeling of action in Felix Angel's untitled acrylic painting. The artist has made the horses larger (or the riders smaller) than they would be in reality, and this gives the work a mysterious, dreamlike quality. 1985. Courtesy Moss Gallery, San Francisco.*

chapter 8

ACRYLIC

2

3

Acrylic paints came onto the art market in America in the 1950's, although Mexican artists David Siquicros, Jose Clemente Orozco and Diego Rivera experimented with synthetic media for exterior murals as early as the 1930's. This new plastic painting medium revolutionized the art world, because it provided a water-based paint that dried quickly and could be worked like oils.

American artists who were among the first to use acrylics were Jackson Pollock, Kenneth Noland, Mark Rothko and Robert Motherwell. Today, both watercolor and oil painters use acrylics as an alternate medium.

2. Juicy brushstrokes characterize this student still life. A flat bristle brush was used to apply the paint, which was mixed to a creamy consistency. The painterly quality creates a vibrating surface.

3. Acrylic paints were thinned slightly and applied with soft brushes in this student painting. Although the surface is rather smooth, the student artist created convincing simulated textures. The excellent drawing reflects careful observation, and opaque color is used effectively.

4

5

4. Shown here are a variety of acrylic painting grounds: canvas boards (both sides) and stretched canvases (both sides). Papers and illustration boards can also be used. Two disposable paper palettes are also shown, but cardboard or plastic can also be used for color mixing.

5. Many kinds of brushes made with synthetic fibers have been designed especially for work with acrylics. They are durable, retain their shapes well and clean up easily. Rounds and flats are made of both white and colored materials, and vary from very rigid to very soft.

To avoid confusion in this chapter, try to remember these definitions: a medium (plural *media*) is an art material such as acrylic, watercolor, clay or metal. Acrylic *medium* (plural *mediums*) is a liquid used to transport pigment. Acrylic resins can be thinned with acrylic medium or water (or a mixture of both) to any desired consistency. They dry as quickly as the water evaporates (a matter of minutes) and the surface is completely sealed and ready for immediate glazing and overpainting. The resulting finish resists chemical decomposition and is almost indestructible.

ACRYLICS

The pigments used in acrylics are the same as those used in watercolors and oils, so the names and range of colors are similar. Chemical composition differs slightly from manufacturer to manufacturer, so brushing quality, color intensity and painting "feel" of the products may vary.

Select colors that reflect your personal interests and needs. You won't need all of the several dozen available colors; eight to twelve colors should provide you with many color mixing possibilities. Because the paints dry rapidly, put caps back on tubes or jars immediately. Wipe excess paint off edges and rims to prevent lids from adhering to containers.

Acrylics usually dry to a semi-matte finish. Adding one of several mediums or water can change the quality of the dried surface. Mediums can produce glossy or matte surfaces or can make the paint transparent without affecting the brushing consistency.

PAINTING SURFACES

One of the advantages of acrylics is that they can be applied to a great variety of grounds or surfaces, such as canvas (primed or unprimed), paper of all types and weights, cardboard, wood, Masonite, metal or plaster. They do not adhere permanently to surfaces covered with oil-based paints. Experiment to find surfaces on which you enjoy painting with acrylics. Before painting on some surfaces (untempered Masonite, for example) it is best to prepare the surface with a coat or two of acrylic gesso. Coating both sides of a panel will help prevent warping. If you want to work on canvas, be sure to buy canvas (boards or stretched) that is primed with acrylic primer.

TOOLS AND EQUIPMENT

Brushes with synthetic bristles have been developed especially to work with acrylics. They are easier to clean and last longer than natural bristle brushes. Many types are available, and several rounds and flats should be among your basic tools.

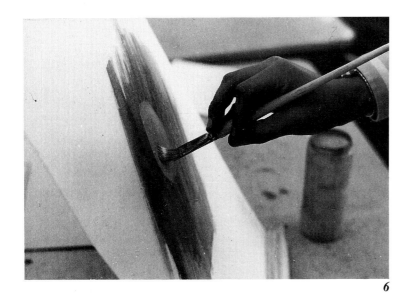

6

7

Because acrylics dry so rapidly, it is essential that you clean brushes quickly and thoroughly. Keep a large jar or can of water handy, and rinse brushes out immediately. Warm water dissolves the paint more readily. If brushes dry with paint on them, try soaking them in an acrylic remover (or lacquer thinner) for several hours. This sometimes works. It is much easier to keep the brushes clean than to have to spend time trying to remove rock-hard acrylic paint.

The same painting knives used for oils can be used with acrylics, for slathering or "buttering" paint on the canvas. Sticks and pieces of cardboard can also be used to manipulate acrylics on the painting surface.

Palettes can be disposable (paper, cardboard) or permanent (plastic, wood). Put only small amounts of paint on the palette until you get accustomed to your needs. Drying acrylics cannot be returned to their tubes, and should not be returned to jars. If you are using thinned acrylics as you would watercolor, with similar techniques, you can use regular watercolor palettes.

WAYS TO WORK WITH ACRYLICS

Because of their versatility, acrylic paints can be used for almost any technique, from transparent watercolor-like washes to impasto and knife work.

To paint transparently, work on the same papers used for watercolors, or on cold pressed illustration boards. The white paper glowing through layers of transparent color will produce true watercolor effects. Dilute the paints with water or acrylic medium to the desired transparency (test it continually) and paint with large, soft brushes. If you thin the color drastically, add some medium so the paint retains a brushing consistency. Color overlays or glazes produce fascinating results.

6. *A student begins an acrylic painting on paper, using a bristle brush and thinned-down paints. A simple table easel holds the paper at a convenient angle for painting while standing up.*

7. *To eliminate the need to close jars each day, this large wooden box is fitted with a nearly airtight lid. Only the box must be carefully capped at the end of each working period. Strips of metal are used for dipping into colors, which are placed on palettes for painting.*

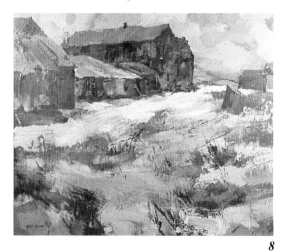

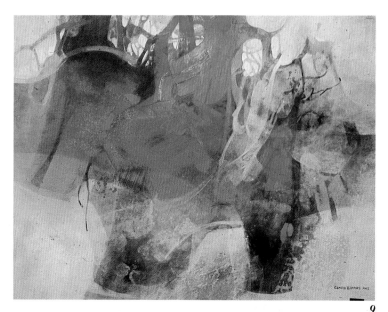

8

9

8. *George A. Magnan painted* Bodie Winter *(24 × 30" – 61 × 76 cm) on canvas. He brushed thin color washes first and then applied heavy, opaque strokes to capture the rugged essence and textures of the abandoned desert town. Note how colors are broken and how warm underpainting peeks through cool areas in places.*

9. *Carole Barnes uses a variety of techniques in developing her painted surfaces. She enjoys experimentation although she often begins by laying down lines, shapes and textures. The compositions evolve from what happens on the paper. Many overlays of color (transparent and semitransparent) create areas rich in color and texture.* Symphony of the Landscape *(28 × 34" – 71 × 86 cm) is suggestive of forest landscape elements.*

10. *Thinned acrylic paints were used transparently in this 12 × 18" (30 × 46 cm) student work. The carefully drawn portrait fills the paper, while the unique color combination produces a dramatic painting.*

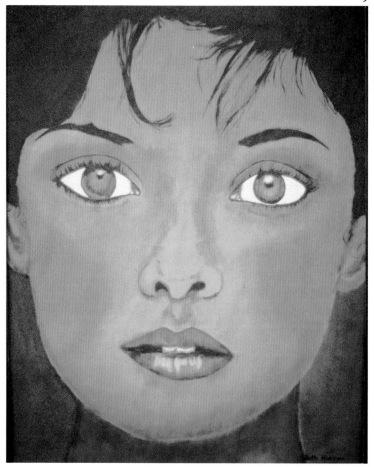

10

To work opaquely, use paints directly from tubes or jars, with synthetic bristle brushes or knives. Use primed canvas or Masonite, cardboard or illustration board. You can brush the paint out flat,

11

12

leave textured strokes or develop an impasto surface.

Combining techniques (glazes over textured brushstrokes, for example) produces surface qualities unobtainable in any other single medium. Line work can be done by thinning acrylics and using a soft, pointed brush.

Before starting a painting, try several techniques on paper scraps. Acrylic mediums make excellent glues for collage, and you can even sprinkle sand and other materials onto the wet surface.

It is easy (and sometimes produces superb surfaces) to paint a new acrylic painting over a previous painting, by first covering the old surface with acrylic gesso.

TRY SEVERAL PAINTING TECHNIQUES

The versatility of acrylic paints makes it impossible to demonstrate all acrylic techniques. It is important, however, that you try several ways of using the paints. That will help you determine your personal preferences and discover how you can use acrylics to express your ideas. Suppose, for example, that you want to create visual surprise in a painting of a rocky landscape. You might want to try working in a soft, almost wash-like style with your paints. Having plenty of experience with that technique will make it easier for you to assess its effectiveness quickly.

Different techniques often demand different working procedures. Refer to the watercolor chapter to observe ways to work transparently. You can apply these same techniques to acrylic work. The tempera and oils chapters suggest ideas for working opaquely. At times, these two extremes—transparent and opaque—can be combined to make effective, unique statements.

Try working with loaded brushes, applying paint in juicy strokes, or creating smooth, flat color areas. Use knives to make crisp and textured surfaces. You may prefer to mix colors, apply paint to your ground and leave it as is, or you may decide to use thin colored glazes over your brushed colors.

Experiment in several directions.

11. The student who painted this old furniture factory used painting knives to apply acrylic paints to a chipboard surface. Colors were applied over each other to create a broken surface effect. The edge of a large knife was used to "print" lines on this 24 × 36" (61 × 91 cm) painting. Detailed sketching is not needed when the paint is put down as thickly as this.

12. Acrylic paints were thinned somewhat to produce a flat surface in this 18 × 24" (46 × 61 cm) optical illusion painting. The student artist planned and drew the design carefully, and used drafting tape to keep the edges straight and clean.

13. *Make several sketches of the subject, exploring aspects of the arrangement such as: a) linear direction; b) major shapes; c) calligraphy and small parts; d) value suggestions. Make enough sketches to feel comfortable with your subject.*

13

DEMONSTRATION/OPAQUE ACRYLIC ON CANVAS BOARD

Acrylic paints can be handled in many ways. This demonstration of a floral subject is painted in large brushstrokes, using both flat and round brushes. Remember that at any time in the process the student artist could have changed methods, and the finished painting would look very different.

14

15

16

17

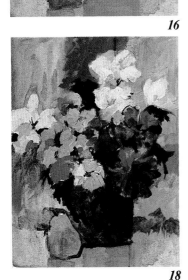

18

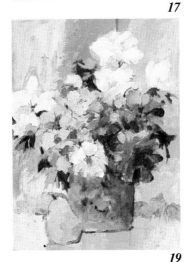

19

14. *Using a round brush and a neutral paint color thinned with water (light gray-green, for example), the student roughly sketches the subject, placing the major elements. Because opaque paint will be used, corrections can be made immediately in the sketch. Details are unimportant at this time. Charcoal or pencil could also have been used for the sketch.*

15. *Using thinned acrylic washes (water and matte medium can be used for thinning), the student quickly brushes color over the surface to cover most of the white canvas. Colors need not be the final hues. A slight indication is made of the value arrangement (compare with sketches).*

16. *A flat brush is used to apply paint directly to the surface, using the actual floral arrangement for visual information. Colors are distributed over the surface to balance them. Hues are mixed and changed to suit the developing painting. Colors are added to some parts of the background. No detail is needed yet, and color shapes are left flat.*

17. *A flat brush is used to apply lighter values of local flower colors to create textured shapes. Brushstrokes are allowed to remain visible. Some colors and shapes are changed, and some previous colors show through newly applied paint. The background is not covered again, but remains as part of the developing painting.*

18. *After some detail is painted with a round brush, darker tones are added to suggest form and shadows. The artist also begins to create unified areas of dark value.*

19. *Highlights are placed with lighter tints of the colors already used, and light areas are also unified. Note how parts of the painting are changed in the final steps.*

Squint your eyes and look at the finished example. Note the large light and dark shapes in the painting, and how their values relate to those sketched before painting began. The background could have been more fully developed, but was purposely kept sketchy and loose.

20

21

22

20. *Rolland Golden thinned his acrylics slightly to create the smoothly painted surface of 100% Cotton. He used the cotton plants to fracture space and produce a designed and flat surface. Yet there is also a feeling of depth created by looking* through *the cotton to the rural scene in the background. The 36 × 30" (91 × 76 cm) acrylic painting is done on canvas.*

21. *Pat Berger spends much time researching her subjects through photography and by sketching on location. She combines these resource materials when painting in her studio. After treating her canvases with several layers of acrylic gesso, she applies paint in layers to create a richly colored surface. In* Boardwalk at Brighton *(48 × 54" − 122 × 138 cm) she was primarily concerned with color, light and shadow, as well as capturing the unique feeling of a British seaside resort.*

22. *James Brooks' nonobjective acrylic work* Anteor, *done in 1981, contains large areas of flat color. Notice how at the bottom of the painting, however, the artist has allowed patches of blue to show through the yellow. Where can you see movement in the painting? Courtesy Gruenebaum Gallery, New York.*

86

LOOKING AND LEARNING: A GALLERY OF ACRYLIC PAINTINGS

One way artists learn is by studying the work of other artists. These artists share with you their personal visual expressions and their individually developed acrylic painting techniques.

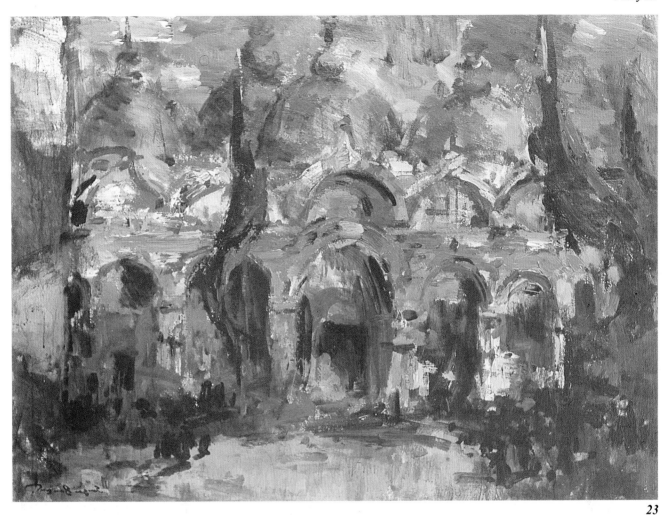

23

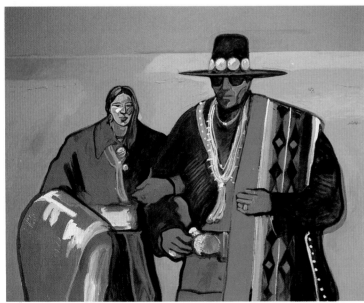

24

23. *Sergei Bongart painted* Cathedral, St. Marks *as an expressive and personal statement, an unusual depiction of this beautiful Byzantine basilica in Venice. The artist says, "A painting must first of all not be a copy of nature, like a photograph. It must be the artist's interpretation, which is the cornerstone of his creativity." He also tells us, "Paint brilliantly, vigorously; to show all of your feelings. Then your painting comes alive!" The work is 36 × 48" (91 × 122 cm), on a canvas ground.*

24. *The brilliant colors and feeling of wide-open space in John Nieto's* Navajo Chaperone *suggest the landscapes of New Mexico, where the artist works. Though the figures are large, the sky and background seem to show an environment that is much larger than they. 60 × 48" (152 × 122 cm). Courtesy the artist.*

87

25

25. *Arthur Secunda combined acrylic paints and a cloth collage to create* Astral Theatre, *a 16 × 17½″ (41 × 44 cm) work. The title and delightful combination of unlike materials causes us to stop and think about other possible combinations of materials and paint. The main design radiates from an oval center to a rectangular outer edge.*

ACTIVITIES

ART HISTORY

☐ Jackson Pollock was one of the first American artists to explore the use of acrylic paints. After researching in American art history books or encyclopedias, write a short paper on his later work. His style changed very much as he matured as an artist. Discuss his drip-and-pour technique as a major new idea in art history. How has it influenced contemporary painting? What feelings might his work give you? Was his work immediately popular? Is it the kind of painting that everyone likes? Why do you imagine he painted this way? What art elements and principles did he see?

☐ Study the murals of the Mexican artists Jose Clemente Orozco and Diego Rivera, and the artists' use of synthetic (human made) media in the 1930's. What major contribution did they make to art and to Mexican history? How can murals be used to comment on society? The styles of these artists combined their Indian cultural heritage with their contemporary need to express themselves. How has their work influenced Mexican art today, both in their homeland and in the United States? How would you describe the unique *style* which they created?

CRITICISM / ANALYSIS

☐ Compare and contrast the acrylic paintings of Rolland Golden (page 86) and Arthur Secunda (page 88), and write a short paper describing each work and telling how they differ. Use your knowledge of art principles in your descriptions.

☐ Nanci Blair Closson used thinned acrylic paints and poured them onto *unprimed* canvas, wet with a sponge. She tilted the canvas and allowed colors to flow and stain the surface. When dry, she

repeated the process with other colors. She used a brush and pen to make the thin lines. Analyze *Midnight Sun* (40 × 50″ — 102 × 128 cm) and describe the process in your own words. What contrasts are evident? How would you describe the edges left by the pouring technique? Describe your feelings about the painting. Does the title help you understand the painting?

AESTHETICS

Look carefully at the painting by Sergei Bongart on page 87. What is his subject matter? How would you describe his painting technique? Is it realistic or representational? Is it expressive or tightly designed? Do you sense the personal feeling of the artist in this work? In what way?

Bongart wants us to *feel* something about this church in Venice, Italy. How do you react to it? Is there a dominant mood, color or feeling in the painting? Do you like it? Why?

☐ Study the student painting of an old furniture factory on page 83. It was painted with painting knives instead of brushes. Describe the surface textures. How are they different from brush marks? Why is the technique appropriate for the subject? This surface can be described as using "broken color". Why is this an appropriate verbal description? Can this technique be used to make exact details? Why or why not? Do you like the technique? Why? What other subjects might benefit from this knife technique?

PRODUCTION / STUDIO

☐ The use of acrylic paints, as seen in the examples in this chapter, ranges from very thin color to extremely thick applications of paint. Make a chart (or a painting) that explores this complete range of visual effects possible with acrylics.

☐ Acrylics can be thinned and used like transparent watercolor or can be painted thickly with brush or knife. Make two preliminary drawings of the same subject on heavy white paper or illustration board, about 9 × 12″ (23 × 30 cm). Paint one with thinned acrylics in the manner of watercolor, and one with very thick paint using either brush or knife. Use the same color scheme in each. You may wish to make a third painting of the same subject that shows contrasting uses of acrylics — both thin and thick.

1. Sergei Bongart uses a full range of colors to depict Roses, *a 32 × 40″ (81 × 102 cm) oil painting. His brushwork is crisp and lush, producing a luxurious surface quality. Note how visible his brush textures are.*

2. Steven DeLair often paints people looking at art in museums and galleries. This carefully designed oil painting features abstract works. Museum Shapes *is 26 × 38″ (66 × 97 cm), on canvas.*

1

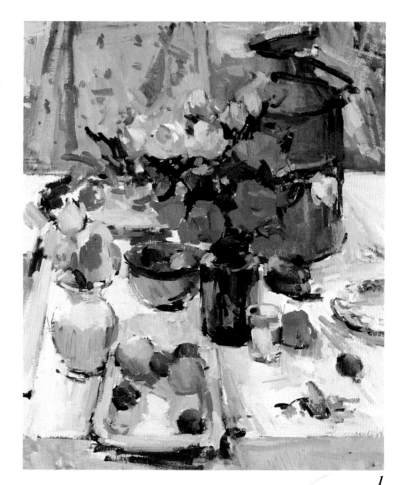

2

chapter 9

OIL

Painting in oils began in Northern Europe in the 1400s, during the early Renaissance. It remained the most popular painting medium until the latter half of the twentieth century, when watermedia increased in popularity. Before Flemish artist Jan van Eyck made the first pure oil painting, oil had been one of the main ingredients in various tempera mixtures. The use of oils spread to Venice, in northern Italy, where Titian created large paintings with *juicy* brushwork, a technique which remained popular for generations. Working on canvas instead of wooden panels, artists could make huge paintings with a wide range of colors and values.

As oil painting developed, great artists such as Peter Paul Rubens, Rembrandt, Jan Vermeer, Francisco Goya, Diego Velasquez, John Constable and Gustave Courbet explored its many possible techniques, styles and directions.

The mid-nineteenth century found oil paints available in collapsible tin tubes, which allowed Impressionist artists to take their colors outdoors and paint on location. New techniques of the time included the use of impasto (thick, textured paint) and palette knife work. In the early twentieth century, Pablo Picasso and Henri Matisse set the stage for contemporary work in oils by exploring abstraction, distortion and unusual uses of color.

PAINTS, MEDIUMS AND SURFACES

Art supply stores have a dazzling array of oil colors, but most artists only use about a dozen for their work. Oil paints are manufactured in several grades and qualities. Pigments are usually ground into linseed oil, which is the binder, and the resulting paint can be thinned with turpentine.

Choose the colors you prefer, but the following are good for beginning, and contain pairs of each hue—one bright and the other subdued. Make sure you get a *large* tube of white paint—you'll use it often, as you'll be mixing it with most of your other colors to create tints.

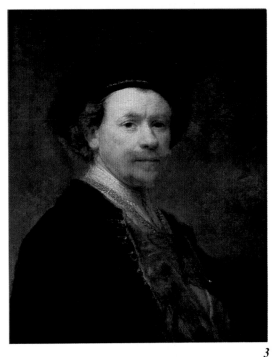

3

3. *The oil paintings of Rembrandt van Rijn emphasize contrasting values and contain superb brushwork. This* Self Portrait *is a 25 × 20" (64 × 51 cm) example which shows his absolute control of light in painting. The Norton Simon Foundation, Los Angeles.*

4. Essential tools for oil painting. Brushes are made of hog bristles (white) or other natural hairs and synthetic fibers. Palette cups are for linseed oil (or medium) and turpentine.

5. The palette knife is used for cleaning palettes and mixing paint on palettes. Delicate, thin painting knives are made in a variety of trowel-like shapes and sizes.

Blues: Ultramarine and Phthalocyanine
Reds: Cadmium Red and Alizarin Crimson
Yellows: Cadmium Yellow and Yellow Ochre
Greens: Viridian. Mix others with yellows and blues.
Browns: Burnt Umber and Burnt Sienna
Black: Ivory Black
White: Zinc White or Titanium White

Oil paint, as it is squeezed from the tubes, is a thick paste and is immediately spreadable with a stiff brush. If you want a more fluid quality, thin the paint a bit with linseed oil. Keep some in a small metal palette cup, clipped to your palette. Another palette cup should contain turpentine, used to thin your paint still more, if desired. You can also use a *painting medium,* a 50–50 mixture of turpentine and linseed oil.

It is important to note at this point that while most oil pigments are non-toxic, some can irritate your skin and can be harmful to breathe. Be careful when you use oil paints — and especially careful when using solvents such as turpentine. Make sure there is *active* ventilation wherever you paint. Wash your hands frequently while painting. Never put your brushes — even the handles — in your mouth. Avoid — or use with extreme care — the following pigments: Naples yellow; cobalt pigments such as cobalt violet, blue, green and yellow; chromium oxide green; veridian; chrome yellow; zinc yellow; strontium yellow; cerulean blue; flake white; manganese blue and violet; raw and burnt umber; Mars brown; vermillion; all cadmium pigments.

Oil painting surfaces can be anything from the traditional canvas (linen or cotton) to paper. Primed canvas can be obtained in rolls to be cut and stretched on stretcher bars. It is also available in many stretched and pre-primed sizes. Canvas boards are ready to use. Wood, plywood, chipboard and Masonite must be primed with acrylic gesso before painting. Watercolor or charcoal paper can be used as is, or can be primed with a thin wash of acrylic gesso.

BRUSHES, KNIVES AND OTHER EQUIPMENT

The brushes most often used for oil painting are made of stiff, white hog bristles, and come in three types: long bristles with rounded tips (*filbert*), long bristles with square tips (*flat*), and short bristles with square tips (*bright*). Soft hair brushes (flat and round) and synthetic fiber brushes (flat and round) are also popular, and make strokes that are different from those of the bristle brushes. Fan shaped brushes are used for blending colors on the canvas and thin *riggers* are used for fine lines and detail. All brushes should be cleansed thoroughly in turpentine and wiped with a cloth when painting sessions are over, because oil buildup will ruin brushes quickly.

A palette knife can be used to mix colors on the palette, scrape

color off the palette or to scrape paint from the canvas if you wish to make a new beginning. Painting knives are thin and flexible, available in several shapes.

Palettes, on which paint is kept or mixed while the artist paints, come in a variety of forms. Traditional wooden palettes should be cleaned regularly and given a coat of linseed oil each time. Tear-off paper palettes are very convenient because you can begin each session on a fresh, white sheet.

Some type of easel is essential. The canvas should be in an upright position so that the artist can stand and work comfortably, and can see the painting surface at the proper angle. Tape paper to a Masonite or plywood sheet and hold it upright. Either a floor easel or table easel can be used in class.

A brush washer can be made by punching holes in the bottom of a small pet food can, and putting it, with the bottom facing up, in a wide-mouthed glass jar. By filling the jar with turpentine to several inches above the can, brushes can be cleaned easily while the discarded paint sinks through the holes to the bottom of the jar.

WAYS TO WORK WITH OILS

Oil paints have been popular for centuries, in part because of their versatility. Artists have been able to use the paint in many ways, from thin washes to impasto and painting with knives.

To paint transparently, the paints can be thinned with linseed oil, turpentine or mediums. These washes or glazes can be applied to any surface and can be used over previously painted areas.

Each type of brush leaves characteristic strokes on the surface. Work on sheets of scratch paper to explore possibilities. Use short, choppy strokes; long, loose strokes; wash-like strokes; lines; shapes; scrubbing strokes (called *scumbling*). Try using the tip, sides and edges of the brushes to see what kinds of marks they make. Use paint directly from the tubes, but also try dipping your brush lightly in linseed oil before you pick up paint from the palette. Add a few drops of turpentine. See how the colors become creamier and thinner, and cover the canvas or paper more completely.

Put colors next to each other on the canvas and mix them with a brush. Or mix them on the palette and then apply them to the surface. Scratch, scumble, stroke, build up and thin down oil colors. After a bit of experimenting with the paints and mediums, you'll be ready to try your first oil painting.

Oil paints need time to dry—often many days. This is a disadvantage if you are in a hurry, or short of storage space, but it is an advantage if you want to rework areas several days later. Store your work-in-progress carefully to avoid smearing and smudging.

6

6. *Ad Reinhardt's* Red Painting *(78 × 144"— 198 × 366 cm) is an abstract work painted in pure, flat color without visible brushstrokes. The Metropolitan Museum of Art, New York.*

7. The shapes of rocks and distant hills are drawn with a soft brush and diluted Cadmium Red and Ivory Black. Corrections and adjustments are made with darker valued lines. Dilute the color with turpentine or medium.

8. Use a large bristle brush and slightly diluted paint to brush in dark shapes and shadows. Think of your light source, but do not be a slave to it. Distribute dark areas around the surface of the painting. Some darks can be lightened later, as the painting develops. Allowing the texture of the canvas to show in places helps the picture retain its sketchy feel.

7

8

DEMONSTRATION/BASIC OIL PAINTING ON CANVAS

Painting in oils requires more patience than painting in watercolor or acrylic, because the drying time is much longer and the brushing techniques are more complex. Many artists feel the extra effort is worthwhile, however, considering the many effects possible with oil.

The following brief outline will help you start an oil painting. The visual demonstration will guide you through important steps. Remember that this is a demonstration of *one* of many ways to work with oils.

9

10

9. *Using a large bristle brush, paint the sunlit faces of the rocks with light-valued color. Add white to lighten values. To add a rough, rocky texture, use undiluted paint, mixed right from the tubes and applied with ragged and irregular strokes. Soften some light-valued colors with medium; use this creamier paint to work into the sky and distant hills. These should not be as textured as the foreground boulders. Some darks may be covered in this process.*

Still using the large brush, add accents of white to the water. The light-valued areas are broken up with still lighter planes. The darks are also broken up with transitional values to ease the contrast between light and dark in some areas.

10. *The darks in the distant hills are grayed and lightened to emphasize distance. The darkest shapes are the rocks in the foreground. A soft hair brush is used with paint thinned with medium, to put in some line—first dark lines in shadows, and then light lines to emphasize rock forms and highlights. The thick paint, evident brushstrokes, canvas texture and strong value contrasts are characteristic of oil painting in this style.*

1. After making several pencil sketches on scrap paper, use diluted color and a small brush to make an outline on the canvas.
2. Traditional oil painters work from dark values to light, so boldly put the shadows and dark values down first.
3. Add any sunlit surfaces and all light-valued areas.
4. Finish with needed details and final value and color adjustments.

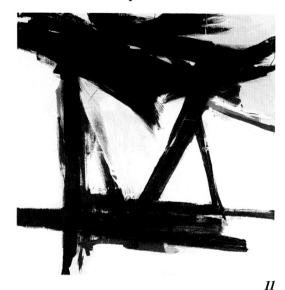

11

11. *Franz Kline attacked his canvas with powerful brushstrokes, creating a dynamic structure of bold lines. The strong sense of rhythm and simple power did not require preliminary drawing on the canvas.* The Ballentine *is a 72 × 72" (182 × 182 cm) oil. Los Angeles County Museum of Art. David E. Bright Bequest.*

12. *Pablo Picasso's unfinished portrait called* Arlequin *(1923) allows us to see his drawing, done in preparation for the work. Note how the artist works on background and figure at the same time. Musée National d'Art Moderne, Centre Georges Pompidou, Paris, France.*

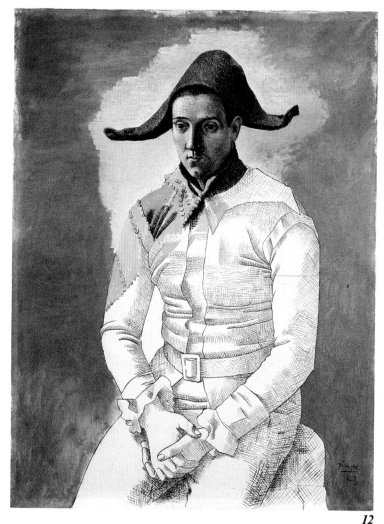

12

TRY SEVERAL WAYS TO WORK WITH OILS

If you study the paintings reproduced in this chapter, you will begin to appreciate the versatility of oil paints. They can be applied to various surfaces with brushes, knives, spatulas and other tools. Strokes may be juicy or dry, thick or thin, jagged or smooth, impasto or flat. Paint can be thinned to make transparent glazes or used directly from the tube. Because of this versatility, it is important that you try several painting techniques and experiment with tools, paints and mediums.

Oil paint shrinks as it dries, and it dries very slowly. Because most oil paintings consist of several layers of paint, remember to paint thick layers over thin layers rather than the reverse. A thin layer that has dried will not remain flexible; if a thick layer beneath it continues to dry and shrink, the thin layer will crack and flake off.

How you approach oil painting depends largely upon your confidence with it and your choice of subject matter. Your work can be spontaneous and immediate, with no preliminary planning or

15

13

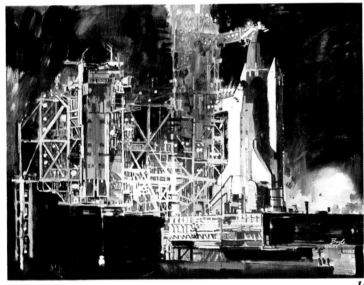

14

13. Careful observation and accurate drawing preceded the painting of these motorcycle racers by a student artist. He effectively placed the textured figures against a thinly applied background.

14. Neil Boyle's dramatic painting, Minus Fourteen Hours and Holding, *captures the energy and adventure of an exciting event. Painted for NASA, the artist chose a night scene with plenty of spotlighted activity. The thinned color, applied to the canvas almost as watercolor washes would be, conveys the feeling of bustle and urgency characteristic of a lift-off.*

15. Impasto brushwork and some areas of knife work are visible in this painting by a student artist. The overall textural quality unifies the surface. 18 × 24" (46 × 61 cm), on gessoed Masonite.

drawing. You may wish to sketch roughly with charcoal or a brush and thinned paint, or to draw carefully, arranging all the important parts in detail. As you study the work on these pages, try to determine which were begun in these different ways.

The paintings on these pages can provide you with some ideas for your own work. More importantly, however, these student and professional examples should prod you into thinking about the many techniques and approaches to style and subject which are possible in your oil painting experiences.

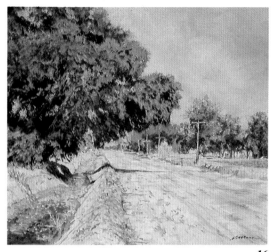

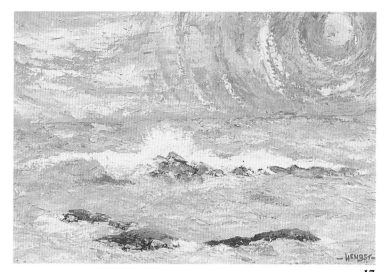

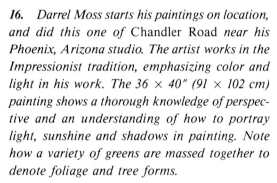

16

17

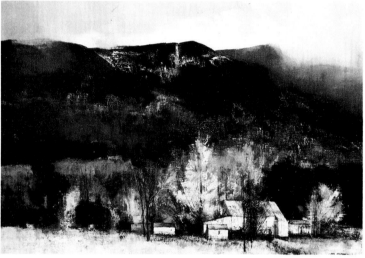

18

16. *Darrel Moss starts his paintings on location, and did this one of* Chandler Road *near his Phoenix, Arizona studio. The artist works in the Impressionist tradition, emphasizing color and light in his work. The 36 × 40" (91 × 102 cm) painting shows a thorough knowledge of perspective and an understanding of how to portray light, sunshine and shadows in painting. Note how a variety of greens are massed together to denote foliage and tree forms.*

17. *This high-keyed student painting was done with a variety of painting knives. The thickly applied paint suggests waves and rocks because the texture simulates the surface textures of water close to the shore. It is helpful to paint subjects with which you are very familiar.*

18. *Tom Nicholas works in many media, and* Signs of Winter *is a 22 × 30" (56 × 76 cm) oil painting done near his New England home. By viewing the work in black and white, we see the values without being distracted by color. Notice his use, distribution and balance of whites, blacks and several intermediate grays. Notice also how whites (lightest values) are clustered for greater impact and importance. Regardless of the colors you use in your paintings, the scale and arrangement of values is vitally important.*

LOOKING AND LEARNING: A GALLERY OF OIL PAINTINGS

As an art student, it is essential that you study the work of other artists. This means looking into art history books, going to galleries and museums and observing the work of your teachers and classmates. The study of painting is a continuous learning experience for all artists.

The oil paintings on these pages are the work of contemporary professional artists and several high school students. Notice the broad range of styles shown here.

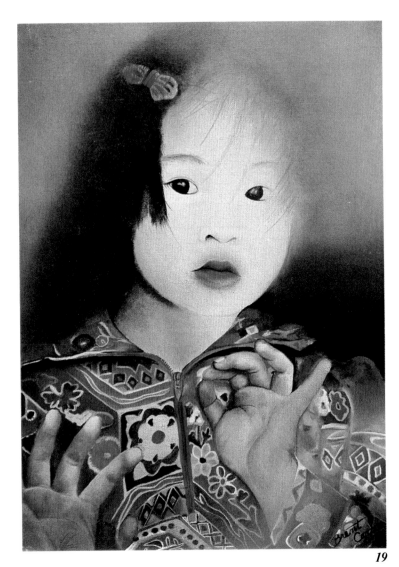

19. Christie at the Window *is a 16 × 12″ (41 × 30 cm) oil painting by a high school student. Colors were thinned so that the surface is smooth and brushstrokes are invisible. Wet colors were softly blended to suggest a foggy window through which the girl looks. The drawing was done with skill, and the paint was applied with great care and a knowledge of technique.*

19

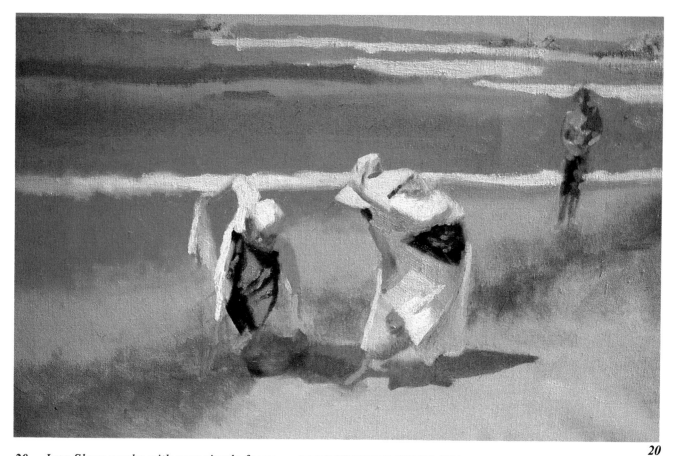

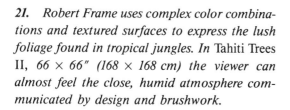

20

20. *Jane Shuss works with very simple forms to create visual statements with great impact. Her interest in the effects of light on objects has led her to work in an Impressionistic style. Edges are soft, spaces are open and details are left to your imagination. This effective beach scene is 24 × 30″ (61 × 76 cm) and you can almost feel the heat of the sun and the coolness of the water.*

21. *Robert Frame uses complex color combinations and textured surfaces to express the lush foliage found in tropical jungles. In* Tahiti Trees II, *66 × 66″ (168 × 168 cm) the viewer can almost feel the close, humid atmosphere communicated by design and brushwork.*

ACTIVITIES

ART HISTORY

☐ The exact moment in history when oil painting was invented is not known, but it is generally thought that the van Eyck brothers, Hubert and Jan, working in Flanders in the fifteenth century, were the first to use oils, often in combination with tempera. The introduction of oil painting revolutionized the art of painting. Research the beginnings of oil painting in art history books, encyclopedias or books on painting media. Discuss its early development briefly; then list the advantages and technical advances that oils provided. What revolutionary painting developments were possible as oil painting developed as a major art medium?

CRITICISM / ANALYSIS

☐ Study this painting, *Basketball,* by Elaine de Kooning. Describe what you see. Are the players and teams identifiable? Why is this not important? How would you describe the artist's brushstrokes? How does she emphasize vertical movement? Why is this appropriate? How does she show action? Why is the painting technique appropriate for the subject? Describe her use of color, line, texture, movement, contrast, emphasis and balance. What other titles could you give this painting?

AESTHETICS

☐ Study this painting by Richard Diebenkorn. It is part of a series of many works the artist painted, all relating to the same visual problem. This one is titled *Ocean Park Series #49* (93 × 81 inches — 236 × 206 cm) and is in the collection of the Los Angeles County Museum of Art. (Museum purchase with funds provided by Paul Rosenberg and Co., Mrs. Lita A. Hazen and the estate of David E. Bright.) Diebenkorn is an abstract artist who used color, line and shape to stand for things in his environment. He has developed his own personal visual vocabulary.

The Ocean Park series deals with open and unrestricted spaces. Can you sense that in this arrangement of shapes and space? How does the work make you feel? Does the title help you understand the work better? What does he tell you about space; proportion; variety: spatial relationships; unity; order, contrast; and his personal vision? You may not be able to "read" all of the artist's intentions, but you may still enjoy his visual imagery. Do you like it? Why?

PRODUCTION / STUDIO

☐ H. L. Bowman makes historical paintings which require intense research into clothing and architectural styles. This charcoal drawing was done in preparation for a painting of the De Anza Expedition in early California history. It will be sealed and the painting will be done over the drawing.

Make two small paintings of the same subject (still life, animal, figure or arrangement of fruit). Make one by drawing carefully and painting over the drawing. Make the other by painting directly (without drawing), putting down color shapes and adding to them to finish the work. Which technique seems more comfortable to you?

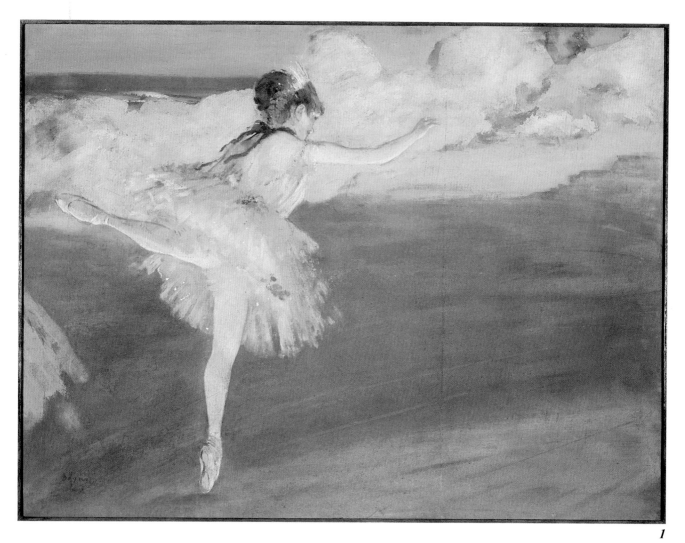

1. *Edgar Degas explored the ballet as a theme over a long period of time and in hundreds of pastel drawings and paintings. This medium allowed for rapid, candid portrayals and let him exploit the Impressionist's interest in light. Pastel lends itself to soft, billowy forms as well as sharp, hard-edged line.* The Star, Dancer on Point *was painted in 1877. Pastel and gouache on paper, 21½ × 29″ (54 × 74 cm). The Norton Simon Foundation, Los Angeles.*

chapter 10

PASTEL

Pastels are powdered pigments mixed with just enough resin or gum to bind them together into a paste. The paste (the word *pastel* is derived from the word *paste*) is then formed into sticks.

Pastels shouldn't be confused with chalk, a harder medium. Chalk serves well as a tool for sketching or rendering preliminary drawings because it isn't as soft or crumbly as pastels. Pastels produce brilliant color, permit subtle shading and lend themselves to fresh, immediate impressions when they are handled deftly.

The history of this medium starts in eighteenth century France during the era of Louis XV and Madame de Pompadour. Rosalba Carriera and Quentin de la Tour captured the opulence of life at Versailles with soft and shimmery pastel paintings.

In the late nineteenth century, Edgar Degas brought the Impressionist interest in light and spontaneity together in his many pastel studies of the ballet. Degas's pastels captured the color and excitement of the dance with more sureness and freshness than would have been possible in oils.

Since the early twentieth century, Mary Cassatt's soft, tender portraits of mother and child and Odilon Redon's symbolic, imaginative, dream-like paintings have exemplified the versatility and charm of pastels.

MATERIALS

Pastels may be purchased in sets of varying sizes, from boxes of twelve colors up to a complete set of three hundred and thirty-six different hues, tints and shades, or they may be bought as individual sticks. The minimum essential palette includes the twelve colors of the color wheel, plus black and white.

Charcoal, in sticks or pencils, is a soft black medium which may be combined with pastels or white chalk, or used alone. Charcoal erases easily with a kneaded rubber eraser.

Finished work in charcoal, chalk or pastels must be sprayed with a fixative to keep it from smearing. Water-based hairspray also works well. You can touch up areas which have been sprayed if you want to brighten them.

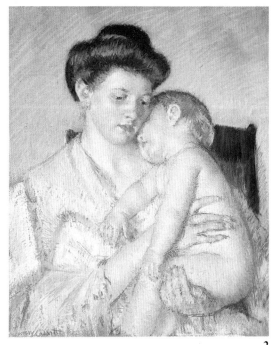

2

2. *Mary Cassatt's pastel painting* Sleepy Baby, *painted in 1910, has delicate shading, light-valued colors and a sketchy, dry-textured quality—all characteristic of this soft, chalky medium. 30 × 21" (76 × 53 cm). Dallas Museum of Fine Arts. Munger Fund.*

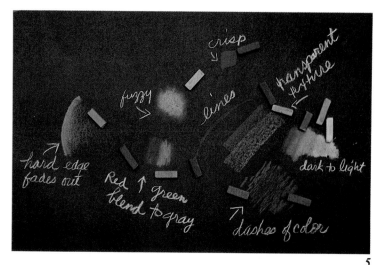

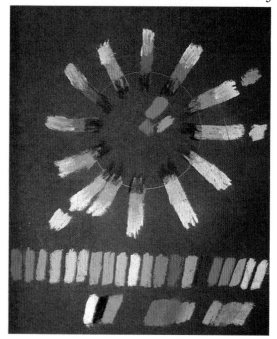

3. *An assortment of pastels, some large, soft and crumbly, others harder, slimmer and coated with a shellac-like substance. Students may buy pastels in bulk and keep them in an aluminum foil kit. Rough papers in pastel colors, grays and black work well with this medium.*

4. *Sample all of your pastel colors and arrange them in a color wheel for quick reference. Put shades in the center, tints on the outside. Try blending complementary colors to achieve rich gray tones.*

5. *Practice ways of manipulating the pastel stick. Create textures, blend colors. Experiment.*

Chalk pencils come in a variety of colors and can be used alone to create paintings or for detail work on pastel paintings. They must be handled carefully, for if they are dropped, the thin stick of chalk encased within the pencil may be fractured.

Oil pastels, made from pigment mixed with an oil base, will produce effects altogether different from those of soft pastels. One way to blend oil pastel colors is by applying a turpentine wash with a brush.

SURFACES

The paper you use with pastels should have a non-shiny, textured surface (tooth) to trap the grains of color. Heavy construction paper, charcoal paper and rough mat board have suitable surfaces for pastels. Experiment with various papers before you start on a painting.

Colored papers work best and can act as part of the painting's color scheme. All tones of gray and pale, dull colors serve as neutral backgrounds. Black is an especially striking choice of paper color for pastels, as colors glow against it and black lines may be left exposed to help define objects.

BASIC PASTEL TECHNIQUES

Pastels require a thorough mastery of technique before any actual painting can be done. It is more difficult to correct a mistake when working with pastels than with most other painting media. Because part of their charm is a look of quickness and freshness, you must be thoroughly confident of your skill in handling them.

Before you begin to think about a composition, sample your colors and lay them out on a chart, preferably in the form of the color wheel. Put tints on the outside of the wheel and shades inside. This will make you familiar with what the colors look like on

6 7

8

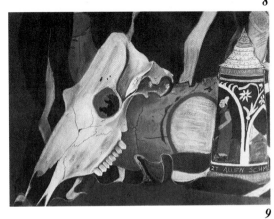

9

paper, and how they appear when placed side by side.

Try applying pastels to a sheet of black paper in various ways. Using the side of a pastel stick, lay down a light texture of one color and go over it lightly with another color to create a tweed-like effect. Blend two colors together with the pastel itself (blending with your fingers will transfer oil to the paper). Use the pastel stick at every angle, from flat on its side to touching only with the point.

Apply pigment lightly at first, and build up the color gradually. If you put it on too heavily at first, the pores of the paper will become clogged, and your picture may look murky. Use complementary colors to shade with. Black tends to give muddy results if blended with soft colors.

Blow away the loose powder as it appears, or it might get ground into other areas of your paper and soil it. Use a damp paper towel to remove any accidental smudges. Cover areas you have completed with a clean piece of paper so that they won't smear as you work on new areas. Keep your hands clean and away from your picture. You may use fixative on areas you have finished to keep them from smearing.

Because it is very important that you don't overwork your pastel painting, do not experiment on it. Instead, try out your ideas on a scrap of paper, practicing effects and techniques before putting them in your painting. This way you can work quickly, cleanly and confidently. Your finished painting will be fresh, and will reflect your confidence.

To learn pastel techniques thoroughly, you may find it helpful to work first in only black and white or black, white and gray. This way you can concentrate on blending the powdery chalk, creating form with light and dark shading, and staying neat and in control without worrying about color. Start with simple shapes and gradually work up to a more complex subject matter.

6. *Georges-Pierre Seurat used the broad side of a conté crayon to create the form in* Seated Woman, *(1884–85), 18⅞ × 12⅜". Without outlining, he pressed harder in some places to get the desired value variation. Collection, The Museum of Modern Art, New York. Abby Aldrich Rockefeller Bequest.*

7. *One of the most famous drawings in the world is Albrecht Dürer's* Praying Hands *(1508). It is a sketch in black and white chalk on blue paper, 11 × 7½" (28 × 19 cm). Instead of blending the pastel by smearing, he relied on precise tonal modulation and intricate linework. Albertina Museum, Vienna, Austria.*

8. *Black and white chalk were used to create volume, value contrast and surface quality in this student still life.*

9. *Several values of soft gray chalk are added with black and white to show value contrast in this student still life.*

105

10.

11

10. *After exploring many sections of the set-up using a viewfinder, create a finalized picture, drawing each object precisely, expressing volume and form through your two-dimensional contour drawing.*

11. *Covering the back of your drawing with white chalk and tracing it onto black paper produces a clean, neat contour drawing which serves as a basis for your painting.*

12. *Start forming the objects you feel most confident about. Work swiftly and deftly—do not overwork. Practice shading on another piece of paper until you get the results you want.*

12

DEMONSTRATION/MAKING A PASTEL PAINTING

Because pastels require a sure, swift approach, it is wise to give much more forethought to your painting. A sequentially structured, step-by-step method will help you achieve works that are orderly and controlled.

First, select your subject matter. Make some thumbnail sketches to organize the composition, and then render a drawing on practice paper the size of your final work.

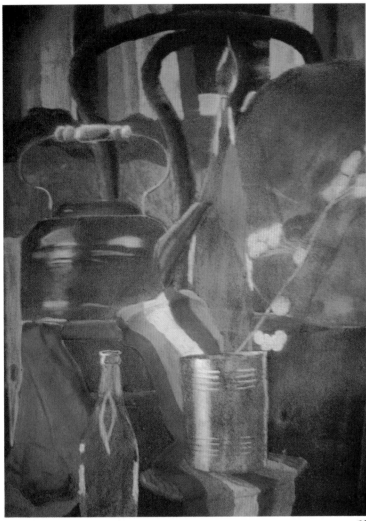

13

13. *After all the objects have been completed, decide on a background that will enhance them. Leave some black paper showing to provide value contrast. Shadows may be put in with charcoal and some highlights may be added with paint.*

Next, trace the drawing onto your heavy, textured paper. Practice your treatment of each object or area on scrap paper until you feel you can get the desired effect effortlessly and quickly.

Work on each area of your painting without smearing the remaining areas. If you pretend you are modeling each shape as you would a ball of clay, it will help you get a feeling of volume or form.

Sometimes highlights, a glint in an eye, a reflection on a glass bottle, can be put in with a touch of paint. Work on your picture from all angles, keeping the elements and principles of design in mind.

14

16

15

14. *Various ways of working with pastels. Experiment and develop techniques of your own.*

15. *Streaks made with chalk pencil, some blended for smoothness, others left for texture, were used in this miniature study, 5 × 7" (12 × 18 cm).*

16. *Oil pastels produce rich, velvety colors. Flat shapes and patterns of dark and light are emphasized in this miniature painting, 6 × 4" (15 × 10 cm).*

OTHER WAYS TO USE PASTELS

Pastels may be dipped in liquid starch or mop oil before they are applied to the paper. This procedure makes the dry, chalky pastels paint-like and somewhat greasy. When dry, the painting need not be sprayed with fixative.

Dipping the pastels in water will also give them a paint-like quality. Wet pastel dries to a powdery finish, however, and paintings made this way must be fixed to keep them from smudging. Try working on damp paper for a similar effect.

Use pastel pencils to create paintings in the Impressionist manner by applying the raw color in dots or tiny lines. The viewer's eye will mix the colors. The pencils are excellent for doing detail work on a pastel painting.

Oil pastels have a waxy consistency, apply smoothly and can be used on paper, board or canvas. This usual application produces a drawing effect, but when brushed over with turpentine or mineral spirits, the colors can be blended or shaded. **(Note: Use turpentine only in a room with active ventilation.)** Oil pastels also lend themselves to scratching techniques.

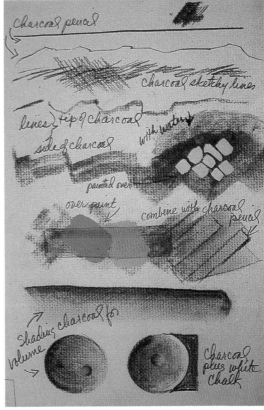

18

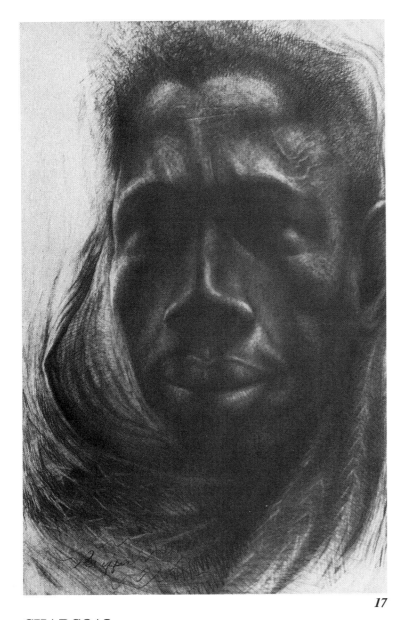

17

17. *John Biggers exploits the ability of charcoal to be smeared, blended and manipulated to mold solid forms through the use of light and shadow. This large portrait is over three feet high.*

18. *Charcoal is a versatile medium, whether used by itself or combined with other media.*

CHARCOAL

Charcoal is suitable for line or tone drawings. It can be used for preliminary sketches or as a medium in its own right. It can be smeared with the finger, a soft cloth, or a stump of rolled paper. Highlights can be picked out with a kneaded rubber eraser or, more traditionally, a bit of wadded up bread. Make washes by brushing water over a shaded area. Sharpen a piece of charcoal with an emery board and use the point as a pencil. A broad stroke can be achieved by using the stick sideways. Charcoal can also be used to darken areas in tempera painting.

Charcoal pencils come in various hardnesses and are used for drawing or detail work on charcoal paintings.

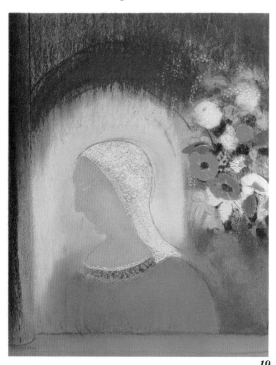

20

19

19. *Odilon Redon liked to escape into the private world of fantasy in his luminously colored pastel paintings.* Profile and Flowers *(1912), a "visual poem," is full of symbolism. The brilliant flowers are a metaphor for the blossoming of a dream, full of mystery and suspense. Pastel on paper, 28 × 22" (71 × 56 cm). McNay Art Institute, San Antonio, Texas.*

20. *Pam Della used oil pastels to create soft and crisp shades, smooth and rough textures in* Decoys and Persimmons. *By building up rich layers of color, she has generated a luminescent quality in her 12 × 24" (30 × 61 cm) work.*

21. Jennifer, *a delicate pastel painting by Roberta C. Clark, reflects the versatility of the medium. The artist, using subtle color and sensitive handling of texture and volume, has created a charming, lifelike portrait.*

21

22

22. *Dry pigment shaded with charcoal pencil for volume and value contrast defines a still life in a unique and interesting way.*

23. *Hues of the yellow color family glow against black paper in this impressive pastel still life. The artist has used the effects of light to create rounded forms in the 18 × 24" (46 × 61 cm) work.*

LOOKING AND LEARNING:
A GALLERY OF PASTEL PAINTINGS

As you enjoy these pastel paintings, note the various styles of the artists. Some paintings emphasize lines, and others shape. Some are realistically rendered, others are looser and more abstract. Note the use of texture, color, value, shape, space and line. Study the compositional qualities of each.

24

24. *Reflections on the table top add interest to this informal grouping of objects. The forms are made to seem round and solid through the use of light and shadow. The pastels on black paper is 16 × 12″ (41 × 30 cm).*

25. *R.B. Kitaj has drawn the face in* Bad Faith (Chile) 1978 *so that it nearly touches the edges of the paper. This close view, combined with the figure's position and expression and the upside-down clock, creates an uncomfortable, disturbing scene. Pastel and charcoal on paper, 30¼ × 22″ (76.8 × 56 cm). Courtesy Marlborough Galleries.*

25

ACTIVITIES

ART HISTORY

☐ Edgar Degas used pastels for making many of his paintings, and was responsible for increasing interest in the medium. He enjoyed using ballet dancers and race course scenes as his subjects. Research this important Impressionist artist and write a short paper on Degas and his use of pastels to portray ballet scenes. Discuss his use of light, soft edges, balance and emphasis in his work.

☐ Three historically important pastel artists are illustrated in this chapter: Mary Cassatt, Edgar Degas and Odilon Redon. Do some research on one of them. Briefly summarize the life and work of the artist. Place some emphasis on why pastel was the medium she or he chose to use extensively. List three major works in pastel by the artist.

CRITICISM / ANALYSIS

☐ Study this student pastel work. Describe what you see. The student artist was trying to capture the essential *quality* of each article in the painting. Was he successful? Why? What mood is established? Describe how the elements of design are used (line, shape, value, space, form, texture). Also point out how balance, contrast and movement are evident. Do you think the work is unified? Why?

AESTHETICS

☐ Look carefully at Mary Cassatt's pastel painting, *Sleepy Baby,* on page 103. The artist was able to combine careful composition (movement, balance, contrast and emphasis) with sensitive feeling. What emotions are evident as you study it? Why are the faces of mother and child treated with greater care and detail? How has the artist shown us the love and care of mother and child? Does the work make you feel good? Secure? Happy? Sad? Cold? Warm? Do you sense something of the artist in the painting? What? Do you like the work? Why?

☐ Study Odilon Redon's pastel painting, *Profile and Flowers,* on page 110. Describe what you see, and also describe how it makes you feel. Is the work realistic? Is it representational? Do you feel that there is something more to this work than a person and flowers? Why do you feel this way? Read the caption and explain how knowing something about the artist and his work can help you understand the painting better. Do you feel comfortable with it? Why?

PRODUCTION / STUDIO

☐ Choose one of your own previous paintings, done in watercolor, tempera or acrylics. Redraw the major parts and use pastel to create a different image of the same subject.

☐ Take black and white photographs of architecture (entire buildings or details) in your town. Make a charcoal and chalk work of one of them, using black, white or gray paper as the ground. Emphasize value contrast.

1

2

1. *Henri Matisse cut the pieces for* Beasts of the Sea *(1950) directly from colored paper, without first drawing the shapes. From hundreds of cut shapes, he selected these to help us see the waters of the South Seas lagoon as he remembered them. Paper on canvas, 116 × 62" (296 × 154 cm). National Gallery of Art, Washington, DC. Ailsa Mellon Bruce Fund.*

2. *Arthur Secunda tears silk-screened papers and allows the torn edges to become important parts of his collages, as in* Cool Fissure *(38 × 26" − 97 × 66 cm). The variety of widths of the parallel strips and the variety of colors keep the image from becoming monotonous.*

114

chapter 11

COLLAGE

Collage is a form of art that consists of pasting or gluing paper or other materials to a surface. It is a contemporary medium, begun in France in 1912 by Pablo Picasso and Georges Braque, who added pieces of oilcloth, wallpaper and newspaper to their oil paintings. By adding such materials they were combining real, three-dimensional objects with painted illusions on a flat canvas. Almost every artist or group of artists of the early twentieth century (Cubists, Fauvists, Futurists, Expressionists, Dadaists, Surrealists, etc.) experimented with some form of collage. Henri Matisse spent many years snipping colored shapes and arranging them in fascinating designs.

Artists combine collage materials with almost every medium employed by painters. They use found, manufactured or handmade papers, or prepare papers themselves. Collage is used in abstract and representational drawing and painting, in fine art and commercial applications and in two- or three-dimensional art.

Collage elements can blend comfortably with painted surfaces or can stand in bold contrast to them. Papers are often used as they are found, but can also be folded, crinkled, sprayed, torn, stained or painted before they are glued to the surface.

Collage techniques lend themselves to experimentation, and can help you discover unconventional ways of expressing yourself. Collage can loosen up your work, encourage more freedom and a sense of exploration and offer an alternate method of working with familiar materials.

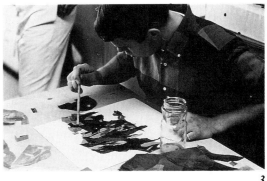

3

3. A student uses clear brushing lacquer to adhere colored tissue papers to a piece of illustration board. The process results in crystal clear, jewel-like colors.

PAPERS TO USE

Collage artists continually experiment with common materials and look for new ones to use. Art stores carry many kinds of white and colored papers: tissue paper, construction paper, tinted cover and text papers, silk-screened and prepared papers, metal foils, mylar, toned charcoal papers and a variety of rice papers.

Many found papers are equally exciting to use: magazine and other printed papers, kraft paper, paper bags, old maps and photographs, scraps of wallpaper, marbled paper from old books

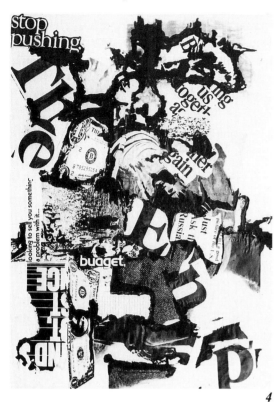

4.

4. *Cutout letters of various sizes are used for their graphic impact (use of interesting shapes and textures), not for what they say. This student collage (24 × 18″ − 61 × 46 cm) also makes use of some photographic material from magazines.*

5. *Nanci Blair Closson uses various rag papers in constructions such as* Cross Series, Magenta *(40 × 32″ − 102 × 81 cm). The papers are torn and cut to produce the required edges, and combined with transparent watercolor.*

5.

and computer paper. Printed pictures and type in both color and black and white are very useful.

SURFACES FOR COLLAGE

Collages can be made on any working surface used for painting: canvas, watercolor paper and boards, chipboard, Upson board, Masonite, illustration board and mat board. Your surface should be appropriate in weight to the materials you will adhere to it. The heavier your collage papers are, the heavier your surface should be. Before gluing papers or fabric to Upson board or Masonite, the surfaces should be coated (front and back) with acrylic gesso.

GLUES AND PASTES

Collage artists use glues and other adhesives that do the best job for them. Some papers require adhesives that prevent wrinkling or smudging. Generally, white glues and acrylic mediums are excellent, nearly permanent adhesives. You may wish to experiment with

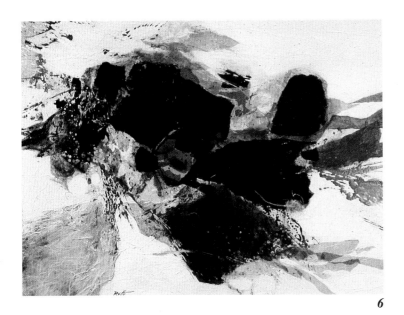

6

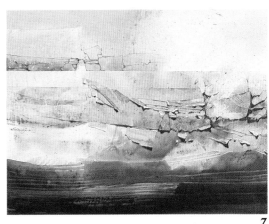

7

several kinds before starting your collages. Make small, trial samples before using any new papers or adhesives.

TOOLS AND EQUIPMENT

Working with collage materials calls for some tools besides those generally used in painting. These can include scissors, razor blades, craft knives, X-acto knives, stiff bristle brushes, tweezers and perhaps brayers for rolling papers flat while gluing them to a surface. These tools are not manufactured and sold specifically as collage tools, of course. Artists use anything necessary to help them manipulate materials and adhere them to surfaces.

UNDERSTANDING COLLAGE

You can work with collage in several basic ways:
1. Combine collage with painting.
2. Use collage materials without painting.
3. Prepare collage papers by painting, staining or printing images on them.
4. Use prepared papers from art stores.
5. Use found papers.

You can employ any of these five approaches, alone or in combination with one another. Collage is a great way to start freeing your mind of traditional notions about painting. Unlike painting with liquids, collage allows you to manipulate your image before it becomes permanent. Your experiments in shuffling shapes, colors and textures will provide you with a new source of abstract images and allow you to exercise your imagination—the most precious asset of any creative artist.

6. Edward Betts combines several watermedia and a variety of rice papers in Sea Fragment, *a 22 × 30″ (56 × 76 cm) mixed media collage. Clear and rushing water and solid, textured rocks are suggested but not realistically presented. The feeling of the sea is captured in collage, without making a picture of it.*

7. Katherine Chang Liu's Ancient Wall Series #9 *(30 × 40″ — 76 × 102 cm) is one of a group of paintings using shallow space to explore texture and color relationships. Transparent watercolor and opaque acrylics are applied to a heavy surface. Torn pieces of printmaking paper are coated with acrylic paint, laid on the surface and positioned to strengthen the design, add texture or provide value and color contrasts. What look like loose edges are painted to appear that way, and the surface is actually flat.*

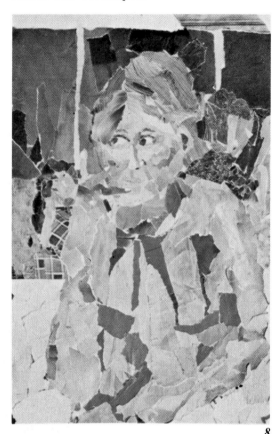

9

8

8. *The colors from magazines can be used as a palette of hues in making collages. This figure was made by a student who worked directly, applying a magazine's colors and textures instead of using paints. A rough drawing on illustration board was the starting point. Rubber cement was used to keep the papers in place.*

9. *This student used construction paper to emphasize depth of space in nature. Mountains were torn from a variety of earth-colored papers, and shifted until they formed a satisfactory statement. The shapes were glued to white paper, cut into three equal pieces to form a triptych and adhered to a piece of illustration board. Does this collage suggest other subjects for you to explore?*

BASIC COLLAGE METHODS

There are several basic ways to adhere papers to collage surfaces:

1. Coat the back of the collage paper with glue or some other adhesive and place it on the surface, smoothing out any trapped bubbles with your fingers, your palm or a brayer.
2. Coat a small patch of the surface with glue and lay the collage material on it, smoothing with a stiff brush or your fingers.
3. Coat both the collage paper and the surface with a *diluted* acrylic medium, and press the two together. Use a stiff brush to add more thinned acrylic medium over the material. This will smooth out any bubbles and seal the surface.
4. Thin papers that tend to wrinkle when used in a collage can be soaked in diluted acrylic medium for several minutes before they are applied to the working surface. This relaxes the fibers of the paper.

Other gluing methods, glues, pastes and cements work with particular papers or in specific combinations—you'll learn these by trial and error. There is no one "correct" method of working with collage.

MORE WAYS TO WORK WITH COLLAGE

Construction Paper

Construction paper is made in a wide range of colors and is easy to cut, tear and glue to illustration board, cardboard or heavy paper surfaces. Experiment with adhesives on a small piece of the paper you intend to use, as construction paper tends to retain stain marks. Try white glues, rubber cement, glue sticks and acrylic medium. The color in construction paper will eventually fade. If you want to avoid this, try using coated papers instead.

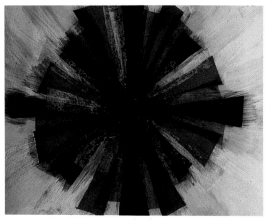

11

10

10. *This seascape collage was made with brushing lacquer. The sails were added with opaque white paper. Notice how overlapping tissue paper changes the paper's value.*

11. *A powerful sunburst design made with acrylic medium. Some colors tend to bleed in this process. Can you see where they have bled into one another here? What effect does that have on this collage?*

Abstract Designs from Magazines

Magazine photographs contain a wide variety of colors and textures. These can be used to learn about design and constructing abstract images.

Cut a small mat or viewfinder from a piece of tagboard or heavy paper, with an opening of about 2 × 3″ (5 × 7.5 cm). Lay the viewfinder over colored magazine pictures and look for exciting abstract designs that show good use of the principles of design. Choose one to be the basis for a large collage. You can either match the magazine colors with the colored paper you use, or use the magazine paper itself to make the collage. Try changing some of the colors in the design—how does that change the collage?

Tissue Paper Collage

Luminous, subtle effects can be created by applying torn or cut pieces of colored tissue paper to white illustration board. This can be done in several ways:

Apply *brushing lacquer* to the board. Put the colored paper down

12

12. *This collage was made from tints and shades of a single color. Each of eight sheets of drawing paper was painted with a tint or shade of the basic color, producing four sheets of tints and four of shades. Still life objects were drawn in pencil on a sheet of chipboard. Using the painted sheets as a palette of colors, pieces were cut and glued to the surface. Notice how tints and shades are repeated in both positive and negative spaces. When finished, some contrasting colors might be added to emphasize the main area of interest. A heavy, dark-valued line/shape was used to outline the still life shapes and unify the composition.*

13. *The student who made this sensitive figure study combined pencil and tempera paint with torn pieces of newspaper. The drawing was made first on chipboard. The model was a fellow student. Thinned tempera paint was used to color the entire sheet, allowing pencil lines to show. When the composition was dry, torn newspaper pieces were glued in place and balanced over the surface (both in positive and negative spaces). Some lines and shading were redrawn with a heavy pencil, and opaque tempera color was brushed on. Some final adjustments completed the process. Casein or acrylic paint could be used instead of tempera.*

13

14

15

and brush more lacquer over the top. The tissue colors turn transparent, like pieces of stained glass, and overlapping colors produce exciting combinations.

Brush *acrylic medium* down first. Then apply colored papers and brush more medium over the surface. Because some colors tend to bleed in this process, edges might not remain crisp, but become more painterly.

Dip the pieces of tissue in *diluted acrylic medium* and lay them in place on the board, smoothing them down with a bristle brush. Tissue paper pieces can be applied flat or crumpled with acrylic medium. Crumpled paper can also be applied to a surface of wet acrylic medium.

Because tissue papers fade in strong light, some artists tint white tissue with washes of acrylic paint, which is permanent.

Combining Collage with Paint and Other Materials

Ever since Pablo Picasso added collage to his paintings, artists have been experimenting with many possible combinations. Some add collage to their paintings; others add painting to their collages. Papers can be painted first and then made into a collage, or they can be applied as a collage first and then painted. Combine and change these basic processes to fit your ideas—you'll find more and more ways to create interesting effects. Try a collage of a figure or a still life. Experiment with a collage that uses tints and shapes of a single color. Combine your collage with rubbings of various textures, or create a *relief collage* with layers of thick cardboard that stand off the picture surface.

14. *Gray chipboard is the basic material of this collage project. Heavy weight chipboard was cut into geometric shapes and set into place. The arrangement of parts was shifted and studied until a satisfactory result was achieved. The parts were then adhered to a chipboard surface with white glue. Here, after drying, it is being given a heavy coat of gesso to unify the surface and provide a white-on-white relief effect. The final product can be painted, stained, antiqued; additional collage papers can be glued on—or the relief collage can be left white.*

15. *A floral collage by Emma Lou Farris. She roughly painted the arrangement in acrylics to balance colors, then used gloss acrylic medium to adhere magazine colors to the surface. Several coats of gloss medium sealed the finished work.*

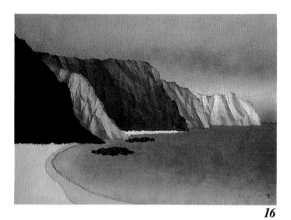

16

16. *Ande Lau Chen works on stretched canvas, to which she adheres tough, textured rice papers which have been colored. Some papers are sprayed with acrylics while flat. Others are crumpled, and paint is sprayed into the crinkles to create textures like those of rocks and eroded mountains. The pieces are arranged and adjusted for composition, emotional impact and color and textural relationships. Acrylic medium is used to adhere the parts to the canvas, after all have been flattened and unwrinkled.* Inaccessible Beach *is a 36 × 42″ (91 × 107 cm) collage on canvas.*

17. *Arthur Secunda's studio contains dozens of flat shelves to hold hundreds of sheets of colored paper which he has silk-screened. Most are solid hues, but others are variegated or contain smooth transitions. He has cut and used many of them in* Starfest. *Notice the subtle variations in the dark, negative space. Many adjustments were made before the pieces were finally glued in place.*

18. *Betty Schabacker uses cloth on canvas to make her collages, after staining the cloth pieces with thinned oil paints. The pieces of* Pale Chanting Goshawk *are stained with warm earth colors. The 18 × 22″ (46 × 56 cm) work has a fascinating textural surface.*

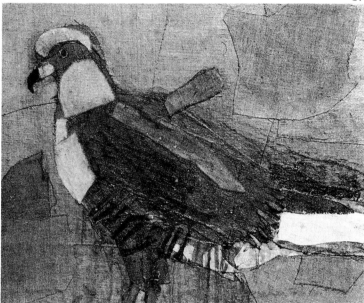

17

18

LOOKING AND LEARNING: A GALLERY OF COLLAGES

Museums and painting books may not contain many collage examples to study. The works of these visual artists suggest the variety of possible techniques and results, and will give you new ideas to pursue.

ACTIVITIES

ART HISTORY

☐ The first collages to be combined with paintings were made by Georges Braque and Pablo Picasso in 1912. Do some research in art history books, encyclopedias or books dealing with cubism or either of the artists. Write an inventive short story (or television script) detailing the "discovery" of collage as an art medium. Include information on *why* the artists wished to incorporate collaged papers in their work. What was their purpose in doing so? What effect did it have on their own work? Did they continue to work with collage for the rest of their lives? How did the collage experience influence their later painting?

☐ Do some research on the painting and collage work of Henri Matisse. Write a short essay on why collage was an appropriate medium for many of Matisse's ideas and techniques. Or write a short paper on how collage allowed Matisse to extend his productive life as an artist. Describe his working methods and techniques.

CRITICISM / ANALYSIS

☐ Choose one of the following topics dealing with collage, and write a short essay on it — either defending the idea or disagreeing with it.

- Working with collage is an ideal way to experience actual textures in painting.

- Collage should only be used if it will improve a work of art in some way.
- Fortunate "accidents" are more (or less) likely to occur when working with collage than with direct painting.
- Experimenting with collage helps you learn to use the "internal resources" of a developing painting.
- The use of collage tends to encourage experimentation.

☐ Study the collage, *Cool Fissure,* by Arthur Secunda, on page 114. Describe what you see in the work. How did the artist create *line* in the collage? How did he create shapes? Describe his use of color and his choice of a color scheme. How did he overcome a possibly monotonous (boring, static) arrangement of similar shapes? Is there a feeling of movement in the collage? If so, how is it achieved and how might it be described? If not, what keeps movement from happening? If it were your own work, what might you have done to change it in some places? Why?

AESTHETICS

☐ Study Ed Bretts' painting, *Sea Fragments,* on page 117. Is this a representation or an impression of the sea? Why do you think so? Did the artist convince you that you are looking at a "sea fragment"? How did he do this without painting a real place? How does he help you "see" or visually experience running water? How does collage help him make a convincing visual statement about the sea coast? Do you like the way the artist made the painting?

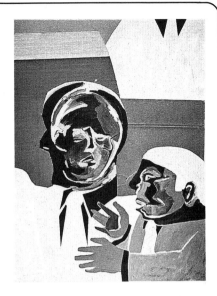

PRODUCTION / STUDIO

☐ Look at Jack Selleck's work, here. He cut shapes out of pieces of corrugated cardboard boxes and collaged them together on a cardboard surface. He then painted with acrylics both on and around the flat pieces. Use this technique (or use it as an idea) and make a collage of your own design. You may wish to use parts of magazine images, as the artist did. Use people, still life objects, fruit, toys, dolls, animals, etc. as subject matter, and paint with either acrylics or tempera.

☐ Review the wide range of collage techniques discussed in the last part of this chapter. As an additional activity, combine any two of them (or three) to make a collage technique of your own — one not described in the text. This experience should help you understand that collage possibilities are almost endless, and that they encourage you to use materials creatively. Write a description of the technique as you develop it.

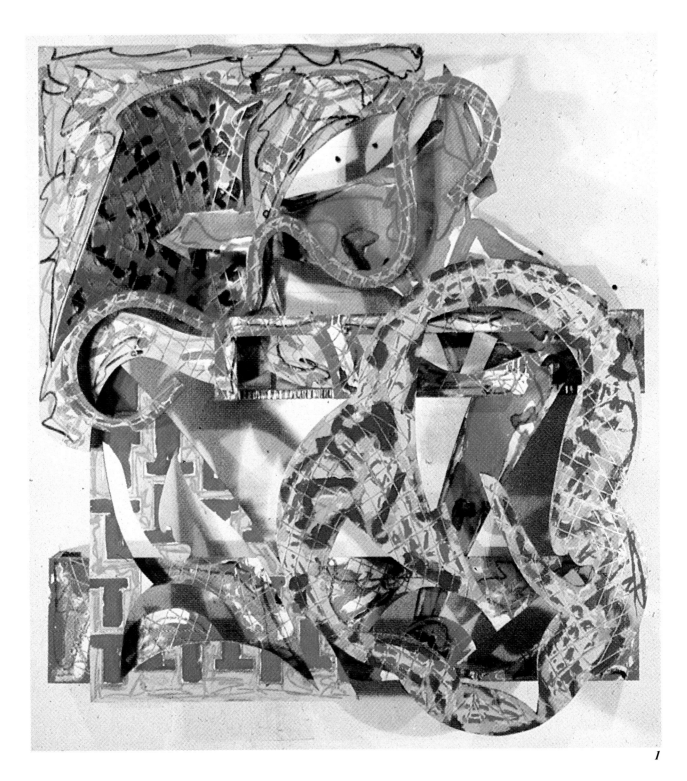

1

1. Frank Stella etches and shapes strips and sheets of magnesium (a lightweight metal) before applying acrylic and other painting and drawing media. Zoler XXII, 1982, 70 × 80 × 14″ (190 × 204 × 36 cm). Leo Castelli Gallery, New York.

chapter 12

OTHER PAINTING MEDIA

Throughout history, artists have explored a variety of media and worked with various combinations of painting material. Fresco and egg tempera, once the most used of all media, are now used by few artists. New media are invented and old ones decrease in popularity. Artists have used auto lacquer, wax and early synthetic (plastic) paints, but have replaced most of them with more convenient media.

You have been introduced to the most popular media in the last six chapters. In this chapter, you'll learn about some of the lesser-known materials that artists use. You may find that unusual materials produce effects or create illusions you hadn't considered before. Look at the work of other artists, and try some new combinations, techniques and tools discussed toward the end of the chapter.

SHAPED SURFACES

Paintings are usually made on flat, rectangular surfaces. Their dimensions are indicated with two numbers, width and height (22 × 30 inches or 56 × 76 centimeters, for example). But some painters ignore flat surfaces and have no use for frames. They paint on shaped canvases or other shaped surfaces. Their work becomes sculptural, no longer confined to easel painting.

Artists are experimenting with materials that adapt well to such shaping techniques. Surfaces can be shaped gently, with few protrusions from the flat canvas surface, or severely distorted, intentionally sculptural. Acrylics and canvas are the basic materials used, but some artists are exploring the use of paper, metal and other shaped surfaces.

ALKYDS

Oil paint is a versatile medium, but its drying time has been considered a problem by some artists. In recent years, several manufacturers have developed fast drying oils, called alkyds. Quick drying, however, eliminates the extended workability of the medium, one of its favored characteristics.

2

2. *Carla Pagliaro paints stretched canvas with acrylics, then removes it from the stretcher bars and shapes it. This untitled piece is 84 × 44 × 13" (214 × 112 × 33 cm) and includes several strips of wood.*

125

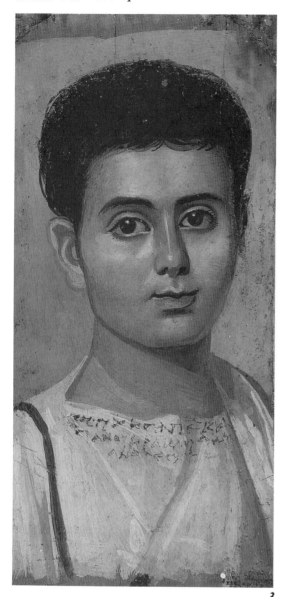

3

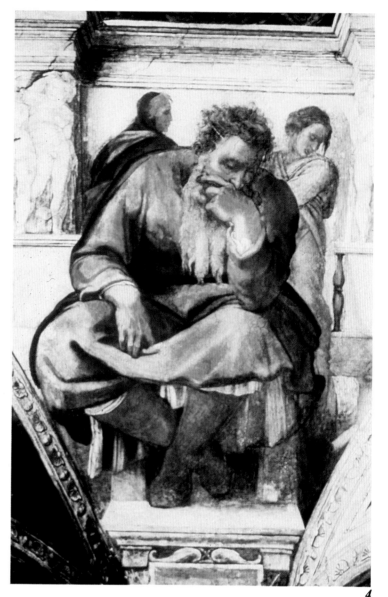

4

3. This Egyptian encaustic painting glows as it did when painted over 2000 years ago. The boy's face was painted on a wooden panel (15 × 7" – 39 × 19 cm) to accompany his body in burial. The Metropolitan Museum of Art, New York.

4. Michelangelo painted this figure of the prophet Jeremiah as part of his gigantic Sistine Chapel ceiling fresco. The entire ceiling took four years to complete, from 1508–1512.

FRESCO

Fresco painting is one of the oldest art techniques, and is generally used on large surfaces. Pigment is mixed with lime-plaster and applied with brushes to a freshly plastered surface, such as a wall or ceiling. Many of the painters of the Italian Renaissance (Michelangelo and Raphael, for example) painted frescoes.

Artists can only prepare enough surface and paint to use in a single day. If the plaster dries too fast, the process will not work. Colors mixed with plaster and brushed onto wet plaster surfaces become an integral part of the wall. Their luminosity is characteristic of the medium. It is both a difficult and rewarding painting technique.

You can create fresco-like effects by painting with watercolor or

5

6

gouache on a shallow tray filled with plaster of paris, or on construction paper coated with gesso. Make a "cartoon" (a plan of the image you want to create and the colors you'll use) and transfer it to the plaster or gessoed surface when the surface is dry. Then paint carefully—you can't hide or erase fresco mistakes!

ENCAUSTIC

Encaustic is painting with wax colors, a process that was common to Egyptian artists in 3000 B.C. Although the formula for encaustic painting was lost in the Middle Ages, it is again being used by contemporary artists. Because wax is translucent, an encaustic surface seems to glow with inner light.

Colored wax is melted and applied with brushes to a wood panel surface. The wax is burnished to a smooth finish and then reheated and polished (a process simplified by using electricity). Ancient artists used encaustic to make portraits (the skin seemed almost natural) but contemporary artists are exploring other uses of the medium.

EGG TEMPERA

Egg tempera, a combination of egg yolk or egg white and powdered pigment, is an ancient medium, first used in the tenth century to paint wooden panels and illuminated manuscripts. Gold leaf was combined with tempera to paint the altar pieces of Medieval Europe.

Today, egg tempera paints can be purchased in tubes, but many artists prefer to prepare only enough paint for a day's use. Egg tempera colors can be applied to prepared surfaces of canvas, wood or Masonite which have been sized and covered with several coats of gesso. All types of soft brushes can be used effectively with this medium.

5. Jasper Johns painted Between the Clock and the Bed *in encaustic on canvas in 1983. He has combined his contemporary, nonobjective approach to painting with an ancient wax medium in this 91 × 126″ (182 × 321 cm) work. Leo Castelli Gallery, New York.*

6. Duccio lived at the end of the thirteenth century and painted Christ Raising Lazarus from the Dead *as one of many panels on an altar piece in Siena, Italy. It is egg tempera on a gesso panel, 17 × 18″ (43 × 46 cm) and includes gold leaf mixed with tempera. Kimbell Art Museum, Fort Worth, Texas.*

7

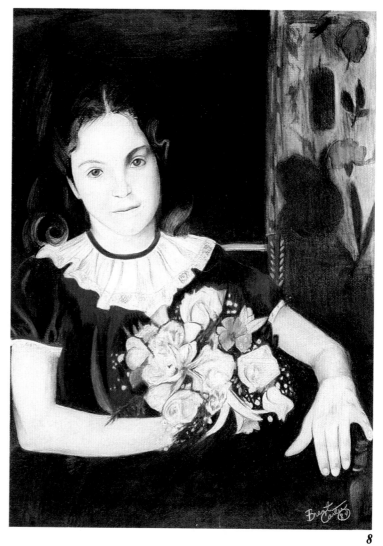

8

7. *With a limited palette of colored pencils and an imaginative approach, a student created this dynamic work.* A Matter of Time, *15 × 12″ (38 × 30 cm).*

8. *Keen observation and a confident approach make* Kemly *a sophisticated student work. Colored pencil, 30 × 24″ (76 × 61 cm).*

Tempera is very versatile, and quite easy to handle, if both the paints and surfaces are carefully prepared. Apply the paint thinly, or it will chip and fall off the surface. Apply opaque colors with brushes or knives, and transparent glazes with soft brushes. The paint dries quickly, allowing you to superimpose many layers on top of one another. You can scrape paint off the surface to eliminate errors or create special effects.

Egg tempera can also be combined with several oil media for differing effect and finishes, but care must be taken to avoid creating mixtures that do not adhere permanently to surfaces.

COLORED PENCILS

A wide range of colored pencils are made by several manufacturers in America and Europe. Soft and firm leads, made up of filler, binder, lubricant and pigment, are available in up to about sixty hues. Most are clad in wood for convenient holding.

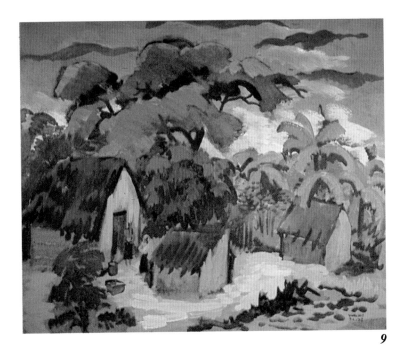

9

10

Certain papers suit certain grades of pencils. Try textured, smooth watercolor or tinted paper. Experiment on scraps to see how the pencil marks differ when made on different surfaces.

Some colored pencils are eraseable, others are not. Some erasers tend to smudge colors or mar the paper surface. Artists often scrape colors off with X-acto knives or razor blades when corrections are necessary.

Sharpen your colored pencils in a pencil sharpener (some leads are so soft, however, that they crumble when such pressure is applied) or with a single-edged razor blade. Carve the leads into points or chisel shapes, according to your needs. Pencils are capable of making both fine lines and broad strokes.

Colored pencil work requires the use of a sprayed fixative.

CASEIN

Casein (pronounced kay' seen) paints are opaque, water-based paints, made by mixing pigments with casein, a glue-like milk protein. Casein paints are available in tubes, although some artists prefer to mix their own.

Casein paint is water soluble from the tube, but dries quickly to a hard, matte finish. It tends to crack if applied too thickly (as in impasto or knife work), but brushes out easily on a variety of surfaces.

Casein is not flexible when dry, so canvas is not a suitable ground for it. Gessoed Masonite, wooden panels and heavy chipboard, watercolor paper or illustration board make excellent surfaces.

Both bristle and soft hair brushes can be used effectively with casein, if you thin it with water. Hair brushes require its being

9. In Dorothy Sklar's Mexican Landscape, *the artist shows the opaque brushstrokes and soft matte finish characteristic of her casein technique. The tightly composed landscape is 25 × 30" (64 × 76 cm) in size.*

10. The pivoting quarterback was painted by a student using homemade casein colors. Both heavy brushstrokes and thinned paint were used in the 18 × 26" (46 × 66 cm) painting on lightweight chipboard.

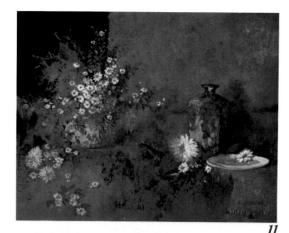

11

12

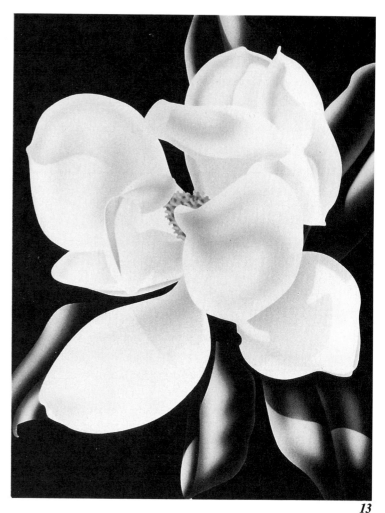

13

11. Tom Nicholas created a jewel-like surface in Lapis Vase *through the use of gouache. Notice how lighter, opaque passages have been applied over darker-valued areas.*

12. A cut stencil is taped to illustration board, and an airbrush is used to color the inside of the circle. This is the correct way to hold an airbrush.

13. Brian Davis uses airbrushes to paint large flower images, such as this 21 × 27" (53 × 69 cm) Magnolia. *The artist used acrylic paints and a series of precisely cut metal stencils to create hand-painted multiple editions of the same image. Courtesy Davis-Blue Artwork.*

thinned the most. Because of the paint's opacity, paintings can be made by applying light colors over dark, as you would with oils and acrylics. Spray finished paintings with Formalin or mount them under glass.

You may experiment with making your own casein paints by mixing dried skim milk with water to make a thin paste. Add dry tempera colors or other dry pigments to this mixture, and you will produce homemade casein colors. To paint, dip a bristle brush into the casein mixture, then into a small pile of dry pigment, mix together on a cardboard palette and apply to your surface.

GOUACHE

Gouache (pronounced gwash) colors are made from the same ingredients used in transparent watercolors. While gum arabic is the binder for both paints, chalk is added to gouache colors to provide more body and to make them opaque. Gouache colors (also known as "designers' colors" or "designers' gouache") are used extensively by illustrators.

Gouache colors have a reflective brilliance similar to that of egg tempera, but are much easier to handle. They can be applied with brushes of any size, as washes, lines or glazes, directly from the tube or thinned, to paper or illustration board surfaces. Use either bristle or soft hair brushes, according to the consistency of the paint. Gouache may also be applied to gesso panels of Masonite or wood. Lights can be painted over darks, and tints are made by adding white. Gouache is often combined with other watermedia (transparent watercolor, pastel, India ink) in the same work.

Make your own gouache paints by mixing transparent watercolor (from tubes or pans) with white tempera paint. Dip the color on a bristle brush and mix it into a small puddle of white tempera, and then apply to your surface.

14

14. *Toothbrushes loaded with watercolor were flicked over stencils to create a strutting dragon. The student used several colors and placed the stencils to produce an interesting, spattered surface that is similar to an airbrushed surface.*

AIRBRUSHING

The first airbrush was patented in England in 1893. Since then, the airbrush has steadily gained attention, and is now considered a sophisticated painting tool. Essential to contemporary designers and technical artists, airbrushes are also used by a growing number of fine artists. They are available in a broad range of styles, functions and prices.

All airbrushes look like fat fountain pens attached by a tube to a compressor. Compressed air (at about 30 pounds per square inch) passes through a narrow passage which opens into a wider space. The expanding air creates a partial vacuum. Paint from a reservoir mixes with the air stream and is atomized, with the spray being controlled and directed by one of many types of nozzles. The pressurized air supply can come from an aerosol can, a foot pump, a cannister or a compressor. Compressors provide the most constant and effective source of air. Because airbrush equipment is expensive, great care should be taken of all the parts.

The wide range of models available reflects the equally wide range of uses for airbrushes — for photo retouching, commercial design and lettering, decorating vans, making record covers, painting works of art. It is a versatile, but not a simple medium: much practice is necessary before artists can be sure of the final results.

A wide range of media can be used in airbrushes: gouache, watercolors, acrylics, oils, photographic dyes, liquid color and colored inks. All must be of finely ground pigment and thinned to a consistency that will not clog the airbrush mechanism. Whichever paint you use, apply it to a surface appropriate for that paint: paper, canvas, board, metal or glass.

Airbrush techniques involve the use of various masks or stencils that allow sprayed paint to color selected areas only. These masks may be made of paper, plastic, metal, tape, film or masking fluid. Overspray (color extending beyond the mask and onto the unused surface) is a constant problem, and can be controlled by using large

16

15

15. *This still life was first drawn in pencil. Following the method outlined in the text, this student both spattered and brushed water onto the surface. When dry, a graphite pencil was used to darken some areas and emphasize forms.*

16. *Sue Wise begins some of her paintings by preparing sheets of paper to use as backgrounds. In* Ascent, *a 21 × 19" (53 × 74 cm) painting, she started by sprinkling water on the sheet, and then sifted dry pigment and powdered charcoal over it. The sheet was rinsed off, dried and re-wet in areas, with creamy and thin acrylics poured on and allowed to blend. The eagle was worked in after this fascinating surface was rinsed again while still damp.*

sheets of protective paper.

Typical airbrush work exhibits exquisite gradations of value and color, made up of infinitely tiny dots. Nozzles can be adjusted, however, to make sharp lines, broad sprays, coarse spatters or variations in between.

A word of caution: Because airbrushing releases materials into the air, safety procedures should be followed. Adequate ventilation and a respirator worn over the nose and mouth must be utilized when spraying a medium which includes a volatile solvent.

USING DRY COLOR

Dry color can be used in two forms—as dry pigment and as powdered tempera. Tempera is better for most projects because it has a binder included in the formula. Dry pigments must have fixatives sprayed over them to insure their adherence to the surface.

Experiments with powdered tempera can take many directions. Once you are familiar with some of the possibilities, try using them in other painting situations, especially in mixed media work. The unique textural surfaces that dry color can produce might provide you with ideas for its use.

Brush, spatter or drip water on a sheet of toothed paper and immediately sift powdered tempera over all or part of the surface. Use one color or several. Rinse immediately under a faucet or spray nozzle; tempera color will remain in the dry places only. When dry, these surfaces may be left as is, or can be drawn into with lead or colored pencils, or worked with erasers. However you alter the surfaces, try to retain the unique textures of the medium.

Dry color can also be sifted over wet watercolor, tempera or acrylic paintings, and then left alone or washed off.

You can make your own paints by adding dry color (tempera or pigment) to small quantities of white glue, dried skim milk paste,

acrylic media, stand oil, clear lacquer, wallpaper paste or other glue-like substances. While such homemade media may not be permanent, they will teach you about the qualities and make-up of paints.

WASHOFF TECHNIQUES

Several varieties of washoff techniques (or paint resists) can provide exciting visual surprises. Washoff techniques rely on the resoluble quality of tempera paints. The basic steps begin with a pencil drawing in line on a piece of chipboard, textured illustration board or other heavy paper with some tooth (do not use glossy finishes).

Paint all the resulting shapes with thick tempera. Results are usually better if the colors are mixed with generous amounts of white tempera. Leave the line areas unpainted, and also leave areas unpainted which you wish to be black. Allow this surface to dry completely.

With a large soft brush, cover this entire surface with a thin layer of black India ink and allow it to dry completely. Ink can also be carefully patted on with a large flat brush. Use ink full strength, or dilute it with one part water to five parts ink.

Finally, wash the entire surface under a cold water faucet, spray attachment or hose, until the black ink washes off the painted areas. Unpainted lines and other unpainted areas will remain black. If the ink is difficult to remove from the painted areas, brush it gently with a soft sponge or rub it carefully with your fingers under the running faucet. Allow the painting to dry completely on a bed of newspapers.

For different results, try colored inks; or paint thick lines instead of shapes with tempera; work on colored paper or boards. You might scratch into the dried tempera surface with a compass point, before applying the ink. Very fine black lines will result.

17

17. The student who painted this still life in a washoff technique used a heavy, opaque rice paper as the surface. The paper is stained with the paint colors, but great care must be taken when washing the surface with water.

133

18

19

18. *Crayon resist—After a floral still life was sketched in pencil, wax crayons were used to color the surface of heavy oatmeal paper. Shapes, not lines, were emphasized. When finished, watercolor washes of complementary colors produced a textural surface you can almost feel.*

19. *Rubber cement resist—Drips, lines and shapes of thinned rubber cement were laid down over a pencil drawing of these leather sandals. Watercolor washes were run over the surface and, when dry, the rubber cement was rubbed off. Ink lines were added with a small brush.*

RESISTS

Resist techniques work because water does not adhere to wax, oil or other such substances. The resisting medium is put down first on paper. Watercolor, ink or watered-down tempera is brushed over the surface. They do not adhere to the resists, but only to the untreated paper. The appearance of the paintings varies with the combinations of materials used and the methods employed, but fascinating textural surfaces usually result. Perhaps these examples will encourage you to experiment with some resist techniques.

MIXED MEDIA TECHNIQUES AND COMBINE PAINTINGS

The term *mixed media* includes an infinite variety of combinations of painting and drawing media, only some of which are presented here. Working with mixed media, artists can explore directions that few others may have tried. A spirit of experimentation is essential.

Combinations can include media that are compatible, such as several water-based media (gouache and acrylics, for example), or those that are unlike, such as watercolor and collage, or casein, pastel and ink. Some combinations will not work at all, but others can produce dramatic results.

Two, three, four or more media can be used together in a single work, and the possible effects are only limited by your imagination. And of course, some combinations simply will not work, but don't let the ideas you must scrap prevent you from trying new ones.

20

21

20. *The student who made this 12 × 18″ (30 × 46 cm) skull used a combination of tempera, glitter, glue, colored pencils and transparent watercolor.*

21. *Sybil Moschetti's* Rocky Hillside *is a 22 × 30″ (56 × 76 cm) mixed media painting on heavy watercolor paper. To create it the artist first tore up previous watercolors, arranged the pieces on a new watercolor sheet and glued them down. Next, she splashed and brushed watercolor onto the surface, and added more collage of watercolor and rice papers. Drafting tapes were stuck on in vertical and horizontal directions, and more color was added. Lastly, the tapes were removed and dark tones and lines were added.*

22

22. *This attractive student work is a 28 × 42"*
(71 × 107 cm) piece that combines colored lac-
quers on Plexiglas, paper tapes and leather
patches.

23. *Richard Wiegmann used oil crayons and*
colored pencils in making Sheep, *a 20 × 16"*
(51 × 41 cm) work on paper. Although both are
drawing media, the artist used them in a way that
reminded him of the richness and flexibility of
oil paint.

23

When actual objects (rather than simply paints) are attached to
the painting surface, the work is called a *combine painting*. An ac-
tual plastic fork, knife and spoon might be glued to a painting that
includes a painted plate with food, a tablecloth and napkin. Artists
have glued their palettes into paintings or added pieces of real
clothing to the canvas.

Innumerable combinations of media are possible. Explore some
of them and get a taste of their possibilities.

ACTIVITIES

ART HISTORY

☐ By looking at the examples in this chapter, you can sense the dramatic change in artists' attitudes toward painting from early Egyptian to contemporary times. Based on what you see here, write a short essay on "changing approaches to painting." What attitudes seem to be expressed most often in contemporary paintings? Are such attitudes related to our fascination with the exploration of space, technology and communication? How? Are some contemporary artists still working in traditional styles and techniques? Is this acceptable? Should it be? Why or why not?

☐ Two ancient techniques introduced early in this chapter are *fresco* and *encaustic*. Using information you find in encyclopedias or art materials books, write a short history of one of these media. Include the titles of several works and/or the names of several important artists who used the medium (where information is available).

CRITICISM / ANALYSIS

☐ Study the painting by Sue Wise on page 132. The artist has combined a wide range of materials and techniques to create this complex work. Read the description of how she did it in the caption. Why do you think she went through such a complicated process to make the painting? Is it possible that some artists are very interested in processes? What art elements dominate

the work? Is the *process* an important part of the work? Why? This is a mixed media painting. Which media are used? How is movement established? How is unity maintained in such a complex work? What is the dominant mood, color and characteristic of this painting?

☐ Robert Vickrey used egg tempera to paint this work of his daughter playing with balsa wood gliders. *Landing Circle* is a 24 × 36″ (61 × 92 cm) work that incorporates *all* the elements and principles of design to present a perfectly unified painting. Make a list of all the elements and principles of design and show either in an oral, written or videotaped manner how the artist used each of them.

AESTHETICS

☐ Look at the work of Duccio (page 127) and Frank Stella (page 124). Explain what you see in each work. Can they be compared in any way? Both are painted by well known artists from different eras of history. Is it at all possible to say that one is a *better painting* than the other? Can you *like* one of them better than the other? Why? Which one do you like better? Why? Your personal reaction and sensitivity to each work is valuable. You do not need to judge one work against another; nor do you have to like a

painting just because someone else likes it. Your personal taste is your own responsibility. It will change as you mature and become more knowledgeable about art.

☐ Study the small gouache painting by Tom Nicholas on page 130. What is the subject of the work? Notice its dimensions; it is much smaller than most paintings shown in the text. Does size have anything to do with the *quality* of a painting? Gouache is an opaque water-medium. Is this painting surface more like transparent watercolor or like an oil painting? Why? Describe this still life in words. Is the painting technique loose or controlled? Do you like the surface quality? Why? Do you enjoy looking at the painting? Why? Look in the index to find other works by this artist.

PRODUCTION / STUDIO

☐ Study Richard Wiegmann's work, titled *Sheep,* on the previous page. Describe the painting. How is it divided? Are the bands equal in size or content? Make a painting in any medium you wish, using a similar concept of three horizontal bands. Instead of sheep, use apples, cats, flowers, horses or another single subject.

part III

SUBJECT MATTER

Marilyn Groch, Pastel Box, *1982–83. Oil on canvas, 36 × 48″ (90 × 120 cm).*

1. In this mixed media collage, the student used a still life setup as a source of information, but rearranged objects to create a workable composition. The collage is made of colors from the yellow color family. What types of contrast do you see in this picture?

chapter 13

STILL LIFE

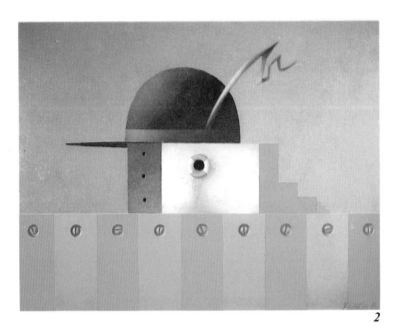

2. *Juris Dimiters is an artist from Latvia, in the former USSR. He gives most of his paintings the title* Still Life, *as this one is titled, and often combines objects that seem unrelated to one another. The neutral background and large areas of flat color in this work dated 1986, make it look one-dimensional, but look again. Where curved objects or forms appear, the artist uses shadows to create depth. Can you see humor in this painting? Oil on board, 18 × 24" (45 × 60 cm). Courtesy International Images, Ltd.*

2

A still life is a painting of inanimate objects—things that do not move. Fruit, flowers, bowls, bottles, pieces of cloth—everyday items that have interesting shapes, colors or textures—may be arranged or clustered to form a still life *setup,* a source of information for the artist.

Painters have drawn inspiration and information from still life arrangements for the past few hundred years. There are examples of dramatic still lifes from the seventeenth century that feature mounds of vegetables and fruits—a display that suggests the abundance and wealth enjoyed by the aristocracy of the time.

As studies in realism, still lifes were painted in the eighteenth century by Jean Baptiste-Simeon Chardin, who emphasized the qualities of everyday life, and in the nineteenth century by Gustave Courbet, who painted exactly what he saw.

Still lifes emerged into the twentieth century with Postimpressionist canvases by Paul Cézanne and Cubist works by such painters as Pablo Picasso, Georges Braque and Juan Gris. Many contemporary artists have chosen the still life as the basis for paintings

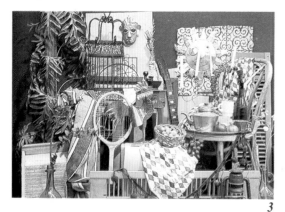

3

4

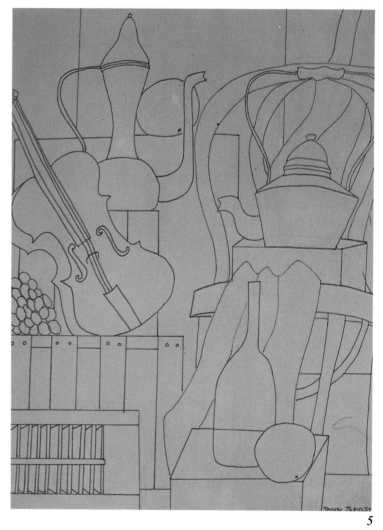

5

3. *Study the still life setup from several different angles.*

4. *Use a viewer to zero in on areas of interest in the still life setup.*

5. *Do a series of thumbnail sketches before you select your favorite portion of the setup for your final working drawing.*

in a wide range of styles.

The still life as subject matter has many advantages. It is convenient. The artist may remain in the studio and have complete control over every aspect of the subject matter — selecting and arranging items, experimenting with lighting. A still life setup can remain intact for long periods, allowing the artist to study it in detail and paint it many times. It is also easy to modify by changing or rearranging objects.

SETTING UP A STILL LIFE

When gathering objects for your still life, try at first to find things that seem to belong together, or that might be found in one place — on a kitchen table, in a music room or garage, on the back porch or at the seashore. Look for a central theme: treasures that reveal someone's personality, objects from a certain time period. Choosing related items will give your still life a sense of unity. Later, when you feel confident about painting still lifes, consider using appar-

ently *unlike* objects in your work. Think about subtle qualities or functions of the objects that connect them to one another; try to suggest a particular meaning through careful juxtaposition.

Many artists prefer to use artificial flowers and fruit because they last indefinitely. Silk flowers and plants can look quite real, and are often as beautiful as living specimens. Fruit made of wax or plastic also may be easily substituted for the real thing.

Select a variety of shapes, some linear, some curved. Look for objects of different sizes. Choose things with patterned, plain, shiny, smooth or textured surfaces. Keep color and value contrast in mind when picking items for your setup.

Arrange the objects on a table or chair, on crates or boxes. Using many different levels can result in an interesting composition. Experiment with draping cloth behind or under the cluster of items you have arranged. View your setup from different angles. Finally, experiment with lighting. Spotlights above, below or from the side will cast interesting shadows and highlight your objects.

ORGANIZING YOUR COMPOSITION

Once you have arranged your setup and are ready to draw or paint, decide on an interesting view. Look at it from below, from above or straight on. You may draw the whole thing or only one part.

Look through a rectangular viewer and find a part of the composition that looks good to you. Use the viewer in both vertical and horizontal positions before deciding on the shape of your picture. At this point, draw several thumbnail sketches and analyze them to see if you need to improve upon the arrangement of your setup. Remember that your painting will appear more stable if most of the shapes are vertical and horizontal. Balance any sloping diagonal shapes with others leaning in the opposite direction. Now is a good time to review the elements and principles of design: color, texture, shape, space, line, balance, unity, contrast, emphasis, movement, rhythm and pattern. Setting up a still life will teach you a lot about organizing a composition.

USING EMPHASIS

Emphasizing some aspect of your still life painting can add interest or excitement to what otherwise might be a commonplace cluster of objects. Some artists emphasize a particular style, such as realism or Cubism. Color, value, shape, space, form or line may be singled out for emphasis by others. The surface quality of objects—texture, pattern, reflection or transparency—is often highlighted to capture the viewer's attention. Light and shadow can be given especially dramatic treatment in a painting. As you study the still lifes in this chapter, look for ways each artist has made a statement through the use of emphasis.

6

7

6. *A lot of patterned detail is visible in this final drawing. The student has decided that pattern is to be emphasized in the finished painting.*

7. *In this crisp tempera painting, the student has decided to focus on value contrast, shape and an interplay of pattern. Movement is created by the repetition of darks and lights throughout the surface of the picture. The setup is viewed from below, looking up.*

9

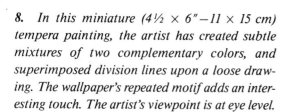

8

8. *In this miniature (4½ × 6″—11 × 15 cm) tempera painting, the artist has created subtle mixtures of two complementary colors, and superimposed division lines upon a loose drawing. The wallpaper's repeated motif adds an interesting touch. The artist's viewpoint is at eye level.*

9. *Sandra Beebe often emphasizes the idea of a collection of items in her still lifes. She has painted collections of military memorabilia, lockets and, here, of intricately embossed silver mirrors in* Margaret's Mirrors. *Shadows, texture and patterns are also important elements of these paintings. Watercolor, 22 × 30″ (56 × 76 cm).*

10. *Collage lets you experiment with arranging and rearranging areas of paper and fabric, and encourages you to emphasize the surface texture of your painting. By taking advantage of this flexibility, you can gain experience in using the elements and principles of design effectively. Torn paper may be combined with paint, charcoal, crayon or pen and ink with impressive results.*

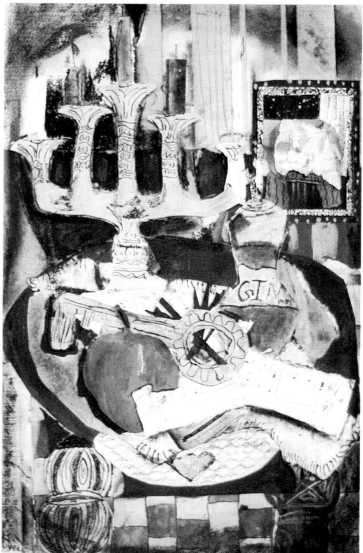

10

11

WAYS TO WORK

Still lifes can be painted with oils or watercolors, acrylics, tempera, pastel or a variety of mixed media. Collage (torn or cut paper or fabric) and various resist techniques are also applicable. Rendering the same setup in several different media or techniques is a challenging approach to still life painting.

STYLE: OTHER APPROACHES

There are many different styles employed in still life painting. Seventeenth century Baroque artists have given us realistic paintings that define form through dramatic use of light and shadow. Another form of realism, called *trompe l'oeil,* literally fools the eye with superrealistic, detailed works — with objects shown at their actual size — that beckon the viewer to reach into the canvas and touch an object.

Pop art, a modern form of realism, makes use of familiar commercial items and is almost like advertising art.

Some still life paintings are abstract — the shapes are distorted

12

11. Tempera is a versatile medium for still life painting. It is easy to control and enables you to work in fine detail. Try using it for a paint resist, as this student did.

12. At the end of the nineteenth century, William Harnett used a style of painting called trompe l'oeil *(fool the eye). His detailed, life-sized objects, dramatically lit to show form, startled people with their feeling of reality. In* Old Models *there is the illusion of looking at an actual still life setup instead of an oil painting. The Museum of Fine Arts, Boston, Massachusetts.*

145

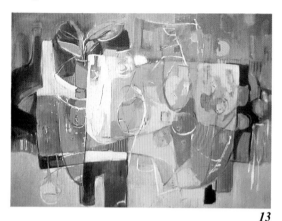

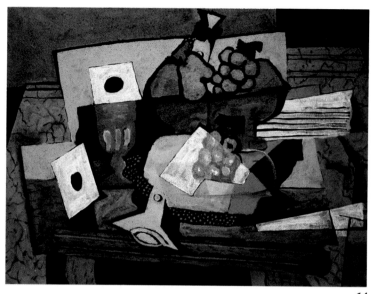

13

14

15

13. Helen Reed paints colorful patterns in her lyrical, abstract still life, Summer Picnic. *Subject matter here is secondary to the elements of color, value, shape and line and to the principles of balance, unity, contrast and movement. Acrylic, watercolor and inks, 26 × 36" (66 × 91 cm).*

14. Flattened shapes and twisted forms grace the canvas of this Cubist painting by Georges Braque. In Still Life with Grapes and Clarinet, *he added real texture, in addition to simulated ones, by adding sand to his oil paint 21 × 29" (53 × 74 cm). The Phillips Collection, Washington, DC.*

15. Tom Wesselmann likes to combine objects often found in advertisements or stores in colorful, three-dimensional collage paintings. This style of painting is called pop art. Rhythm is created through the repetition of identical elements. Oil and assemblage on composition board, 48 × 72 × 4" (122 × 182 × 10 cm). Rose Art Museum, Brandeis University, Waltham, Massachusetts.

or flattened. Examples of abstract painting are found in the Cubist still lifes of Georges Braque, Pablo Picasso and Diego Rivera in the early twentieth century.

Of course, all artists develop a personal style that emphasizes the elements and approaches they find most interesting. As you look through this chapter, try to identify the differences between the illustrated approaches to still life painting.

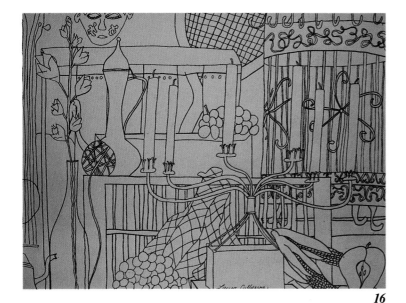

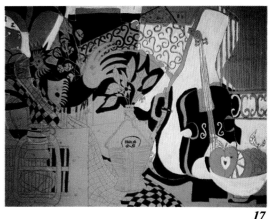

17

18

16. *A drawing is made from a still life setup and transferred with carbon paper to a sheet of brown construction paper.*

17. *After painting about one-fourth of the picture with black india ink, white is painted in some areas. The brown paper is now a middle value. Lighter tans and darker browns are added next. If white is too bright in places, it may be repainted in a duller color.*

18. *The colors in this work were enriched by adding green, yellow, orange or red to its basic brown tone. Can you pick out several ways the artist directs your eye to the center of this still life?*

DEMONSTRATION/PAINTING A STILL LIFE

There are many approaches to painting a still life and many different media to choose from. Here is a demonstration of one method used in a classroom situation. The students moved carefully from one step to another, first doing thumbnail sketches of the setup, next superimposing division lines on the finished drawing (See Chapter 5, More Drawing Ideas) and finally making the painting, using a monochromatic color scheme.

19. *Rich earth tones and unity of composition are stressed in this tempera paint resist on rice paper. Objects are united because they overlap and are all touched by the checkered cloth. An unusual perspective is in evidence here—the simultaneous viewing of objects from above, at eye level and from below. Can you spot examples of each?*

19

LOOKING AND LEARNING: A GALLERY OF STILL LIFE PAINTINGS

Artists choose many approaches to painting still life subjects. As you study these paintings, look for the ways each artist has used color, shape and line, as well as the other elements and principles of design. Also notice how each artist approached the subject with a different goal and style.

20

20. *Robert Frame depicts the objects he paints with photographic realism in* Still Life with Oil Lamp. *He relies heavily upon color to establish a sense of unity in this 18 × 30" (46 × 76 cm) oil painting.*

21. *Audrey Flack has captured the realistic essence of the fruit in this fascinating still life, but upon closer inspection, we notice parts that trick our eyes. For added impact, the painting is large, and gives us a close-up view. A Pear to Heade and Heal, acrylic, 38 × 56" (97 × 142 cm).*

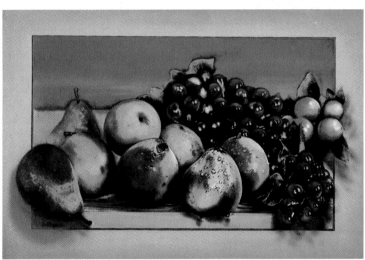

21

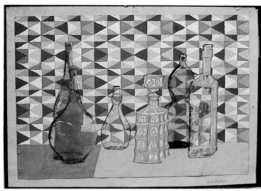

22

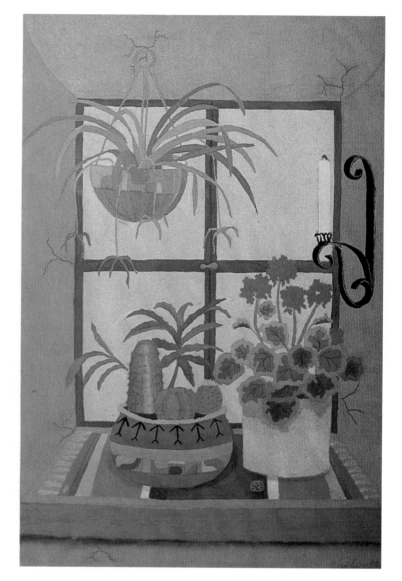

22. In an unusual approach, subject matter is subordinate to the repeated pattern of darks and lights forming the background of this tempera painting. The rhythmic geometric shapes in the wallpaper capture your eye, making the arrangement of bottles of secondary interest.

23. The warm ambience of Santa Fe is captured and becomes the dominant element in this lively tempera painting. Another unifying factor is the repetition of two complementary colors (red and green) in varying mixtures and intensities. The artist has used diagonal lines from each corner to lead the eye into the picture.

ACTIVITIES

ART HISTORY

☐ Early in the history of painting, still lifes were only details in larger paintings. Baroque artists in Northern Europe in the seventeenth century began to feature fruit, vegetables, fabrics, ceramics and other objects in their paintings. These works often showed the material wealth of the times. Find examples in art history books, books on Baroque art or in encyclopedias, and list five titles and dates of such works, the artists who painted them and the countries in which they worked.

☐ Pablo Picasso and Georges Braque developed Cubist techniques while painting still life subjects. Research the Cubist movement, or either of the artists, and write or present discussion (illustrated with slides or prints) on the importance of still lifes in developing Cubism. Define and use terms such as *fracturing, displacement, contour continuation* and *simultaneity.*

CRITICISM / ANALYSIS

☐ Lynn Wolfe captures the environment around him by painting the things he lives with. The horse (a part of a weather vane from his childhood farm) and a plant are by the window overlooking a grove of aspen trees in the yard of his Colorado home. Imagine the painting without the window lines and aspen branches. What do they contribute to the painting? Why has he used

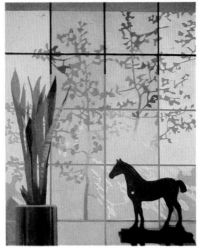

line in his work? Where do you find value contrast in the work? Give examples of other kinds of contrast. How is unity achieved?

☐ Helen Reed's and George Braque's still lifes are shown together on page 146. What similarities do you note? How do the paintings differ? Make a statement about each painting that describes the artist's unique use of line, shape, color and value. How is unity created in each of the paintings? What words would you use to describe each painting?

AESTHETICS

☐ Compare the paintings of Sandra Beebe (page 144) and William Harnett (page 145) in this chapter. How are they alike and how do they differ? In which one is the personality and feeling of the artist evident? Why? Which is more realistic? Are they both realistic? Representational? Naturalistic? How does each painting make you feel? With which of them do you feel more comfortable? Why? If you could make a choice, in which style would you rather paint? Why?

PRODUCTION / STUDIO

☐ Draw some objects from a still life, each on a separate piece of paper. Cut them out and experiment by rearranging them on a large piece of paper. When you find a composition you like, glue it down. Either paint over the collage, or transfer the drawing to a painting surface, and paint it with the medium of your choice.

☐ Do a large drawing of a still life. Crop it to a small size by using only a small part of the total drawing. Use two L-shaped pieces of cardboard to help find the section you wish to use. Perhaps your selected area will be a group of abstract shapes. Redraw the result in a larger format and paint it with tempera or acrylics.

1

1. *Kent Twitchell's gigantic figures loom over parking lots and streets in downtown Los Angeles. His paintings of friends (this is titled* Edward Ruscha as Christ) *look very realistic in spite of their large size. The artist develops detailed drawings and small paintings before transferring his image to a wall. Here, the work is still being finished.*

2. *Mary Cassatt painted* Mother and Child *(1890) in a loose technique. The artist emphasized the love between mother and child in much of her work. Note how the center of interest (the child's face) is handled with a bit more detail than is found in the rest of the painting. Oil on canvas 35 × 25″ (89 × 64 cm). Wichita Art Museum, Kansas.*

2

chapter 14

PEOPLE

Artists have been painting people from the earliest of times. They have painted portraits, full figures and groups, and have painted people alone and in environmental settings. They have painted nude and clothed figures, young and old, abstracted, stylized and realistic, large and small, in every available painting medium. If you look through an art history book, you will find more paintings of people than of any other subject.

Throughout history, artists have recorded how people looked, dressed and lived. We have no photographs of George Washington, yet we know how he looked. The invention of the camera caused artists to take a second look at people, and changed both the purpose of their people paintings and their ideas about portraits and people in their art. The camera provided a way to create detailed portraits, so paintings of people could become more generalized, and design and style more dominant.

There are two main aspects of every painting involving people: 1) the depiction of the person or people, and 2) the composition of the work. Some carefully finished portraits appear in poorly composed paintings. And in some well designed paintings the figure is not well done. If these two elements are in balance the result is usually pleasing.

When working with figures or faces in paintings, you can consider them in one of two ways: 1) you may decide that they must look realistic in order for the painting to work; or 2) figures may be secondary to the subject of the painting and need not look like actual people. As high school students studying painting, you will find that this second consideration is generally more important. You are learning to make paintings with people in them, rather than accurate portraits. It is important to understand some generalized features of people and use them in your work, but successful portrait painting generally requires special drawing and painting classes.

LEARNING TO PAINT PEOPLE

Success in painting people is based on the successful *drawing* of people, which is based on careful observation. Study how the human

3

3. *This is a contour drawing; the artist emphasizes outside edges and overall shapes in the model's form.*

153

5

4

4. *This portrait stresses form and feeling, and is drawn in ink, wash, crayon and charcoal. What mood does it project?*

5. *Try many approaches to drawing and painting people. A student has brushed down colored washes in the* general *shape of the student model. He is now drawing over the washes with a stick and India ink, recording* specific *observations. Continue to check proportions as you work on each figure.*

form is affected by light and shadow, color, line; study the body's attitude, pose, action, shape and form. If you are going to include people in your paintings, you should constantly practice drawing them.

Draw generalized faces and figures as well as specific features and characteristics. Draw in every medium and on all kinds of surfaces. The more you observe, the more you will see, and the easier it will be to draw people. As a result, including figures in your paintings will become routine.

You can observe people in many ways, and all can help your drawing skills. You can draw posed students and your family. Observe the faces around you. Take note of the variety of facial features and expressions, stances and postures, gestures and body types. Fill sketchbooks, scratch pads and drawing sheets with your observations in both wet and dry media. Changing media tends to sharpen your powers of observation, and even changing papers will encourage different responses to your subjects. Some of your drawings may become subjects for future paintings.

As you look through this chapter, notice that there are innumerable approaches to painting people, and that artists use a wide range of media in depicting figures. You will probably find that firsthand observation of people is the best way to improve your paintings of people. Learning to observe details is a useful skill for beginning artists to acquire.

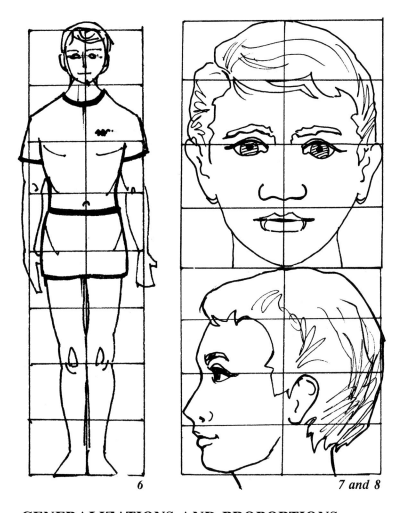

6

7 and 8

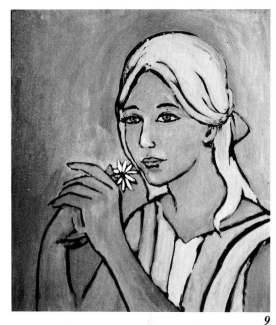

9

GENERALIZATIONS AND PROPORTIONS

Many artists write books to teach people how to draw figures and portraits, each explaining his or her favorite method. When you include people in your paintings, it is generally important that they "feel" comfortable and are correctly proportioned. Diagrams can sometimes help you proportion faces and figures.

Some artists make figures about eight heads high and two heads wide (when viewed from the front). Actual proportions are about seven heads high, but slightly taller figures seem visually more attractive. Fashion illustrators use nine- or ten-head-high figures. Why do you think they do this?

The diagrams show general head proportions also. These generalizations can be altered to provide for individual characteristics such as wider set eyes, narrower nose, thinner lips and so on.

6. Example of a figure sketched to be eight heads high. Notice where waist, knees, elbows, shoulders and hands are located on the measured grid. No two humans are exactly alike, so these proportions are simply generalizations, to be used as a guide.

7 and 8. A human face can be drawn on a four-space vertical grid. Notice where eyes, nose, mouth, ears and hairline appear on the grid. Both front and profile views are shown. Profiles are drawn on a square grid while front views are drawn vertically in a rectangular format.

9. Proportions may be compared to each other to be sure that hands, eyes, mouth and so on are in size agreement, as they are in this student gouache painting.

10

11

10. *Part of a page of figure sketches, drawn on ruled notebook paper. Figures are about eight spaces (heads) high, and are sketched in several styles. These might be appropriate for landscape or cityscape paintings.*

11. *Robert E. Wood emphasized composition in* Her Painted Fans, *a 22 × 30" (56 × 76 cm) watercolor. The fans contain more details and visual interest than the figure, but the figure shape still dominates the asymmetrical, informal design.*

12. *The student who painted this oil painting chose to use a strong symmetrical composition, focusing on the sitar player. The background was intentionally kept simple to emphasize the figure of the musician and the formal, classically balanced composition.*

12

For practice, fill pages of ruled note paper with sketches of figures, making each eight spaces high. Or make nine equally spaced short lines in your sketchbook, and use those spaces to proportion your figures.

Artists often alter general human proportions and details to fit their personal styles and purposes, as you can see in the illustrations in this chapter. Most painters continue to practice figure drawing for much of their lives.

COMPOSITION AND DESIGN

Figures are often incidental parts of paintings, with buildings, flowers or landscape being the main subjects. In such cases, the figures should be painted as part of the environment and should not draw attention to themselves.

Where people are the main subject of a painting (either portraits, full figures or groups) be sure to design the entire surface carefully. A face is often the center of interest and should be placed appropriately on the surface. The placement of a figure should be visually interesting; it should not merely occupy the center of the painting. Groups of figures should be clustered into unusual arrangements or shapes. Pay the same careful attention to placing figures in paintings as you would to placing objects effectively in still lifes or landscapes. Whether the figures are abstract or realistic, they should help make the overall composition interesting, dynamic and effective.

FIGURES IN THEIR ENVIRONMENT

Once you have learned to observe and have practiced drawing basic figure proportions, you can think about making paintings that include figures. When you paint them into a particular setting, you should consider how you integrate them into your painting. They should be a vital part of the work and should not appear to be cut out of one painting and pasted into another.

Remain aware of proportions, both the proportions of each figure and the relative proportions of figures to objects in the painting. Check these regularly as you plan the drawing for your painting, so that windows, doors, cars, chairs, plants, and so on, are proportionate in size to the people.

Figures can dominate the painting or can take up a small part of the designed surface. But if you include them, be consistent — make them fit the painting in style, brushwork and technique. Treat them as you do all the other objects in the painting.

13

14

13. *Sally Storch placed this chef in his natural environment — a short-order kitchen.* Gus *is a 24 × 34" oil painting (61 × 86 cm). The painterly brush strokes and subdued color allow the figure to be emphasized, but shading unites it comfortably with the background.*

14. *Steven DeLair placed* The Dancer *in a museum, showing her enjoying her art viewing experience. The figure stands alone and is the focus of interest, yet is completely integrated into the 20 × 30" (51 × 76 cm) oil painting.*

16

15. *The student who painted these two figures in acrylic used fashion proportions (ten or more heads high) and allowed them to run off the bottom of the sheet. These proportions and the work's clean, crisp style create the look of a fashion illustration.*

16. *Neil Boyle combined several clusters of people in* The Hustler, *a 30 × 40″ (76 × 102 cm) oil painting. He has combined action (note every pose) and groupings to illustrate graphically the activity in a western pool room.*

15

FIGURES IN GROUPS

When two or more people are grouped together in a painting, the figures should appear to belong together. They should be in proportion and should cluster or overlap to indicate their "togetherness." The overall shape made by the grouped figures should be visually interesting in and of itself, and should also work with the rest of the painting.

Practice grouping people together by drawing complete figures over each other. Then eliminate some lines to produce an overlapping and clustering effect. Think of how you overlap objects in still lifes, and apply those ideas to your group figure painting.

FIGURES IN ACTION

To paint figures in action, you must be aware of the articulation of human joints and limbs. This can be done by: 1) studying and drawing a mannequin in active poses; 2) photographing students and athletes in action; 3) drawing stick men in action poses; 4) painting active silhouette figures from posed models or imagination; 5) studying sports photographs.

Active people are painted most convincingly when placed into active environments. Slashing brushwork, soft edges, asymmetrical compositions and clashing colors can help establish a sense of action in your painting.

17

18

19

20

17 and 18. *These two pastel paintings by Randy Hayes show figures in groups. Notice how the artist uses facial expressions, shadows and light to make you feel as if you just walked into these people's conversations.* Pinkie, *top, courtesy Linda Farrif Gallery. Private collection.* Great White Way, *bottom, courtesy the artist.*

19. *Wooden mannequins like these can help you paint realistic figures in action.*

20. *The student who painted this pillow fight worked from a photo she had taken at a school event. The active poses and slashing brushstrokes help project a feeling of great physical action.*

21

22

23

21. *The angular portraits in Paul Klee's* Two Heads *are colored shapes, punctuated by red dots and lines. Norton Simon Museum of Art, Pasadena. Blue Four-Galka Scheyer Collection.*

22. *LeRoy Nieman used his easily recognizable style in painting* Hank Aaron. *The textural surface glitters with contrasting warm and cool colors, brushed in an impasto technique.*

23. *Sergei Bongart reveals his feelings and concerns for Russian farmers in his expressionistic painting,* Two Peasant Women. *The artist's characteristic style and brushwork are evident in this 36 × 24″ (91 × 61 cm) oil painting.*

FIGURES IN ABSTRACTION

Abstraction is one of many painting styles. In an abstract work, an artist may emphasize one particular aspect of design (line, shape, color, texture, etc.), or try to reduce faces or figures to geometric simplicity, attractive patches of color or dots of paint.

Some painters break up figures in their works and put them back together in unfamiliar arrangements. Painters who work in abstraction are trying to show us different ways of seeing people, and not trying to paint realistically.

Can you tell immediately which of the illustrations in this chapter are abstractions? Some of these examples may give you ideas for stretching your figure painting efforts in new and exciting directions.

STYLE

As we have said (see Chapter 4), artists develop their own styles after many years of experimentation. In that time they search in many directions to find the best ways to express themselves visually. Most mature artists therefore have distinctive and recognizable styles, while the styles of younger artists may change every few years. Students' styles change even more often.

Some artists wish primarily to express emotion in their paintings of people, and their style may reflect this: Their brushstrokes may appear brisk, almost angry; they may use the same vibrant colors in all their works. Others prefer to emphasize light, texture, color, caricature or design, concentrating above all on how one element—

25

24

24 and 25. Two student works show completely different styles. The pastel portrait shows careful concern for shading, form and realism. In the watercolor painting a still life is effectively stylized—shadows and light are simplified to painted shapes. The work shows two mannequin heads (from department stores) and a small wood mannequin.

or several—can be explored within a painting. To some artists, a sense of reality or even photo-realism is most important in a figure painting. Your painting style becomes an expression of your individuality, your personality, your outlook on things. Thus as your outlook changes so do your paintings. While you are learning to paint confidently, it can be helpful to experiment with other artists' recognizable styles. Practice their brushstrokes, their approaches to composition. How do they express their feelings about the people they paint? Can you do the same? As you practice, you'll learn about another artist's ideas and techniques as you learn about your own likes and dislikes, strengths and weaknesses.

Throughout history, artists have painted the human form in every conceivable style. You may like some styles more than others, but all are attempts at painting people in personal and meaningful ways.

DEMONSTRATION/FIGURE IN NATURE (WATERCOLOR)

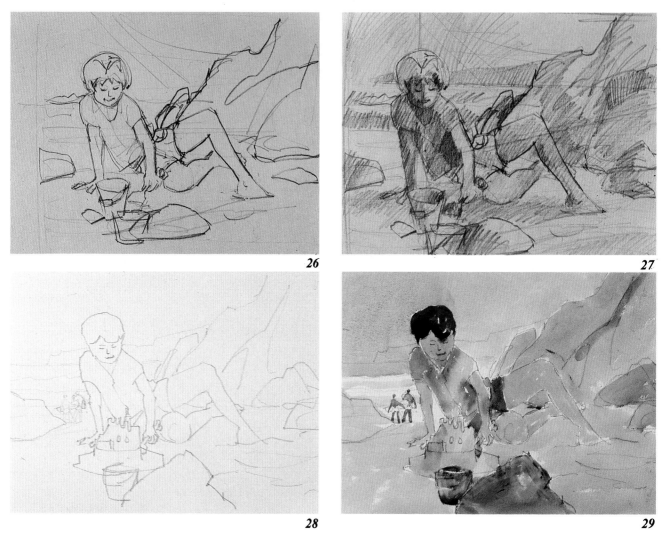

26 and 27. Large sketches (18 × 24″ — 41 × 61 cm) in both line and value help determine the placement of the figure and the amount of area around it. It is important to keep figure and environment together as a unit.

28. Start with a pencil outline of large, important shapes on a sheet of heavy white drawing paper.

29. Washes are applied quickly with a flat brush. Colors are light values of "local colors" (colors of the sand, skin, shirt, rocks, ocean, sky, etc.). Parts of these color areas will not be touched, and will be the lightest values in the finished painting. Areas of white foam and spray are left unpainted throughout the process.

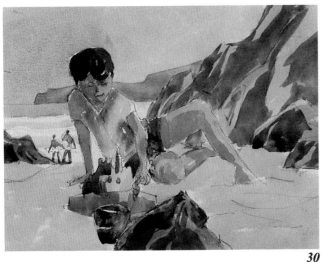

30

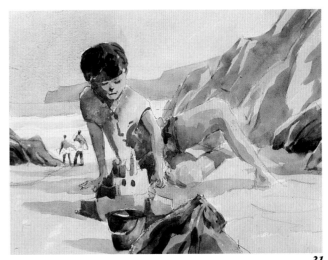

31

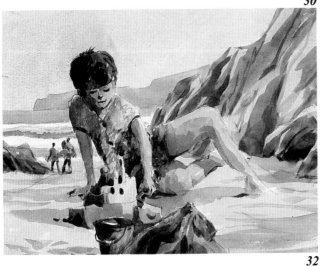

32

33

30. *When the surface dries, middle values, tinged with cool blue, are applied in all shadow areas of the figure, rocks, sand castle, beach and distant land. These colors are applied as shadow shapes; there is no concern for detail at this point. Light and middle values have now been established.*

31. *Darker values and some linear passages are added next to suggest three-dimensional form and shadows. The hues of these darker washes are changed slightly to add interest and excitement to existing middle-valued areas. Some line and detail are added, but kept to a minimum.*

32. *Final darkest values are placed in areas of most contrast and greatest possible weight, or where objects and the figure rest on the sand. Color details (spots of local brightness) are added. Details are not present at all, and yet the figure seems to have weight, and sits comfortably on the sand. Using the same colors (blue/browns) for shadows on the figure, sand and rocks creates a convincing feeling of unity. The figure should look as though it belongs in the painting.*

33. *Dark lines have been placed over the painting to illustrate important features. 1) Long lines show movement to the center of interest (the area of the boy's hand and the sand castle). 2) Short lines show elements that tie the figure and the landscape together. Notice how the edges of the painting are tied to the center of the picture plane so that all the surface is involved in creating a sense of unity.*

163

34

35

36

34. *After drawing a costumed student model or illustration board, colored tissue paper and magazine cutouts were glued to the surface. Colored inks and India ink were applied with pens, brushes and sticks to accentuate details and define specific shapes.*

35. *Kent Twitchell paints large portraits on walls, working from smaller drawings and paintings to proportion his images correctly. His work often has religious overtones, and the title of this realistic portrait is* 7th Street Altarpiece.

36. *Only black and white acrylics were used to paint this dramatic portrait. Sketches were made from a photograph, and the painting was composed from the sketches. Mixing varying amounts of black and white acrylics produced a wide range of values. The grays were an especially expressive color choice for the subject.*

LOOKING AND LEARNING: A GALLERY OF FIGURE PAINTINGS

These paintings were made by both students and professionals. All of them had different concepts in mind when working with their figure subjects. Can you tell which techniques they used to make their paintings?

All these works illustrate the wide range of styles, media and techniques used by contemporary artists who make figure paintings. Perhaps they will help you with ideas for your own figure paintings.

37

37. *Juan Cardenas used oil to paint* Self-Portrait with White Shirt, *1982. Grays and browns give the work a somber mood; unfinished boots make it somewhat mysterious. Would you say the artist has used realistic proportions? 45⅞ × 22″; 117 × 56 cm. Courtesy Claude Bernard Gallery, Ltd.*

38. *Linda Doll's stylized figures are derived from a series of drawings in line and value. In the resulting painting she has not painted flesh at all, but only the clothing and surrounding shapes, which allow the face and hands to come alive. Remove the tree branch and the cat disappears. Remove the window ledge and hair, and the face disappears. The colors in this 22 × 22″ (56 × 56 cm) watercolor are purposely kept flat to emphasize design and shape rather than form.*

39. *Milton Avery painted* The Seamstress *in 1944. He chose to use flat areas of pure color in his abstract work, but the seamstress and her activity are not at all difficult to recognize. Oil on canvas, 48 × 32″ (122 × 81 cm). Photograph courtesy Borgenicht Gallery, New York. Private collection, USA.*

39

ACTIVITIES

ART HISTORY

☐ Portrait painting has always been a major subject for many of the world's artists. Choose one of the following artist/portrait combinations, and after researching it, write a short paper on the artist and his/her work as a portrait painter. Discuss subject, style and purpose of the work. Choose from: Leonardo da Vinci (*Mona Lisa*); Gilbert Stuart (*George Washington*); Albrecht Durer (*Self-Portrait*); Hans Holbein (*Anne of Cleves*); Jacques Louis David (*Napoleon*); Elizabeth Vigee-Lebrun (*Therese, Countess Kinsky*). You may use other artists and subjects if you wish.

☐ Several contemporary artists continue the portrait/figure painting tradition today. Look in contemporary art books, catalogues or magazines and select one of these artists to write about: Audrey Flack, Alfred Leslie, Chuck Close, Larry Rivers. Discuss how the artist makes unique visual statements (what is his or her personal style?) and describe the style and technique. Use slides or reproductions to illustrate your report. You may also use other artists and their work from the text as the subject for this report. You may wish to prepare a videotape as your report.

CRITICISM / ANALYSIS

☐ Study the student painting of a pillow fight on page 159. What did the student emphasize in this work? How are movement and action indicated? Describe the edges used. How do the edges enhance the feeling of action? Is line used at all? Describe the negative space. How does it amplify the vigorous movement of the figures? The student took a photograph of this subject at a school tournament and used the photo as a visual resource. Is the painting photographic? Why is it even more effective than a photograph to express action?

AESTHETICS

☐ Study the two paintings by Steven DeLair and Sally Storch, shown together on page 157. Both show people in environments. Describe them both. Are the subjects and painting techniques compatible in each? Why or why not? What do you think each artist is trying to say about the people? Are they successful? Does one communicate feelings more easily to you than the other? How does each make you feel? Are the feelings the same? Have the artists communicated *feelings* to you? Which do you seem to like better? Why?

☐ Study the painting of two peasant women by Sergei Bongart on page 160. Describe how the women look. Describe the artist's brushing technique. How does this gestural technique make you feel? Are the women joyful or sad? Describe your thoughts about them. How has the artist helped you see these women as he sees them? What mood does the artist communicate here? Is the artist an expressionist or a designer of space? Do you like the painting? Why?

PRODUCTION / STUDIO

☐ Study the grid method of drawing faces on page 155. Instead of the regular grid, distort the dimension (taller, wider, curved, etc.) and draw the faces to fit the resulting spaces. Do this in several ways on $9 \times 12''$ (23×30 cm) sheets of paper. Take one or two of them and make paintings of the distorted faces.

☐ Draw a small portrait (about 6″ (15 cm) high), and trace it on six sheets of paper or cardboard. Use a different medium or mix media on each image to explore the use of various techniques in making portraits. Do not worry if the six appear unlike in their final form. Arrange the six on a panel.

1

1. *John Constable painted many sketches directly from nature before finishing* The White Horse *(1819) in his studio. He enjoyed depicting the English countryside, such as this scene near Dedham. The artist described this work as "a placid representation of a serene, grey morning, summer." Oil on canvas, 52 × 74″ (131 × 188 cm). The Frick Collection, New York.*

2. *A crazy quilt of fields and treelines covers the entire canvas of* Guatemalan Landscape, *an oil painting by Esti Dunow. Notice how the distinct curves of the hills give the work a roller coaster-like movement. Can you tell which direction the sun is shining from? Painted in 1985, 30 × 34″ (76 × 86 cm). Courtesy the artist. Photograph by Allan Finkelman.*

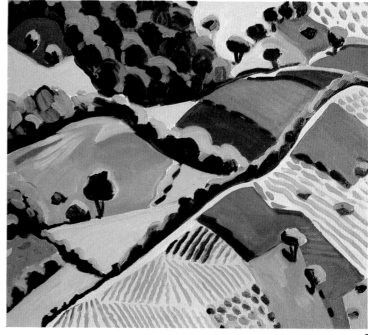

2

chapter 15

THE NATURAL ENVIRONMENT

3

4

Chinese painters had already worked with landscape themes for many years by the time European artists of the Renaissance (fifteenth and sixteenth centuries) became interested in painting their natural environment. The Renaissance revival of interest in naturalism caused painters to look carefully at nature and attempt to portray it on panels and canvas. At first they used the natural environment as backgrounds for paintings which featured figures and animals—landscapes could be seen, for example, through windows or behind Biblical subjects. But landscapes gradually became dominant in paintings, and figures became secondary, merely part of the natural scene.

Late Renaissance painters sought to depict the characteristic textures, colors, forms and lines of trees and mountains. Light, value pattern, foliage, reflections, shadows and color were studied with intense interest. Giovanni Bellini (Italy), Claude Lorraine (France) and Pieter Bruegel (Flanders) were important early landscape painters. Succeeding artists expanded on their themes. Peter Paul Rubens and Jacob von Ruisdael led the surge of interest in landscape painting in seventeenth century northern Europe.

Modern landscape painting began with English painters John

3. *Pieter Bruegel painted* Hunters in the Snow *(1565) as one of a series of works depicting the seasons of the year in sixteenth century Flanders. Although the peasants are important to the story, and appear to belong in the painting, the painting is actually a crisp winter landscape with imaginary mountains in the background. Oil on canvas, 46 × 64" (117 × 161 cm). Art History Museum, Vienna.*

4. *Asher Brown Durand was a painter of the Hudson River group—early nineteenth century artists who glorified nature in their interpretations of New York scenery. They painted both actual and imaginary scenes with care and detail. Imaginary Landscape—Scene from "Thanatopsis," 1850. Oil on canvas, 39 × 61" (99 × 154 cm). The Metropolitan Museum of Art, New York. Gift of J. Pierport Morgan.*

169

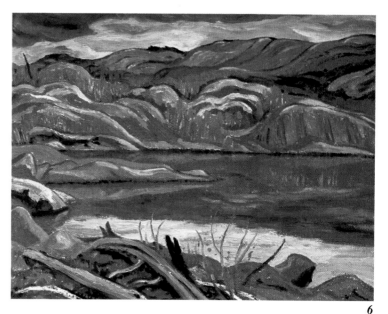

5. *The student who painted this watercolor of a rural church has simplified the basic elements into large shapes. Simple, uncluttered lines add detail, effectively express a variety of textures and suggest various growing things. A limited palette, shapes within shapes and controlled visual movement are important aspects of this carefully designed work.*

6. *A. Y. Jackson was one of a group of artists who interpreted the Canadian landscape in the early twentieth century. Each painter in the group chose a different way to extol the glory, power and subtlety of the Canadian natural environment. Gem Lake, 1941. Oil on canvas, 25 × 32" (64 × 82 cm). Art Gallery of Ontario, Toronto, Canada.*

Constable and William Turner in the early nineteenth century, and their powerful influence can be seen in the works of French realists and the American Hudson River group. Winslow Homer and Thomas Eakins realistically painted the American scene in the early twentieth century, while the Impressionist artists of France and America eliminated detail and emphasized the light reflected from objects in their depictions of the natural environment. Postimpressionist Vincent van Gogh created landscapes that seem to reflect his personal turmoil, and Paul Cézanne stressed a sense of design in his work. Both these tendencies in landscape painting carried over into twentieth century art, in which personal expression is more valued than realistic depiction.

Regional painting in the United States and Canada during the early twentieth century shows artists' preoccupation with the westward expansion of both nations, as well as increasing industrialization and urban/rural tensions. What do contemporary landscape paintings tell us about artists' attitudes toward their surroundings?

ENVIRONMENTAL ELEMENTS

The natural environment cannot actually be divided into separate elements, because land, vegetation, water and the atmosphere are almost always present in various combinations. But these are the basic environmental elements:

The *land* itself includes rocks, mountains, plains, boulders, sand, cliffs, soil, mesas, hills, palisades and the like.

Water includes oceans, bays, surf, lakes, ponds, rivers, streams, waterfalls, reflections and even puddles.

Vegetation includes all plant life: trees, flowers, cactus, grasses, bushes and other growing things.

The *atmosphere* includes sky, clouds, sunshine, fog, mist, rain, snow, storms and so on, which often provide the moods of landscape paintings.

All landscape artists work with these basic environmental elements and arrange them either as they are found in nature or in some personal way. All kinds of media can be used to express ideas and reactions to natural scenery.

Landscape paintings can also include buildings, people and animals, but generally the landscape elements remain dominant. Human elements can be used to establish scale, to show the effect of human habitation on the environment, or to portray the actual local scenery.

SOURCES FOR SUBJECTS

With so many landscape elements around you or familiar to you, how do you choose a subject for your painting? Where do you look for possible environmental themes? Traditionally, landscape painters go out into nature to look for themes, wishing to react directly to their natural surroundings. After much experience, they can select *parts* of the total landscape that have the most meaning or visual power for them, and put their reactions and feelings on paper or canvas. Some use a small cardboard frame to help them select and isolate possible subjects and arrangements from the complex environment.

Some artists prefer to make sketches (in pencil, marker, watercolor, pastel or other media) on location and use those as visual source material for paintings they do in the studio. Sketches can include verbal notes on color, size, mood, light and the like, and can vary from extreme detail to a few simple lines, according to the preference and skill of the artist.

Some artists prefer to photograph possible subjects and use these visual records of field experiences to provide ideas and details for later paintings. Sketches or direct paintings can be made from photographs, and artists can select the elements they want to include as work progresses.

Other paintings and drawings of natural scenes can be used as visual information for landscape paintings; be careful not to imitate them. Use them only as sources of basic information, from which you make a personal statement.

Using Source Material

Before you use any of these types of visual information, it is important to note how other artists make use of them. Look carefully at your subject, as other artists do. You cannot paint everything you see, so you must *select* certain things to include in and certain things to leave out of a particular work. This can be called *selective vision*. It is a good idea to make several sketches to simplify

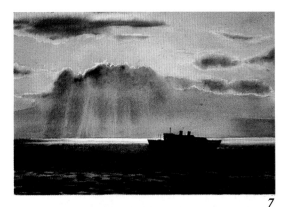

7

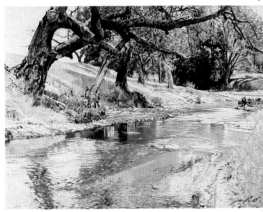

8

7. *Wayne LaCom's watercolor is a simple but powerful and dramatic statement, painted with a very limited palette. The artist has carefully observed and interpreted the scene. The white and glowing reflection on the sea was made by leaving the paper unpainted. Untitled, 15 × 22" (38 × 56 cm).*

8. *Dale Peche's* Yerba Buena *emphasizes the stunning sunlight and high-keyed colors of an actual place. Working from photographs, the artist selected the elements he wished to use and arranged them to fit his personal requirements. Careful attention was paid to some details, but also to overall patterns of dark and light. Gouache, 12 × 16" (38 × 56 cm).*

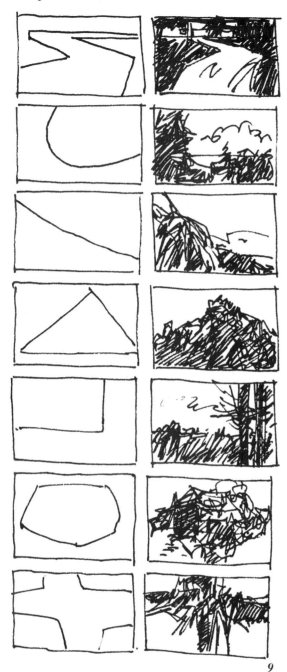

10

9. *Sketches illustrate several of the many possible design formats.*

10. *We look past a grouping of tree trunks to see the brilliant colors of Rolland Golden's* Fiery Fall. *Watercolor, 22 × 30″ (56 × 76 cm).*

and rearrange the landscape elements you choose to include (See *Making a Watercolor Painting,* Chapter 7). Once these seem to work well together, draw them on your paper or canvas and begin the painting process.

Remember as you work that the responsibility of an artist is to interpret nature in a personal way, not to imitate or copy it. Even artists who work realistically try to express some basic feeling or reaction to a scene, and do not simply try to imitate every leaf, flower, color and line. The variety of personal interpretations in this chapter alone will tell you that each artist treats his or her natural subject differently.

Often the color, texture, complexity, simplicity, mood or visual arrangement in a scene will spur an artist's thoughts. Once the subject is chosen, the artist decides how to express the personal feelings the scene stirs. The artist asks questions such as: How can I best show the mood or light? How much can I leave out and still communicate my feelings? Will I get a better composition by rearranging some of the parts? What should be the most important part of the painting? What colors will best express my ideas? The answers help shape the personal statement that each artist wishes to make.

ORGANIZATION AND DESIGN

Landscapes are excellent subjects to explore in many different media, as well as to use for refining skills in a single medium. One especially beneficial project is to paint similar landscape subjects in several media, to see how you can handle them while treating a single, familiar theme.

The arrangement of the fundamental parts of a painting is referred to as its *design format*—usually a group of large, simple

11

13

12

11. Arthur Secunda selected, simplified, stylized and layered horizontal earth elements in a vertical format. The Alps is a collage, made with torn pieces of silk-screened paper.

12. Robert Frame shows us the wondrous colors and shapes of a tropical location at close range. Tahiti Trees is a 66 × 66″ (168 × 168 cm) oil on canvas.

13. Darrel Moss works with oils on location, and uses his impressionistic style to convey his fascination with light, texture and color. Oak Creek Path is a 24 × 30″ (61 × 76 cm) oil on canvas.

shapes. (The sketches on this page show several basic formats.) Formats are used to compose the essential elements of the subject into a workable arrangement—one that will provide good visual movement and an exciting sense of balance. While there are many possible basic formats, artists generally adapt several and rely primarily on them.

Within each chosen format, however, you should be aware of the effective use of the principles of good design and composition (See Chapter 3).

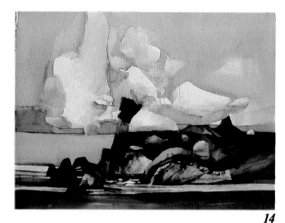

14

14. *Robert E. Wood.* Island Clouds, *watercolor,
22 × 30" (56 × 76 cm).*

*"Even after visits to many far away lands, I
find some of my best 'mood watercolors' are
invented in my studio. Island Clouds is not a pic-
ture of a specific location. The memory is a
wonderful tool if it is developed. I have practiced
using my own memory by painting away from my
subjects at times. Although I can't bring forth
a photographic image of a particular scene, I can
often invent something better. Using the memory
forces the artist into being a storyteller. The im-
portant elements of a place are recalled, even
nicely exaggerated, and the unimportant are
forgotten."*

*The artist was working on another island
painting when the idea for this one grew out of
the developing work.*

15. *Pauline Eaton.* Head in the Clouds, *water-
color, 40 × 30" (102 × 76 cm).*

*The artist had moved to Northern California
and was searching for new cultural roots in a dif-
ferent physical environment.*

*"The branching arms are still reaching, but the
roots more and more anchor themselves. My
future direction is still a mystery, a great unknown
to me. The fogs [a new experience for the artist]
now cloak my future, but with transplanted roots
being nourished by my new location, even as I
continue to grope, I paint on in confidence that
I will find my new direction. To have one's head
in the clouds is to be a dreamer, and that is the
essence of the creative, expressive person. The
subconscious is a wonderful font of creativity."*

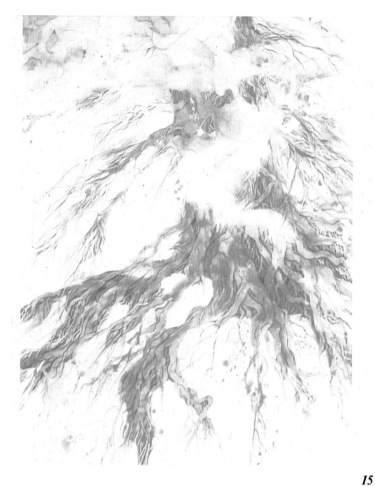

15

Study the landscape paintings on these pages. Think about and
discuss the kinds of formats these painters used, and the char-
acteristics of their styles. Most are successful artists; each treats
landscapes in a distinctive way. Try to discover similarities and dif-
ferences between their paintings.

MORE THAN JUST A LANDSCAPE

By now, you should understand that most artists try to do more
in their landscape paintings than simply depict the natural environ-
ment. Some artists respond to color, texture or the physical arrange-
ment of landscape elements, and paint to convey their responses.
It can be interesting to read what some artists say about their work.
It will give you an insight into the thinking processes that accom-
pany the artists' working methods.

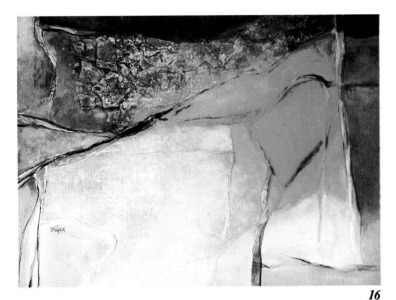

16

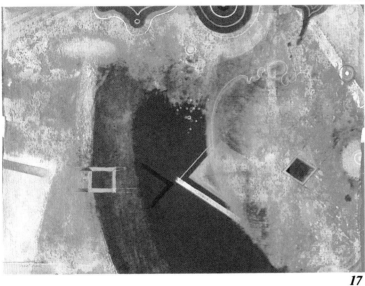

17

16. *Alexander Nepote.* Below Remote Crest, acrylic, pastel and collage, 30 × 40" (76 × 102 cm).

"I work from studies and sketches so I have a general concept of what I want to create. When I start, however, the process and the accidental become very important parts of the final product. I am very conscious of the available information from all five senses, and even a sixth . . . which means being responsive to everything that exists, known and unknown. I translate the discoveries and insights into relationships of color, value, shape, texture, etc., which are incorporated into the interconnecting layers of each work. As I work, the predictable and the unpredictable are fused together into what I feel is a unified whole."

17. *Glenn Bradshaw.* Middle Earth Series, casein and Oriental papers, 12 × 17" (30 × 43 cm).

"I believe in examining my ideas and subject matter from unusual angles. Most of us see our worlds . . . from similar heights, but we have more options than that. As artists, we can see everything near and far in sharp focus; we can view the world from our shoe tops or from a satellite; we can see inside and outside simultaneously; we can express time, motion, feeling — things which are not generally visible.

"My current work is nonobjective and is concerned with the contrast between static and fluid forms, and many have symbols painted in various places. It has neither narrative nor message. It is intended to be an interesting visual adventure, to be enjoyed."

Landscape is simply subject matter. Some artists who work with landscapes are experimenters, applying various techniques to landscape subjects. Others wish primarily to communicate their *feelings* about landscape; still others use the landscape as a point of departure, allowing their memories and experiences to direct the painting process. As a student of art, you may wish to approach landscape painting from all these angles, intentionally changing your emphasis from time to time. Such experimentation will give you valuable practice and will focus your thoughts and skills in a beneficial way.

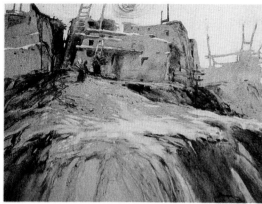

18

19

18. *Jane Burnham has developed a unique method of working, and has used it in painting* Wood Gatherers, *a 30 × 40" (76 × 102 cm) watercolor. She coated a sheet of watercolor paper with a mixture of one part acrylic gel medium and two parts water, which seals the surface when it dries. She then mixed only two colors, ultramarine blue (transparent) and brown madder (a sediment color) and covered the surface with a middle value. After rocking the sheet back and forth to cause the sediment to settle, she drew, lifted color with a damp brush and applied more color to create the powerfully designed composition.*

19. *Lee Weiss painted* Fall River Mist *(40 × 30" (102 × 76 cm) as a direct response to a remembered scene. The strong impressions of autumn color and morning mist provided a fascinating interchange of ideas, techniques and style. She flows watercolor onto a formica-topped table and "prints" her watercolor sheet from the wet surface. With this initial color impression as a start, she allows the resulting color and textures to suggest the forms, direction and development of the painting.*

LOOKING AND LEARNING: A GALLERY OF LANDSCAPE AND SEASCAPE PAINTINGS

The paintings on this page and the preceding two pages will help you understand some of the many ways that landscape subjects can be treated. All are rather representational (the subject matter closely represents nature), but each artist has seen and visually recorded in a unique and personal way. Notice how some artists use unusual techniques in their work. Perhaps you have seen some of the same kinds of environments. How would you have responded to and painted the same subjects?

ACTIVITIES

ART HISTORY

☐ Renaissance artists often used landscapes as settings for their figure paintings or historical works. Find reproductions of the following paintings in art history books:

Mona Lisa, by Leonardo da Vinci

St. Francis in Ecstacy, by Giovanni Bellini

The Alba Madonna, by Raphael

The Adoration of the Shepherds, by Giorgione

Select two of the paintings and describe what each is about. Then write a detailed description of the natural environment in each work. Discuss color, atmosphere, mood, objects, landscape elements and what the landscape does for the painting.

☐ American artists played an important role in America's westward expansion. Their work was used to show Easterners the glories of the west and to lure them westward. Look up the work of Albert Bierstadt, Thomas Moran and Frederick E. Church. Select two paintings and list the titles and artists. Then describe each work, and comment on reality, romanticism, personal expression, dramatic impact, painting style and the purpose of the painting. Compare the value of painting vast scenes or close-up, detailed views. Which would be more likely to attract attention?

CRITICISM / ANALYSIS

☐ Study the painting *Tahiti Trees* by Robert Frame, on page 173. Describe the colors used by the artist. Do you think they are real or imagined? Why did he use such colors? Do they help you *see* and *feel* the tropics? Why? Would the same colors be as effective in painting a forest scene in Montana or Georgia? Why? What colors might be more appropriate there? Why? Describe the painting and analyze the artist's use of color, value, balance, pattern and contrast.

☐ On the opposite page are two paintings by artists who have used unique techniques to paint their landscapes. Describe the paintings by Jane Burnham and Lee Weiss, and then tell how they differ and how they are alike. Read about their techniques and discuss how each artist used her technique to interpret the subject. Write a brief essay on the effective use of adapting technique to subject matter.

AESTHETICS

☐ Study the watercolor painting by Dong Kingman (*Yosemite in the Snow*) reproduced here. Describe what you see. Do you think Yosemite Valley actually looks like this? Is the artist's personal style evident? Has he been selective or has he reproduced every detail? Are his colors realistic or imaginary? Does he capture the feeling of the place? How would you describe Yosemite Valley after looking at the artist's interpretation? Would your description be similar to your description of a photograph of the valley?

Why or why not? Do you like the painting? Why?

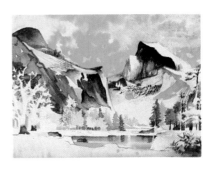

☐ Look at the work of the four artists on pages 174 and 175, and read the comments by each artist concerning the work. Which work seems to have the most appeal to you? Why? How do you respond to the artists' comments? Is it possible for landscape painters to put more into their work than trees, sky and rocks? Why do you think so? Which artist's comments seem to fit the work best? Why? Why do the comments help you understand the work better? Do you often sense such feelings when you are working on your own paintings? Not all artists are so personally involved in their landscape paintings. Can you explain why not?

PRODUCTION / STUDIO

☐ Use your camera to shoot black and white or color photographs of some natural environmental subjects, and make a display or notebook of them. Arrange your photos under three headings: 1) wide sweeping views; 2) close-up details; 3) abstraction in nature.

1. *This large oil painting by Georgia O'Keeffe almost bursts from the canvas with its vibrant colors and waving forms. She has used mainly warm colors, with a few touches of cooler grays and red-violets.* Red Canna, *ca. 1923. Oil on canvas mounted on masonite, 41½ × 35½" (104 × 91 cm). University of Arizona Museum of Art, Tucson. Gift of Oliver James.*

2. *Delicate lilies dominate this student still life with fruits, done in pastel. The colors glow against the dark background.*

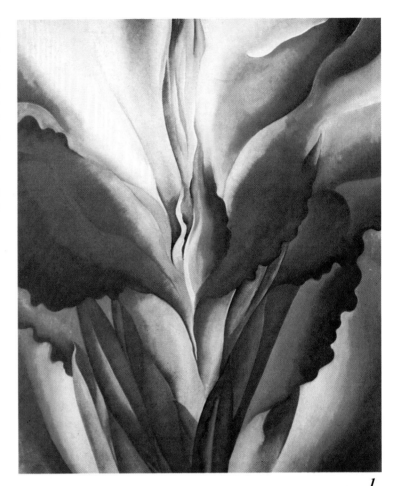

1

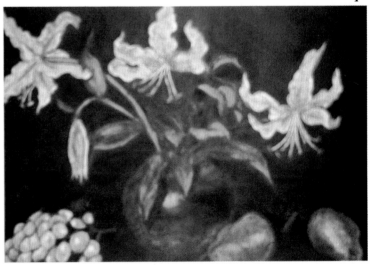

2

chapter 16

PLANTS AND FLOWERS

Plants and flowers offer a source of beauty and serenity in a fast-paced, industrialized world. Their glowing or subtle colors and fascinating shapes and patterns make them endlessly appealing as subject matter.

AN HISTORICAL LOOK

Throughout the ages and in most parts of the world, abstract floral motifs have been used in architectural detailing, in patterns on rugs and tapestries, and for decorations on manuscripts, pottery, wallcovering and fabric. Realistic portrayals of flowers and plants are found in botanical prints and watercolors, as well as in chinaware patterns.

Many nineteenth century painters recorded the beauty of plants and flowers: Claude Monet's luminescent water lily landscapes and Vincent Van Gogh's series of sunflower still lifes are compelling examples.

Henri Rousseau's exotic jungle paintings, the bright cut paper works of Henri Matisse and the gigantic close-up views of irises painted by Georgia O'Keeffe make it clear that the attraction of painters to flowers and plants has lasted well into the twentieth century.

FLOWERS AND PLANTS AS SUBJECT MATTER

Flowers and plants may be featured in a still life or a landscape, combined with people or animals or arranged in a pot or vase.

As with all subject matter, a variety of techniques and media may be used. Consider painting plant life with oil, acrylics, watercolor, tempera or pastels. Try a crayon or paint resist or perhaps a collage to express the beautiful shapes and colors.

The Impressionists painted flowers in their studios as a way of bringing nature indoors. Some artists are fascinated by the colors, shapes and textures of flowers, others by their pure design. American artist Georgia O'Keeffe began painting flowers in part because she loved their forms. She painted them very large because she thought

3

3. Enjoying the atmosphere in a greenhouse and choosing plants to draw for future reference is a good way to begin a painting.

4

4. White Cabbage, *a watercolor by Virginia Pochmann, fills the entire 22 × 28" (56 × 71 cm) surface with delicate colors and shapes. Notice the way that patterns of line and use of light lead the viewer's eye to the center of the picture.*

5. *The diagonal linear pattern of the leaves draws attention to the middle of the palm frond in this dynamic watercolor. Edith Bergstrom makes use of value contrast to define the shapes. Palm Patterns #10, a 38 × 29" (97 × 74 cm) painting is part of a continuing series by the artist.*

6. *Joseph Raffael paints a dynamic composition in tints and shades of red and green in his watercolor* Luxembourg Gardens. *He has filled the paper, even the green background, with pattern.*

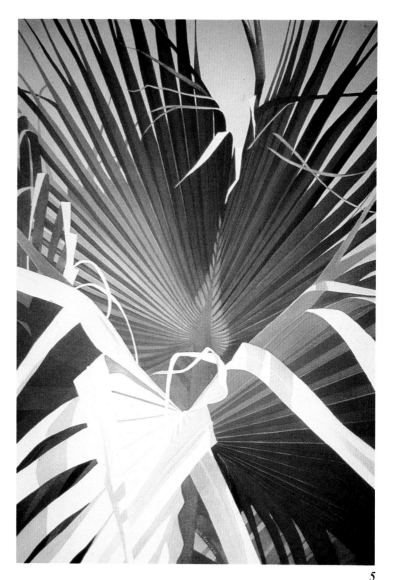

5

6

7

8

they would be noticed by people who were usually in too much of a hurry to look closely at a flower.

In the 1970's, more people became interested in growing house plants in the United States, especially in urban areas. Small gardens became important elements of visual design in architectural planning, both inside and out. At this same time, many artists, especially watercolorists, turned to flowers and plants as a central theme for their paintings. At one extreme, painters may choose to magnify one flower; at the other, they may opt to paint an entire garden.

If flowers seem too simple, common or feminine to interest you as subjects for a painting, try thinking of them as exotic shapes and glowing colors. Think of a flower as a machine, for example. How do its parts work? What does it produce? What does it need to make it "run"? Or think of a flower as a building. Could you live inside it? What legends or fairy tales have flowers in them?

ORGANIZATION AND COMPOSITION

When planning your flower and plant painting, keep in mind the elements and principles of design. Do you want to emphasize a textured or a smooth surface? Do you want to emphasize color contrast or soft muted colors of one color family? Do you want to leave some empty space or cover your surface with pattern? Will you choose formal balance or an asymmetrical composition? Will there be one main point of interest or several?

Study the student and professional paintings here and try to decide what the artist wants to emphasize in each. The student works are tempera paintings. All the students were given the same assignment: to depict plants in a window. Note the ways they have used individual judgement in organizing their paintings.

7. In Kitchen Garden, *Colleen Browning has coupled a detailed arrangement of plants with a large, empty space. Because of its brilliant, warm color, the space competes with the objects for importance. Notice the way the branches create movement and balance in this painting. 36 × 50" (91 × 128 cm). Courtesy Kennedy Galleries, New York City.*

8. The ivy branches that almost touch the other plants, the window frame, table mat and shadows tie everything together in this painting. The artist intended the viewer's eye to move from one dark area to the next, around the picture.

181

9

10

9. *Working drawings should be precise, not sketchy. Study the shapes of leaves and flowers carefully.*

10. *After a large window has been drawn on manila paper, cutout drawings of plants can be experimentally arranged, and then transferred using carbon paper.*

DEMONSTRATION/MAKING A FLORAL PAINTING

Some artists like to paint flowers and plants while sitting outside. Others prefer working in the studio, using live or artificial plants, or slides or pictures as their sources of information. The method shown here starts with a trip to a local greenhouse and follows a step-by-step process to the finished painting. Painting plants in a window sequentially begins with observation and continues with drawings of plants, small sketches of windows, planning the composition, transferring large working drawings to gray paper, and then painting the initial negative background shapes. Tempera paint was used by the students in these examples.

11

13

12

11. *By painting background (negative space) first, you will become especially sensitive to the subtle shapes of plants. For maximum value contrast, choose a pale color for the background.*

12. *After the background has been completed, the painting has a special charm, even in the unfinished state.*

13. *Use fine-tipped Oriental brushes to paint leaves in just a few strokes. If you want the leaves to look transparent, use thinner paint and have them overlap background in places.*

14

14. *After the plants are painted, you are ready to consider colors for pots and the treatment of wall and shelf.*

15. *The curved lines of the window and fern gracefully lead your eye to the plants on the shelf below. The texture on the wall was applied with a sponge.*

15

16

17

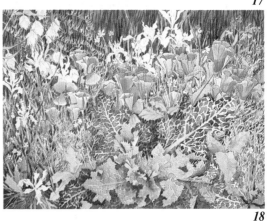

18

LOOKING AND LEARNING: A GALLERY OF FLOWER AND PLANT PAINTINGS

These artists take obvious delight in capturing in paint the colors and shapes found in the world of flowers and plants. Their finished paintings may suggest a direction you would like to pursue when planning floral paintings of your own.

16. *Joseph Raffael often adds an accent in pastel to his watercolor paintings. He feels that every part of the painting should have variations of tone and color. Notice the patterns on the leaves and in the background.* Reflection, *15 × 13″ (38 × 33 cm).*

17. *Lynn Schwartz has used the lines of the branches and petals to lead your eye to the very center of* The Camelia—A Sign of Spring. *Notice the way the colors sparkle against the dark background. Watercolor, 22 × 30″ (56 × 76 cm).*

18. *Ann T. Pierce creates innumerable textures and exquisite detail in her watercolor,* California Spring. *All shapes and lines seem to lead to the cluster of orange flowers in the center.*

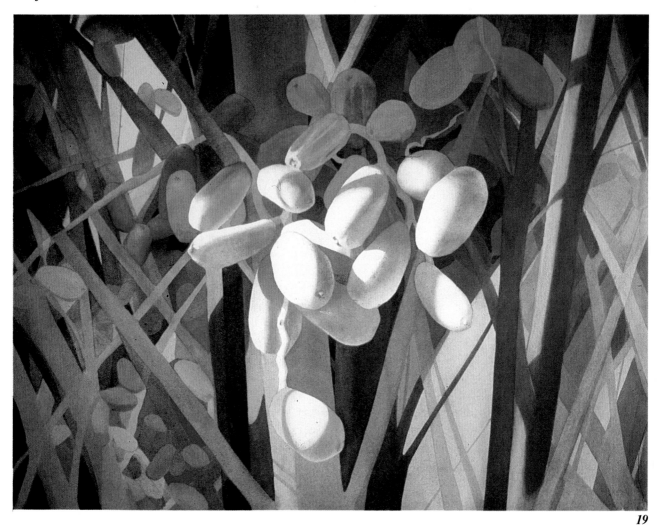

19

19. *Edith Bergstrom's masterful use of light and shadow suggests volume and creates depth in her luminous watercolor,* Dates, Palm Patterns #107. *She has selected a close-up view to capture the essence of the palm tree, 22 × 30″ (56 × 76 cm).*

ACTIVITIES

ART HISTORY

☐ Persian artists have been wonderfully adept at creating designs based on flowers and leaves. Research Persian art and make some linear pencil studies or sketches, copying some of the motifs developed by these artists. Enlarge some of them or sketch only parts of designs. Display the results of your research.

☐ Look through current or back issues of art magazines or show catalogues and note how many artists are painting flowers and plants. If possible, clip twenty pictures and arrange them on a cardboard panel or bulletin board. Identify each by title, artist, date, medium and size. Magazines such as *American Artist, Southwest Art, Art in America, The Artist,* etc. are available in art supply stores, from book stores or from artist friends.

CRITICISM / ANALYSIS

☐ Study the student painting reproduced here. Write a paper or prepare a videotape, discussing some of these ideas. How many kinds of lines can you identify? How do shapes lead your eye around in the painting? Where do you find value contrast? What contrasts are evident in the use of line? How is unity established? How do repeated lines form patterns? How is the curve of the arch-shaped windows repeated elsewhere? What mood does the painting create? What about the subject seems important to the artist? Why?

☐ Study Edith Bergstrom's painting on the opposite page. Write a short paper that describes the painting. Tell how she used line, shape, form, color, value, texture and space. Do design elements dominate the painting, or is the subject still most important? Explain why this is important in a painting.

AESTHETICS

☐ Study the three paintings on page 180. Write a brief paper describing each of the three works. Then select the one which you seem to like best. Write a paragraph, telling why you like it. What is your personal response to it?

You learn to be selective in your choices by looking and listening to your own reasons for liking certain paintings. Not everyone can like every painting equally. Why is this so? Why is this an important lesson to learn about art?

☐ Take color slides of gardens in bloom with many flowers. When you project them on a screen, show them in various degrees of focus, from tight to very loose. How can this experience help you understand about impressionistic images, the importance of color and light, and composition? Do such out-of-focus images still give you the visual sensation of flower gardens? What can artists learn from such knowledge? How can this help you as you create your own paintings?

PRODUCTION / STUDIO

☐ Draw a large floral painting on white paper (a clump of iris, for example). Fold the paper in half four times (making 16 rectangles). Paint each rectangle separately, changing color slightly in each rectangle.

☐ Take a flower photo or picture and use a small frame (viewfinder) to locate some interesting abstract images in the details. Use one of these as the basis for a large, non-objective painting.

1. *Harold Joe Waldrum used large areas of bright and dark color when he painted* A las cinco de la tarde. *His treatment of this Southwestern church makes it appear solid, powerful and pure. Acrylic on linen, 54 × 54" (137 × 137 cm). Courtesy The Peters Corporation, Santa Fe.*

2. *Antonio Canaletto used linear perspective, with all parallel lines running toward invisible vanishing points, to establish depth in his detailed* The Piazetta, Venice, Looking North *(1755). While his portrayal of the buildings is architecturally accurate down to the last detail, his placement of the figures is designed to provide eye movement and balance in the composition. The Norton Simon Foundation, Los Angeles.*

·1

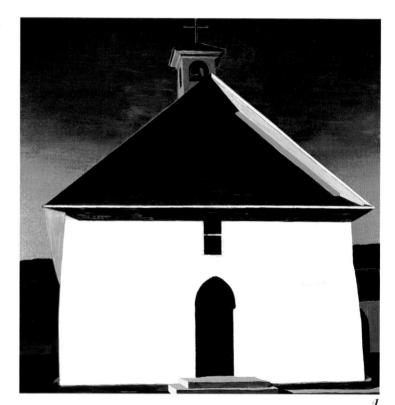

·2

188

ARCHITECTURE

Although architectural elements appear in late Gothic or early Renaissance religious paintings of the fifteenth century, it was not until Canaletto's time (in eighteenth century Venice), that architectural views were painted for their own sake. His paintings of European capital cities were prized by the wealthy of that era as travel mementos. Today they serve, as well, as faithful records of life and architecture as they existed two hundred years ago.

Architecture was not again a major painting motif until the late nineteenth century, when Claude Monet worked with the light patterns on the façade of Rouen Cathedral, and Camille Pissarro painted the flickering light of the streets of Paris. Paul Cézanne frequently used the buildings of southern France as subject matter. The early twentieth century found artists such as Fernand Leger, Lionel Feininger, Umberto Boccioni and Joseph Stella responding to the growth of cities and painting them with distinctive styles.

A group of American artists, calling themselves "The Eight" (1908–1913), painted our cities in a realistic way. Two of the eight were Robert Henri and George Bellows. Great American urban painters since then have included John Marin, Charles Sheeler, Edward Hopper and Charles Burchfield.

SELECTING A VANTAGE POINT

One of the most challenging aspects of painting architecture is to find an interesting vantage point from which to view your subject. Try looking down from a hill or up from ground level; face your subject from head-on or from an angle. Because buildings can't be picked up and moved around like pieces of fruit in a still life, it's up to you to walk around your subject until you find a good composition. Climb a tree, look through a window, sit on a rooftop to improve your perspective! Or you may need to use your imagination to see your subject from the best location. Can you determine where the artists positioned themselves while painting the pictures in this chapter?

3

3. Dale Peché has come in for a close view of Victorian architecture as he singles out one house to paint realistically in a monochromatic color scheme. Linear patterns, value contrast and repeated shapes add interest to this crisp gouache painting.

5

6

4. *Only a portion of a decorative front porch is selected as subject matter for this charming tempera painting by a student.*

5. *Light and shadow and the patterns made by rooflines seem to fascinate the student who painted this familiar American scene. Can you pick out repeated shapes and colors? Does the artist's style remind you of other professional art you've seen in this book?*

6. *While painting the architecture around you can be rewarding, try an occasional painting of the buildings of other cultures. Use photographs and drawings from history books or travel magazines as inspiration, as this student has done.*

You can approach architectural subject matter in much the same way as you would a still life setup, a figure painting or a landscape. You may decide to include a panoramic vista—a view which surveys a wide area. Or you might want to narrow your field of vision and limit the scope of your painting to nearby structures. It is possible to move in closer and focus on only one part of a building—a porch, window or corner of a house. With the use of a viewfinder, you can zoom in on an even smaller area—a piece of architectural detailing, for example—which forms a good composition. If it is inconvenient to draw your subject on location, photograph it, and use the slide or print as your source of information in the classroom or studio.

190

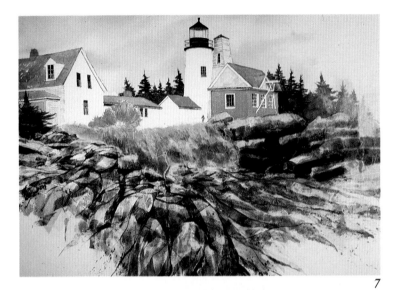

7

9

8

LOOKING FOR SUBJECT MATTER

Subject matter for architectural paintings may be found the world over, in a nearby city or town, or right in your own neighorhood. Painters respond to a wide variety of architectural forms, from magnificent churches to weathered barns, from the quaint charm of Victoria gingerbread to the harsh reality of an inner-city street.

So look around you. Think of a building you've been acquainted with for years, and try to draw it from memory. What does the roofline look like? Is the door in the center of a wall, or slightly to one side? Does the building have rainspouts? A chimney or vent? Is there wooden trim around the windows? If you have difficulty remembering the details, take a close look at that building or any other. You'll probably find that there is more than enough architectural subject matter within a mile of your home or school.

7. A rural lighthouse scene by Gerald F. Brommer makes interesting subject matter, especially when it is organized dynamically and painted in a vigorous style. Pemaquid Light is a 22 × 30" (56 × 76 cm) collage and watercolor.

8. Larry Webster has isolated one side of a farm structure for a close-up view of old textured wood and the linear patterns of weathered boards. Shed #1. Watercolor, 30 × 40" (76 × 102 cm).

9. A student tempera painting of a small section of a building showing classic architectural forms is made solid and convincing through shading. Depth is created by the darker shapes in the background.

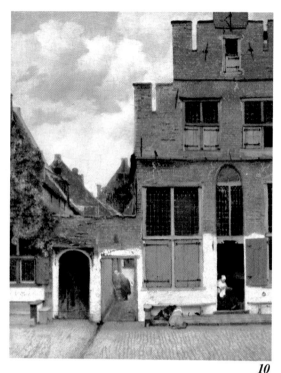

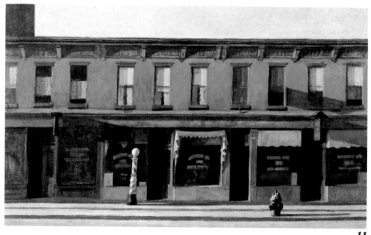

11

10

12

10. *Dutch painter Johannes Vermeer painted things just as he saw them. His painting* Little Street *(ca. 1660) shows this attention to absolute realism. He painted everyday things with precision, in realistic color and bathed in light. Oil on canvas, 21 × 17" (53 × 43 cm). Rijksmuseum, Amsterdam.*

11. *Rhythm is produced by the repeated patterns formed by windows and doors in Edward Hopper's painting,* Early Sunday Morning *(1930). Note the use of complementary colors and their mixtures. Oil on canvas, 35 × 60" (89 × 152 cm). The Whitney Museum of American Art, New York. Gift of Gertrude Vanderbilt Whitney.*

12. *Larry Webster's watercolor,* Geometric Façade, *emphasizes rectangular shapes and value contrast. He uses these elements to establish asymmetrical balance in the 30 × 40" (76 × 102 cm) watercolor painting. Notice that he has concentrated on only a fraction of the total structure.*

COMPOSITION

After you have decided on your architectural subject and isolated the area you choose to paint, other considerations about composition spring forth. Does the subject matter seem to call for stressing color, formal balance, rhythm or value contrast? Choose from among the elements and principles of design (See Chapter 3) those which are most compatible with the ideas you wish to express in each painting. The paintings here illustrate ways in which three different artists choose to portray the façade of a building. Note how they use windows in their compositions.

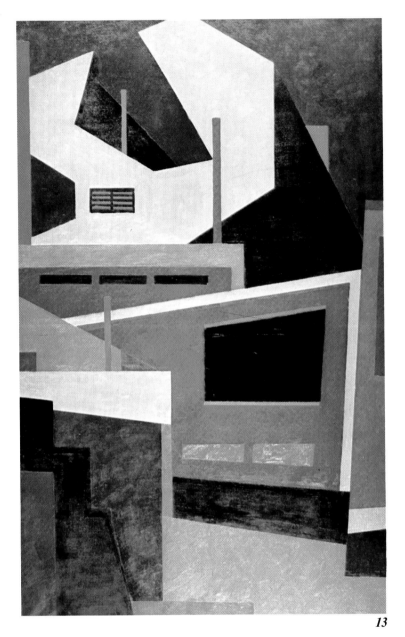

13

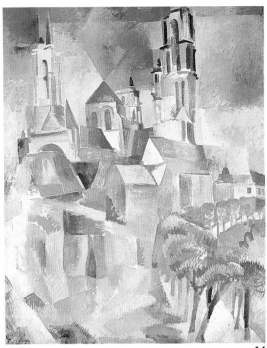

14

13. *Niles Spencer represents building forms with flattened geometric shapes in his abstract painting,* In Fairmont. *Overlapping planes and diagonal edges lead the eye around this large painting. Oil on canvas, 1951, 65½ × 41½" (164 × 104 cm). The Collection, Museum of Modern Art, New York. Edward Joseph Gallagher III. Memorial Collection.*

14. *Robert Delauney has fragmented the objects in* The Towers of Laon *(1911) into shifting planes of color, in the style of cubism. Color harmony is created through the use of hues from the blue color family. Musée National d'Art Moderne, Centre Georges Pompidou, Paris, France.*

STYLE

Between the extremes of the camera-like images of photo-realism and the geometric shapes of abstract painting lie a multitude of approaches to architectural painting. Each artist develops a personal style — a preferred way of painting buildings — after much experimentation. If you continue to work at painting architecture, you will, too.

15

15. *After making several drawings of an old Victorian house, one is chosen to be the working drawing for the painting. Transfer the drawing by covering the back with chalk and tracing over it onto gray paper. Here, a pinkish-gray of a middle value was chosen, as it will remain exposed in many areas of the finished painting. If fading is a problem, you can later match the paper color with paint and paint those exposed areas.*

16. *Lines of paper show between the spaces covered with tempera paint. At first, all the paint colors should be pale and a lighter value than the paper so that the lines will show up. Later, you may decide to repaint some areas darker to contrast with lighter colored lines. Here the artist has decided to have the source of light come from the left (note the bay window). More distant areas are painted a duller shade. Some artists may wish to call their paintings finished and mat them at this point.*

17. *More shades and tints may be added for variety. Here the negative space of sky was painted to reveal shapes of trees. The pinkish-gray in this painting appears in areas where paper is left exposed. The painting may also be considered complete at this stage.*

16

17

DEMONSTRATION/PAINTING HOUSES IN TEMPERA

One of the many ways to paint architecture is to transfer a drawing onto heavy gray construction paper and paint the spaces with pale colors, leaving gray paper showing through for the lines. This technique may be used to create a finished painting, or as the basis for a paint resist. The student works shown here will give you some idea of the wide range of treatments different artists give to a similar subject.

18

20

19

18. *After all areas are painted, and some lines of paper remain exposed, the paper can be carefully coated with a thin layer of India ink (thickened with black powdered tempera) and then gently rinsed off. The results will be similar to this illustration. Experiment on scraps of paper with resist techniques before you try them on your painting. A limited range of colors helps unify this painting.*

19. *Pastel colors were used as accents to add interest to this tempera painting. Textures in leaves of trees and bushes, which offer a soft contrast to the linear quality of the house, were applied with a sponge. Notice ways in which the artist has created movement and balance.*

20. *Here, the student transferred the working drawing onto pinkish-gray paper, defined the lines in ink and painted the negative spaces with a light bluish-gray tempera. Detail contrasts intriguingly with empty space in the finished painting. Notice the way the sidewalk shape guides your eye into the painting.*

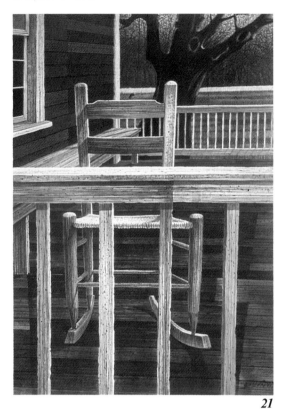

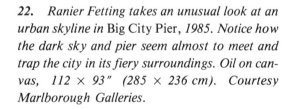

21

21. *Rectangular shapes along with both horizontal and vertical lines form repeated patterns in Rolland Golden's watercolor,* Wood Rests. *Look carefully and note the artist's use of diagonal line to create eye movement.*

22. *Ranier Fetting takes an unusual look at an urban skyline in* Big City Pier, *1985. Notice how the dark sky and pier seem almost to meet and trap the city in its fiery surroundings. Oil on canvas, 112 × 93" (285 × 236 cm). Courtesy Marlborough Galleries.*

22

LOOKING AND LEARNING:
A GALLERY OF ARCHITECTURAL PAINTINGS

These paintings by professional artists are good examples of different media (oil, acrylic, watercolor, collage and mixed media). They represent many styles and techniques, some of which you may want to try in your next architectural painting.

23

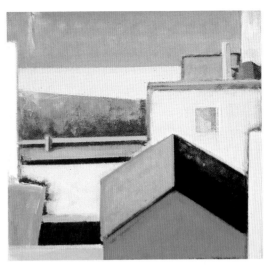

25

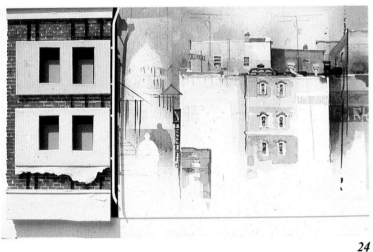

24

23. A chain link fence unifies Deborah Brouwer's large multipatterned cityscape. The diagonal lines also add contrast to the predominantly rectangular shapes of the subject matter in the background. Oil on canvas, 66 × 84" (168 × 214 cm).

24. Many materials and techniques are used by Guenther M. Riess in his unique approach to painting architecture. In D.C. Series '83, *the building on the left is a three-dimensional construction which looms forward, while the delicate painting to the right fades into the background.*

Can you see how the artist uses size and color to balance and unify this painting? Watercolor, acrylic and ragboard construction, 26 × 36" (66 × 91 cm).

25. David Rich has flattened space in his oil painting, Rooftop, *by depicting buildings and landscape as a set of simple geometric shapes. He alternates cool colors with warm ones, and horizontal lines with vertical ones, in the 34 × 36" (86 × 91 cm) work on canvas. Collection Piper, Jaffrey and Hopwood. Courtesy Dolly Fiterman Gallery, Minneapolis.*

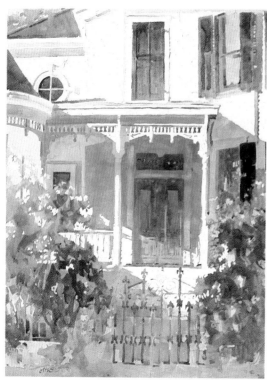

26

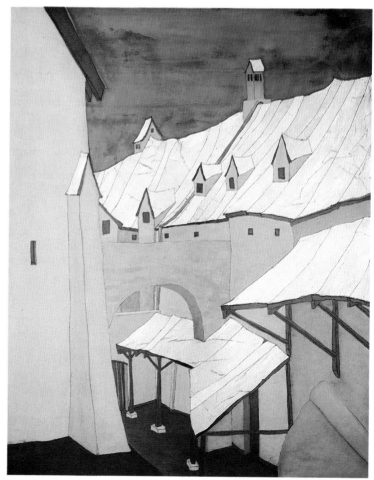

27

26. *Judi Betts painted a sunlit façade in her watercolor* Southern Sunday. *By leaving white paper showing and by using complementary colors, she created brightness and sparkle in her 30 × 22″ (76 × 56 cm) work.*

27. *The repeated pattern of striped rooftops and small windows unifies* Old Courtyard, *a mixed media work on panel by Skynear. Can you see how the dark red sky makes the light-colored buildings seem to come forward in space? 1985, 60 × 48″ (152 × 122 cm). From The Anderson Collection. Photograph courtesy Elaine Horwitch Galleries.*

ACTIVITIES

ART HISTORY

☐ Study the architectural paintings of these four artists, reproduced in this chapter: Edward Hopper (page 192), Johannes Vermeer (page 192), Niles Spencer (page 193) and Robert Cottingham (this page). Write a short paper explaining how the architectural paintings of each artist reflected the historical, social and cultural times in which each lived.

☐ Write a brief essay on one of the following topics, either defending the idea or refuting (disagreeing with) it:

- Realism is essential in a successful architectural painting.
- Canaletto: The artist as souvenir maker.
- John Marin and Robert Cottingham: Painters of architectural extremes.

CRITICISM / ANALYSIS

☐ Study the painting by Robert Cottingham (*J. C.* Acrylic on canvas, 21 × 23″; 53 × 58 cm.) How is line used in the painting? How are light and shadow used to show depth and three-dimensionality? Discuss Cottingham's use of contrast. What style of painting is this?

Make a small, simplified drawing that shows only the major shapes. How has the artist kept the work visually interesting? Discuss the use of essential details in such a painting.

☐ Analyze the painting by Canaletto, shown on page 188. Discuss his effective use of linear perspective to show space, and his accurate depiction of details. Are these elements essential to all architectural painting? Why or why not? Make a diagram of Canaletto's linear perspective by tracing the image in pencil and drawing ink lines to the vanishing points.

AESTHETICS

☐ Architectural painting can take many directions. Look at the work of three artists (Canaletto, page 188; Judi Betts, page 198; and Guenther Riess, page 197). Write a paragraph about each of their three paintings. Describe what is shown in each work, and explain why you think the artists worked in this style. Which do you like best? Why?

☐ Discuss the mood established by Robert Cottingham in his painting, *J. C.* Describe how it makes you feel. What do you think he is trying to show us in the work? Do you think he used photographic images to help him? Why? What is the purpose of such a painting style? Has the artist succeeded? Why? Why can such work be called *photorealism?*

☐ Compare and contrast the paintings of Robert Delauney (*Towers of Laon,* page 193) and Edward Hopper (*Early Sunday Morning,* page 192). Why did each artist paint architecture the way he did? Describe each work. What does each artist make you feel about buildings? Which painting makes you enjoy architecture more? Which do you enjoy looking at? Why?

PRODUCTION / STUDIO

☐ Draw several architectural details (moulding, door, light fixture, door knob, bannister, window, etc.) in line, and allow them to overlap to form abstracted shapes. Paint the resulting *shapes* with tempera in a limited color scheme.

☐ Add three-dimensional elements to an architectural painting. Glue cardboard, balsa wood, wood scraps, sandpaper, glass or wire to the ground. Use acrylic gesso to paint the surface white. Leave it white or use other painting techniques to finish the work.

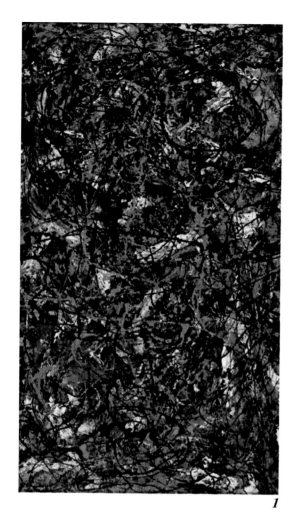

1. *Jackson Pollock helped lead American artists into the* Abstract Expressionist *movement. He dripped and poured liquid oil paint to make* Full Fathom Five, *1947, 51 × 30″ (130 × 77 cm). Oil on canvas with nails, tacks, buttons, key, coins, cigarettes, matches, etc. Collection, The Museum of Modern Art, New York. Gift of Peggy Guggerheim.*

2. *Robert Frame painted* Matrix II, *a 67 × 70″ (170 × 178 cm) oil, using indistinct edges and high keyed colors. Brushstrokes an important quality of the surface.*

3. *Barbara Engle assembled various papers on a 13″ (33 cm) square panel to create this collage. The soft-edged rice papers vary in color, size, texture and shape, yet present a unified surface.* In Front of Behind *is in the collection of the Honolulu Academy of Arts, Hawaii.*

200

chapter 18 NONOBJECTIVE ART

In the second half of the nineteenth century, some painters began to move away from showing their subject matter realistically. They began to *abstract* their still lifes, landscapes and portraits, treating them with geometric precision, brilliant (often unnatural) colors, fractured planes and distorted features.

In the early twentieth century, several artists carried this trend a step further, and began making paintings that were *nonobjective*—not showing any recognizable objects at all. Their work featured colors, shapes, movement, excitement, design, action—not trees, flowers and people. These artists combined the elements and principles of art with personal feelings, and discarded traditional subjects.

Wassily Kandinsky painted explosions of color; Piet Mondrian carefully designed the lines and spaces on his canvases; Willem de Kooning covered huge surfaces with juicy brushstrokes. Jackson Pollock dripped and spilled liquid color from cans onto his surfaces; Mark Rothko formed soft shapes that floated over his picture plane; and Lee Krasner created richly textured surfaces with collage.

Artists such as Joseph Albers, Kenneth Noland and Ellsworth Kelly used hard edges and geometric shapes in their works, while others—Sam Francis, Helen Frankenthaler and Morris Louis, for example—found organic shapes most expressive. Some artists painted with great gusto (Hans Hofmann, Franz Kline and Adolph Gottlieb), while others precisely controlled their surfaces (Barnett Newman, Frank Stella and Gene Davis).

Some examples are shown on these pages. Examine some art history books or other art references to see how some of these artists developed their nonobjective styles.

4

4. *Wassily Kandinsky was the first artist to avoid recognizable subject matter in his work.* Open Green, *1923, is a nonobjective painting in which color, lines, shapes and movement are the actual subject. Norton Simon Foundation, Los Angeles.*

5. *The student who painted this nonobjective work emphasized rhythm and movement. The colorful painting was made with oil sticks blended with turpentine.*

6. *Cut an opening in a sheet of heavy paper. Look through the opening as you sit at your desk, or as you walk around your home. What shapes do you see? Might any of these make an interesting nonobjective painting? Try to look at* shapes *rather than at objects.*

7. *Active brushstrokes and strong colors give* Scudera, *by Franz Kline, great power. Oil on canvas, 1961. 108 × 78″ (274 × 198 cm).*

LOOKING FOR NONOBJECTIVE DESIGN

We are surrounded by nonobjective images, if we teach ourselves to see them. Take a sheet of heavy construction or drawing paper and cut a 3 × 5″ (8 × 12 cm) opening in it. Walk around your school or home with this viewfinder or mat, and lay it down on various surfaces. What interesting nonobjective images do you see? Look in unexpected places: cracks in sidewalks, patterns of leaves, on walls, doors, corners, old bricks, accidental spills, fabrics and so on. Sketch some of these images, and study them for possible painting subjects.

Use a very small viewfinder, ½ × 1″ (1 × 2 cm), and lay it down on parts of magazine photographs to find still more nonobjective designs.

8

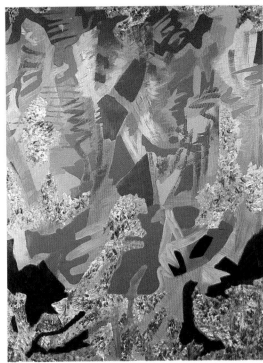

9

You may also take pictures of nonobjective images. The more you become aware of such visual images, the easier it will be for you to see design and possible subject matter for paintings all around you.

USING ORGANIC SHAPES

Abstract Expressionism burst on the American art scene following World War II. It emphasized freedom of expression and got its name because it was *abstract* (nonobjective, actually) and *expressive* (stressing individual feelings rather than design or formal arrangements). It was a short-lived movement (about fifteen years) but it revolutionized the world of art. With emphasis on organic shapes and movement, it was also called *Action Painting,* and has influenced artists to the present day. Willem de Kooning, Hans Hofmann, Robert Motherwell, Jackson Pollock, Mark Rothko, Lee Krasner and Franz Kline were among the first generation of these expressive artists.

Nonobjective painting styles that emphasize organic shapes, emotional feeling and *painterly* quality (meaning that brushstrokes are evident and important) are related to Abstract Expressionism. There are no recognizable subjects in the paintings on these pages, yet they are exciting because of their color, design, technique and quality.

Often, when starting to work with a new medium, it is a good idea to explore its possible uses by working nonobjectively. You can concentrate on the handling and quality of the paint itself instead of trying to paint trees, boats and people successfully.

Perhaps the swinging of your arms and the joy of responding to inner rhythms will help you fill a painting with color and movement. Listen to music and allow the rhythms and sound to set your hand in motion. What kinds of paintings might you make in response to marching band music? Or to rock, lyrical, Western or classical music? Instead of bringing recognizable images to mind, concentrate on painting the color and movement that you feel.

Some paintings using organic shapes are more controlled than others: they may have harder edges and not be so painterly. If that painting style attracts you, experiment with it. Respond to the colors you use and compositions you create, letting the work develop according to your feelings.

Working with paint rollers on large sheets of paper can provide the sensation of action and movement better than brushes. Try working on the floor. Attach a stick to a brush or roller to make the handle very long, or hold the brush with both hands as you paint. Explore. Try to think of uncommon ways to use paint or color in nonobjective works.

8. *Nonobjective painting using organic shapes need not always be soft-edged and painterly. Perry Owen used organic shapes, but kept their edges crisp and the colors flat.* Huntington Rocks, *acrylic and ink on illustration board, 30 × 40" (76 × 102 cm).*

9. *Esther Schooler has been influenced by extensive work with collage.* Untitled #1 *shows this influence—many colors are hard-edged and clear, and look as if they have been pasted over one another. Oil on paper, 1986. 38 × 50" (97 × 127 cm). Collection, Edward J. Sichta.*

10

10. *Frank Stella painted geometric shapes and hard edges for many years.* Protractor Variation *(1969) is painted in oil on a shaped canvas 120 × 240" (305 × 610 cm) in size. The colors do not touch, but are separated by a thin space of unpainted canvas, which reads like a thin white line. Los Angeles County Museum of Art.*

11. *Frederick Hammersley's hard-edge paintings are often designed to fit square formats.* Figure of Speech *has precise edges, limited color, flat geometric shapes and a simple but effective design—as does much of this artist's work. Oil on canvas, 40 × 40" (102 × 102 cm).*

11

12

13

14

USING GEOMETRIC SHAPES/HARD EDGES

Not all nonobjective painting is full of emotion, visible brushstrokes and excited movement. Some artists reacted to Abstract Expressionism by painting hard-edge designs in which no brushstrokes can be seen at all. Because they painted large, flat areas of color with distinct edges, their work has been called *Color Field Painting*. It has also been called Classical Abstraction, Hard-Edge Painting and Post-Painterly Abstraction, and has been nicknamed Cool Art because of its lack of emotion. Joseph Albers, Barnett Newman, Kenneth Noland, Ellsworth Kelly, Frank Stella and Gene Davis were among the many artists who painted flat shapes and lines, smooth surfaces and carefully constructed designs without emotional content.

This hard-edge work usually contains precisely painted shapes with no soft edges. The design principles of balance, pattern and unity are stressed. The resulting work is far more precise than Abstract Expressionism, but the content remains nonobjective.

Rulers can be used in planning and making the final drawings, because precision is one of the goals. Edges must be painted carefully. Drafting tape, stencils or other methods of control can be used if necessary to paint crisp edges.

Color should be flat and must be applied with soft brushes or sprays, so brushstrokes will not be evident. Making a collage of flat colors is a good way to begin working with color field methods.

Make precise sketches before you start to paint, so you get a good idea of how the finished design might look. Not all hard-edge paintings need be geometric in character, but flat color and crisp edges are essential.

12. *This small color plan was made by a student as preparation for making a hard-edge painting. Colored paper was cut, positioned and pasted to provide a comprehensive idea for the final work. Emphasis was placed on design principles such as balance, movement, emphasis, contrast and pattern as the sketches were made. The final painting was as close to this plan as possible in color and arrangements of shapes.*

13 and 14. *Look carefully at these two hard-edge paintings made by student artists. Can you figure out how each one was made?*

Some hard-edge paintings have overall patterns of repeated geometric shapes and colors. Do these two paintings fit that description? How would you describe them to other students in terms of colors, shapes, values, emphasis, variety, unity and balance? Compare the student works in this chapter. How are some of them alike? How are some of them different? Can you find characteristics they all have in common?

16

15

USING PATTERN AS SUBJECT

15. *Judy Chicago used stencils to create the patterns in her airbrushed painting,* Through the Flower, *a 60 × 60" (152 × 152 cm) acrylic work on canvas. The stencils produced the hard edges of the shapes, while the airbrush technique created the soft color transitions within each shape. The pattern is regular and the design is formal.*

16. *Sandra Beebe's watercolor,* Rock Pool *(22 × 30"−56 × 76 cm) is derived from natural subject matter, and is treated with random and irregular pattern. If you place a small mat over various sections of the painting, many nonobjective patterns can be seen. If you use pattern to abstract natural subjects, your paintings may include many nonobjective areas.*

The key to understanding pattern is *repetition*. When lines, shapes or colors are repeated with a degree of regularity, pattern is created. Look around you. Both regular and irregular pattern occur in ceiling tiles, windows, fabrics, sidewalks, trees. Designers use pattern to unify surfaces and to provide visual enrichment. It is this second use which is most important to painters.

Some nonobjective painters have made extensive use of pattern in their work. They use line or shape to create patterns of various types, and often the pattern itself can be considered the subject of the work.

A variety of nonobjective paintings which emphasize pattern can be seen on these pages. Some of the other paintings in this chapter also make use of pattern, since many hard-edge and optical artists use it to design their picture spaces.

When you make nonobjective paintings using pattern, remember that your pattern can be regular or irregular, planned or random, formal or informal. Look at pattern around you to get ideas for your paintings. Use a small viewfinder or mat to find patterns in your immediate environment. You can also use such a viewfinder to find nonobjective patterns in your own paintings, and enlarge them to make a new painting.

Study, select and sketch some ideas before you start working. Select colors to emphasize the patterns so they will remain the most important part of your work, and become the subject matter of a nonobjective painting.

17

18

17. *Many kinds of pattern are combined in this student's tempera painting. Notice the care taken to keep edges crisp and colors as pure as possible. When designs are as complex as this, several sketches must be made to plan the arrangement of the various parts.*

18. *This nonobjective painting by a student is made of several types of pattern — large irregular shapes and small dots. A tempera paint and water mixture was first dropped on a piece of waterproof black mat board, which was tilted to make the color run and drip. When dry, bands were drawn across the board, and the resulting shapes were filled with tempera dots. A limited palette of close values of complementary colors creates the vibrant effect.*

19

20

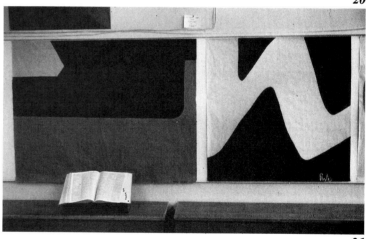

21

19. *Look through magazines and cut out some large letters or words. Using a razor blade or scissors, cut exciting shapes from these letters, and mount them on a piece of cardboard. Select several of the best shapes and make small designs (about 4 × 6″ — 10 × 15 cm) in either squares or rectangles. Use two colors of your choice and make the designs in tempera or from cut paper.*

20. *Select one of these designs and enlarge it proportionately (use ruled squares to help make it accurate) onto a piece of kraft paper, corrugated cardboard or butcher paper. Make the painting very large (4 × 6′, 1.3 × 2 m). Use latex house paint or thinned acrylic colors or tempera paint and a soft varnish brush to finish the work.*

21. *The final works, shown in the school library, provide a look at the finished sizes in relation to a large dictionary.*

DEMONSTRATION/
LOOKING FOR NONOBJECTIVE SUBJECTS

This demonstration project was designed to help students become aware of nonobjective design in unlikely places. You may wish to follow similar steps to make large color field paintings. The demonstration pictures are not all of the same painting in progress, however.

22 *23*

24

OP ART PROJECTS

In the 1960's, several artists used optical sensations to make art that created visual illusions. Some of their painted surfaces seemed to bend and bulge while others swayed, vibrated and squiggled. Hard edges, precise craftsmanship and close color values often resulted in peculiar optical images which were nicknamed "Op Art."

Bridget Riley led the movement in England, while Victor Vasarely and Richard Anuskiewicz were the foremost American Op artists. Their dynamic images still fool our eyes.

Optical art relies on complete abstraction (nonobjectivity) to tease our eyes. Look at some examples and then make up your own designs. Several general ideas will help in your efforts. Gradually making some lines closer together than others will produce different visual sensations. Changes in size and space will create a variety of effects. Complementary colors of the same values will provide the maximum visual effect. Experiment a bit in several directions.

Use rulers and compasses to get the best results. Measure carefully to insure accuracy, an important part of Op Art images. Making designs with wavy or curved lines can be easier if you cut templates or patterns to make sure that the lines will be accurately duplicated. Pencil in the lines carefully and then begin the painting. Use pointed watercolor brushes and tempera paint for best results.

22 and 23. *The students who made these paintings used several Op Art techniques to make their surfaces seem active. Experiment with templates of curved or wavy lines, moving them up or down in regular intervals to develop interesting shapes and create undulating (rolling up and down) surfaces. Make pencil samples to determine the kinds of images possible, before attempting a finished painting.*

24. *One of Victor Vasarely's early Op Art designs is called* Supernovae *and makes use of several different visual arrangements. Notice how sizes or shapes of several elements are gradually changed to create the desired effects. The 1961 oil on canvas is 95 × 60″ (242 × 152 cm). The Tate Gallery, London.*

25

25. *Sylvia Glass combines airbrush painting and brushwork to make her acrylic paintings on paper. Her unique approach produces paintings that are rich in texture and subtle in color. The sensitive treatment of texture in* Silver Cloth *suggests an ancient, cloth-like object, although it is not strictly realistic.*

27

26

LOOKING AND LEARNING:
A GALLERY OF NONOBJECTIVE PAINTINGS

When you look at these paintings, do not try to determine what they look like. Remember that, like the other nonobjective art in this chapter, they are what they are. They are not meant to look like buildings, people or plants. They are colors, lines and shapes arranged on paper and canvas.

Look at each painting carefully. Does it stir any particular feelings in you—sadness, calm, delight, agitation? What is the dominant mood of each painting? How can you tell? Does the artist's choice of colors affect the work's mood? Also consider where you see movement and action, where the painting seems to be leading your eye or your thoughts. Do any of these paintings express an unspoken idea you've had?

26. Nanci Closson painted Green River *(64 × 50" — 162 × 128 cm) with thinned acrylic paints, poured from jars onto a large, stretched canvas that had been sponged with water. The canvas was tipped to allow color to spread and flow, staining the unprimed surface. When the canvas was dry, paint was added with brushes and fine lines were drawn with thinned paint and a pen. Careful control of the technique is essential to produce the clean colors and the variety of edges seen in this work.*

27. Glenn Bradshaw applies casein paint to rice paper so the color soaks through the sheet. He actually paints both sides of the paper, developing the surface with brushes, sponges, cardboard and paper towels, and allowing each layer to dry before more color is applied. Diluted colors are sometimes dropped into wet paint. The wet rice paper is fragile and must be turned constantly when drying or it will stick to any surface. Only by working in this way can the artist develop the rich color areas and complex relationships he seeks. Birdsong Remembered *is 25 × 39" (64 × 99 cm) in size.*

28. *Perry Owen used curved horizontal lines and straight vertical lines to establish initial basic rhythms. He filled in the resulting spaces with chunks of tissue paper, brushed areas and shorter lines. The overall effect suggests an imaginary construction project, which is perhaps why it was called* Blue Structures. *The large work is 48 × 60″ (122 × 152 cm).*

ACTIVITIES

ART HISTORY

☐ Several styles of twentieth century painting are based on nonobjective concepts. Do some research in art history books (or books on modern or contemporary art). From that research, write a one-paragraph history of four of the following styles: De Stijl; Abstract Expressionism; Minimalism; Color Field Painting; Classical Abstractionism; Enlarged Field Painting. List several artists who worked in these styles.

☐ Russian artist Wassily Kandinsky was the first painter to work with nonobjective subjects (although he began as a subjective, figurative artist). Research his life and work, and prepare a written report or videotape (perhaps an imaginary interview) that explores the reasons for his switching to nonobjective imagery.

CRITICISM / ANALYSIS

☐ Study the work of the three artists on page 200 (Jackson Pollock, Robert Frame and Barbara Engle). Are there any similarities in the way they used the elements and principles of design? What are they? Describe as many similarities as you can. What are the greatest differences you notice? Do you like one painting more than the other two? Why?

☐ Describe what you see when you look at the work of Sylvia Glass, Nanci Closson and Glenn Bradshaw (pages 210 and 211). Make up five questions concerning each artist's use of art elements and principles. Then write answers to your own questions.

AESTHETICS

☐ Study the painting by Sybil Moschetti (*Filament Flux,* a 30 × 45″ (76 × 114 cm) mixed watermedia work) reproduced here. A complex process was used to create the surface textures, lines, colors and values. How does the painting make you feel? Do you enjoy the way you react to it? Why? Imagine the artist at work on this painting — and write a description for a news article. (Or write a poem about the artist at work). If you had to select one word that would describe this painting, what would it be?

☐ Compare and contrast the work of one of the following pairs of artists, based on their paintings reproduced in this chapter:

- Frederick Hammersley and Frank Stella
- Perry Owen and Franz Kline
- Victor Vasarely and Judy Chicago
- Jackson Pollock and Wassily Kandinsky

Write several paragraphs explaining your comparisons.

PRODUCTION / STUDIO

☐ Nonobjective painting styles are personal and unique, and you can explore the sensation of working in some of them by painting in similar ways. Select four artists from the following list, and make a small painting study (no larger than 8 × 10″; 20 × 25 cm) in the style of Franz Kline, Frank Stella, Frederick Hammersley, Jackson Pollock, Wassily Kandinsky, Piet Mondrian, Mark Rothko, Sam Francis, Judy Chicago, Robert Motherwell, Richard Diebenkorn or other nonobjective artists.

☐ Use a small mat (viewfinder) to locate nonobjective subjects in your artroom or on the school grounds. Make several sketches of one of them and follow up with a large, acrylic painting.

☐ Make a painting to music, allowing the melody, movement and rhythm of the music to suggest painting strokes, textures, rhythms, movement and colors. Use tempera, watercolor or acrylic for your painting, and react freely to the musical suggestions.

1

2

3

1. This quick watercolor sketch was made by a student who had drawn horses many times before. She first laid down a light wash to establish general shapes and attitude; then followed with darker brush lines to capture specific edges and contours. Such sureness comes from much practice and keen observation.

2. Besides the obviously unusual use of color, what makes this painting abstract? Is there anything realistic about it? Can you identify all its elements? *Franz Marc,* Yellow Cow, *1911. Oil on canvas, 55⅜ × 74½" (141 × 189 cm). Solomon R. Guggenheim Museum, New York. Photo: Carmela Guadagno.*

3. *Sue Wise painted* Monumental Mother *by using a combination of mixed watermedia and carbon pencil. She prepared a textured sheet by painting, splattering and flowing acrylic paint on watercolor paper. She sprinkled dry pigment into the wet colors and rinsed, scraped and splattered the surface. When the surface was dry, she transferred to it the detailed drawing of sow and piglets and worked on them with acrylics and carbon pencil, but let the original textures dominate. Some transparent watercolor washes were put over the sow to unify colors. The background was painted over with a deep, red-black acrylic mixture to isolate the positive shapes and provide a sculptural quality.*

chapter 19 OTHER SUBJECT MATTER

4

5

The previous six chapters have shown you examples of some ways to paint still lifes, people, landscapes, flowers, buildings and several kinds of nonobjective art. There are many other kinds of subjects to paint, and by exercising your imagination you can make a long list of possible subjects.

ANIMALS

Artists have painted animals from ancient times to the present. Painted Greek vases show the importance of horses to that ancient culture. Dogs, cats and birds have been painted in almost every country in every time. Renaissance and Baroque artists in Northern Europe drew and painted animals in private zoos. Nineteenth century Romantic artists were intrigued with animals from exotic lands: lions, leopards, tigers, elephants and the like. During the westward expansion of America, artists such as Frederic Remington and Charles Russell helped us visualize the plains filled with cattle, buffalo and horses. Outdoorsmen such as Winslow Homer shared their love of animals with us. And today, wildlife artists treat birds, animals and fish with extreme realism.

4. *Linda Stevens used watercolor to portray the colorful Koi in this pond. We look directly down on the backs of the swimming fish, which are set against the black bottom of the pool. Rippling water distorts the fish shapes, shattering their brilliant colors.* Water Fish #18 *is 30 × 42″ (76 × 107 cm) in size.*

5. *The student who made this portrait of a mountain goat decided to use tissue paper collage as a medium. After outlining the basic shapes, she glued several colors and values of brownish tissue paper to a sheet of illustration board with clear lacquer. Overlapping papers created many value and color changes.*

6. A unique view of an ostrich mother (Myrtle) *was painted in acrylics by a student. Handling this subject in such an unusual way makes the simple painting extremely interesting.*

If you wish to learn to paint animals in any medium and any style, you should spend time looking at them and making many sketches. The more easily you can draw animals, the less trouble you will have painting them. Draw animals in several ways to become familiar with their shapes, gestures, attitudes and textures. Make contour drawings, gesture drawings, flat drawings in both positive and negative shapes. Use a variety of media and work both generally and in detail. Use your own or a friend's pet as a subject, or go to a natural history museum or zoo to find examples to draw. Study photographs, drawings and paintings. When you feel you are familiar with certain kinds of animals, you can begin to paint.

Consider painting animals as portraits: the entire animal or its face set against a neutral or flat background. You may also place animals (alone or in a group) in a natural setting, where they seem comfortable.

Study the paintings on these four pages. Some of the animals are painted realistically and some reflect the artist's own, less realistic styles. Notice how these artists use animals to create moods or embellish a scene.

USING YOUR IMAGINATION

When you paint, you use your imagination and personal insights, perhaps more than you realize. Even when working from still lifes or figures, you add colors, objects or moods to your paintings that another painter might not add. Often, these are not in the original subject at all, but are part of your response to the subject, or are recalled from your memory.

Your imagination is a precious thing, and is one of the great motivators in art. Two simple words can stir your imagination into action. They are "What if . . .?" You can create images in response to questions such as "What if the earth were square? What if I were painting at the bottom of the ocean? What if all rocks were light enough to float? What if the only colors available were cool? What if I were an ant . . . or an eagle? What if all steel turned to soft rubber?" Can you see what kinds of painting images might result in answer to each "What if . . ." question? Try making up a list of such questions, and give yourself a chance to envision a painting in response to each of them.

Even when working with traditional subject matter you can often change the entire concept of your painting by asking a few "What if . . ." questions. "What if the still life collapsed? Or turned purple? or were covered with snow? What if the landscape were all gray? What if the figures were in a jungle? Or sitting alone on top of the world?" Strange but exciting images can result from such thinking.

If you feel that a painting is flat and uninteresting, you can inject some new ideas by asking yourself such questions as, "What

9

7

8

7. *Rolland Golden's watercolor painting,* Fall Fragments, *explores interesting questions such as "What if the world were mostly asphalt? How can a familiar subject be made more exciting? How can perspective be distorted to add visual excitement?"*

8. *Bird-like and mouse-like creatures attend an odd birthday party in this student's colored pencil work. What might the artist have been thinking of as she worked? Does the picture tell a story?*

9. *Lee Weiss did not have to imagine this scene, but she did use her imagination to choose a way to show her impression of a space shuttle launch. She was commissioned by NASA to watch the launch and paint her sensations.* After Image *is a 36 × 46" (91 × 117 cm) watercolor. You might paint in response to such questions as, "What if I were at a rocket launch? What if I were an astronaut? Or what if the world seemed to be exploding?"*

10

11

10. *The student who painted the acrylic painting* The Keyboard *looked carefully at the surfaces of pearls, ivory keys and wood and noticed the reflections, highlights and shadows. Notice the crisp edges and the way colors are reflected in the beads.*

11. *This painting by Alex Guthrie,* Genuine '47, *takes a "close-up" approach to its subject. The artist has responded to color, texture and shape, and especially to light and shadow. Bent metal, chipped paint and light-reflective surfaces are treated with great care, because the artist diligently sketches and photographs in preparation for each painting. The painting is a transparent watercolor.*

if I moved the tree to the left? What if the horizon were darker in the picture plane? What if the shadows were darker, or the highlights brighter? What if I added flowers in the foreground? Or put the distant mountains and trees in a fog?"

Not all of the paintings on these pages are obviously the result of "What if . . ." questions, but they might encourage you to ask a few questions about your own work, as you improve your own interpretive painting skills.

MACHINERY AND HARD SURFACES

If you look around you, you will notice that many objects have hard, reflective surfaces. Desks, bottles, bicycles, piano keys, sinks and the like are made of metal, glass, porcelain or plastic and their surfaces reflect light in particular ways. Look for highlights, reflected colors and images, and reflected light and shadows.

Weathered metal surfaces are quite different from new, shiny metal. Look carefully at different kinds of metal surfaces and try to figure out how you might paint them in various media. This will cause you to look at the surfaces with new interest—you are no longer trying simply to paint flat shapes. Look *into* the reflections to see what is there.

Artists often photograph metal, plastic and glass objects to "freeze" the reflections. Natural light is constantly changing as the sun moves across the sky, so the reflections, highlights and shadows also change constantly. Photographs enable you to see how objects and their surfaces look at a certain moment in time.

It can be exciting to look at metal objects at close range and paint details rather than the whole. Look at the design, the shapes and forms, the color, texture, light and reflections of cars, tools, building materials. These become the subject, rather than the automobile

12

13

or motorcycle from which they were taken, and can also become the basis of dynamic abstract or nonobjective paintings.

In other parts of the book, you can find the work of artists who work with hard, reflective surfaces. Their work might be called *superrealism* because of its exactness and detail.

FANTASIES

Fantasy art, with its roots in Greek mythology and medieval monsters, goes beyond using imagination in painting, and at times makes visible the subconscious thinking of the artist. Marc Chagall, Giorgio de Chirico, Paul Klee and Max Ernst painted fantastic works, as did Salvador Dali, Joan Miro and René Magritte. Their works often place realistic or surrealistic objects or people in weird environments or unreal combinations. Although this is an extremely personal approach to art, these artists sometimes grouped themselves together, calling themselves Dadaists or Surrealists, for example.

You can explore fantasy themes by studying the work of these artists, and updating their themes to fit your circumstances. What are some of your most outlandish thoughts? What objects or places hold mystical significance for you? Fantasy art is usually very detailed and superbly finished, and often includes personal symbolism.

12. A student used watercolor to paint his own monster with dozens of squiggly, armlike extensions. The painting is actually a portrait of a fantasy creature.

13. This surrealistic interpretation by a student is titled An American Dream *and includes many symbols of American culture. The large (49 × 24" – 122 × 61 cm) acrylic painting features a huge flag with stripes turning into cross-country highways. Would you call this a still life?*

219

14

14. *A mola-like design painted on black construction paper. After studying mola designs from Central America, the student outlined animal shapes. These were patterned and painted with tempera paints, allowing the background color to show around each applied mark. Then simple background patterns were added and repeated in typical mola colors. The student tried to balance the amount of painted and unpainted surface to create the stylized mola effect.*

15. *Most of the positive shapes in this watercolor still life were left unpainted, and the negative space was treated with detailed patterns. After drawing a basic still life, vary your approaches to it: Paint only existing warm hues; only cool hues; only positive shapes; only negative shapes; and so on.*

15

EXPLORING IN OTHER DIRECTIONS

Experimenting with a variety of techniques, media combinations and styles can provide you with innumerable ways to approach painting. The student works shown here may help you think in new directions.

Every time you try a new approach, you expand your painting ability and your understanding of the various painting processes.

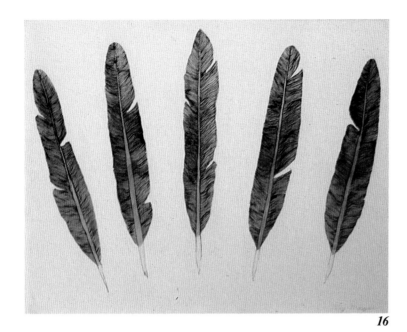

16

17

18

LOOKING AND LEARNING:
A GALLERY OF THOUGHT-PROVOKING IDEAS

What else is there to do in painting? What other concepts, ideas and techniques are there? Where can you go from here? These are logical questions, because you have seen hundreds of ideas in this book. But artists are always probing; always looking for new ways to communicate their ideas.

Look at these examples carefully to see what each artist did to expand normal painting concepts. Then imagine what you might do with some of these ideas. What new kinds of imagery can you create? How can these ideas help you expand your own frame of reference?

Where can you go from here? As far as you wish! You can explore many ideas and concepts, and continue to do so, or you can work in a few familiar ways to become expert at them. That is only one of many choices you will make as a student of painting — and as an artist.

16. *The feathers in this student painting were first drawn as shapes on a piece of white illustration board. Water was puddled within the shapes. While wet, watercolor paint was added and allowed to settle and dry. When all was dry, India ink was used to draw the fine lines.*

17. *Morris Shubin explores many ways of using watercolor in his work. He drew this boat and divided it into large, simple shapes. The outline was not painted, and remains white. Notice the variety of textural treatments used in the negative spaces of* Chinese Junk, *a 22 × 30″ (56 × 76 cm) watercolor.*

18. *Roy Lichtenstein's style is derived from comic strip techniques.* Two Paintings *is one large work (64 × 90″ — 162 × 228 cm) that shows both the front and back of an oil painting. The work is done in oil and Magna on canvas, and the artist used stencils to make all the round dots the same size. Courtesy Leo Castelli Gallery, New York.*

221

19

19. *In* The Bench, *two seated figures are reduced to simple black and white shapes and are placed against an even simpler background of flat color. Does this student work give you ideas for similar treatment of people, animals, flowers or other subjects?*

20. *James Voshel is painting a street mural on a three-story wall in Baltimore, Maryland. (He is working in the center.) The way he has combined the paintings of many children might give you ideas for a group painting. Or you and your classmates might wish to submit a mural design for your school.*

21. *Colleen Browning painted* Wow Car *to show part of a graffiti-covered New York City subway car. That is the first fascinating concept. But look at the round windows! The portrait faces of five of her neighbors can be seen in them. The artist has shown us a moving, changing mural of contemporary urban life in a 36 × 54″ (91 × 188 cm) oil painting. Courtesy Kennedy Galleries, New York.*

20

21

ACTIVITIES

ART HISTORY

☐ Several important art movements have dealt with fascinating imaginative directions. Research such movements as *Dada, Surrealism* and *Fantasy Art* and write a report on one of the movements and what the involved artists were trying to do through their work. List several major artists associated with the movement. Present the work as an illustrated slide program, videotaped program or written report.

☐ Animals have appeared in the work of some artists for hundreds of years, and some cultures have used animals in their art more than others. Rosa Bonheur was a French artist who loved to paint animals of all kinds. Read about her life and work in an encyclopedia or in books dealing with her or with animal painting. Write a short report on her life and work, using illustrations where possible. You may choose to write a similar report on American artist John James Audubon, who painted most of North America's native flora and fauna.

CRITICISM / ANALYSIS

☐ Study the oil painting *Workhorse at Night, Fulton Street,* by Sally Storch, reproduced here. She first painted the subject in daylight (because it stood still for so long) but realized it would be a more powerful subject as a night painting — so she changed it. What do you now see in the painting? Analyze the work by determining how the artist used the elements and principles of design to make a convincing visual statement. Discuss the artist's painting technique, as you can see it in the reproduction.

☐ Select one painting from this chapter and write ten questions that would help someone analyze the painting and the artist's use of the elements and principles of design. Be sure to include the artist's name and title of the work in your questions.

AESTHETICS

☐ Study the paintings by Neil Boyle (page 97) and Lee Weiss (page 217). Both artists were commissioned (at different times) by NASA to paint their impressions of rocket lift-offs from the Kennedy Space Center. Compare and contrast the two paintings. What did each artist choose to show us about the lift-off? Are their interpretations the same? Are they both valid representations of the artists' feelings and sensations? What important lesson does this teach us in regard to personal visual expression? Which do you like better? Why? What does this tell you about your own visual sensitivity as compared to that of others?

PRODUCTION / STUDIO

☐ After some exploratory sketching, paint an incredible animal (monster) or a "mechanimal" — a fantasy creature that is part animal and part machine. Combine media in unique ways to help express the strangeness of the creature you are painting.

☐ Combine several painting ideas that are explored in this chapter. Sketch a bit first to give form to your ideas, and then choose a medium that will best suit your exploration. Combine one or more of the following:

- mola (page 222) and an animal or machine
- silhouette (page 222) and an animal or machine
- fantasy and an automobile
- imagination and machinery
- other combinations of your choice

1

2

1 and 2. *Artist Sandra Beebe photographed a flowering plant and referred to her slide as she painted* Birds of Paradise. *A slide projected on a screen in the studio can serve as a good substitute for the actual subject.*

3 and 4. *Project a slide of a house and use it as a model for a painting like the watercolor/ mixed media work on the right. The artist may wish to copy the slide exactly or use it as a point of departure and reorganize its components, as did this student artist.*

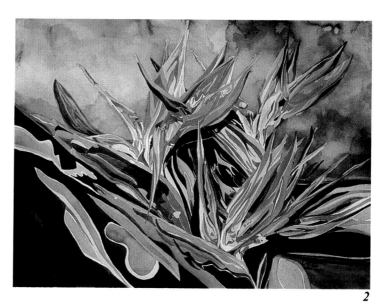

3

4

chapter 20

USING VISUAL RESOURCE MATERIAL

5

Many artists consider location painting the prime art experience, but sometimes painting on location is difficult or impossible. Inclement weather, lack of time or the nature of your painting technique may make the controlled environment of the studio much more appealing and productive. In such cases an artist may make use of visual resource material: photographs, slides, sketches and pictures from magazines or books for information and ideas for paintings.

PHOTOGRAPHS AND SLIDES

Taking black and white photographs helps you see the world around you in a highly selective way. By looking through the camera's viewfinder, you are able to isolate portions of your environment for subject matter and form a composition for your painting. By studying your black and white prints, you can become aware of value contrast, light and shadow, reflections, form and texture. A black and white picture can provide details and serve as a source of invaluable information as you work.

In addition to black and white photographs, slides and color prints provide color information and create a mood or ambience

6

5. Just a few of the many records, notes, color samples and drawings that make up an artist's reservoir of ideas. Every painter should continually collect information, as well as accumulate visual impressions. It should be an ongoing habit that plays an important part in the total painting experience.

6. Using a viewfinder on a large black and white photograph can help you choose a small, successful composition.

7

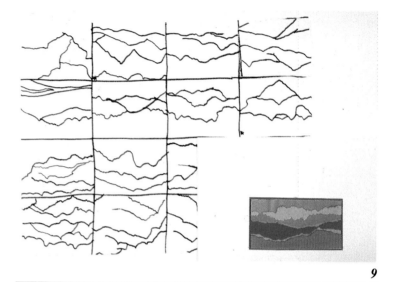

9

8

7 and 8. *A student found this oil painting,* Dual Focus *by Jan Hoowij, in a book, and it gave her an idea to use in her abstract tempera painting of seashells. Both paintings contain superimposed circles, like spotlights, that emphasize specific areas through a change in color.*

9 and 10. *Sketches and drawings prove of value to the artist when planning a painting. Here, sketches of the configurations made by mountain ranges helped determine variations in the subject as well as serving as a guide for a torn paper collage and for the painting at the upper right.*

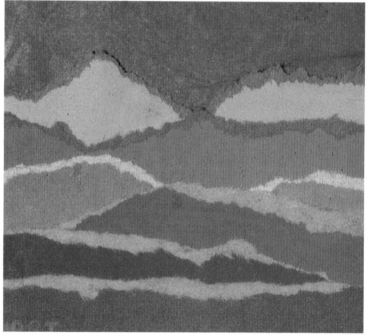

10

which may motivate the artist. Projected on a screen, they can serve as a visual resource while you are painting. Slides can also be viewed in small or large viewers which do not reveal the finest details, but emphasize the larger shapes, objects and composition.

PRINTED MATERIAL

Pictures from magazines or books can inspire ideas, help you learn specific techniques and provide visual information. Artwork in children's books and art books, specialized, well-illustrated books on any subject, greeting cards and calendars all provide meaningful material for the artist.

11

13

12

14

SKETCHES AND DRAWINGS

Any sketches and drawings you do of your visual environment will help you become more aware of the way things look, and record your impressions for future reference. Some drawing is done for gathering information, some for organizing and composing your picture, and some working drawings furnish bases for the finished painting.

Remember that resource materials are sources of information, not sources of art. Do not become a slave to them. Use all your art skills, interpretive abilities and knowledge of composition and design to put your paintings together. Copying from *any* source (nature, photographs or the work of other artists) may increase your painting skills, but will always be just that: copying. Learn to use your acquired skills to make personal visual statements and to show others how you respond to a variety of visual resources.

11 and 12. Gerald Brommer gathered information and experimented with layout and composition in a series of sketches in San Miguel d'Allende, Mexico, from which he painted San Miguel Impression. *Note the similarity between the sketch at the bottom right of the sheet and the finished watercolor.*

13 and 14. You can use sketches to gather information. Student sketches of seashells and buildings served as reference material for paintings. A sketchbook is the perfect place to make visual and verbal notes about your environment.

1

1. *Matting should be done in a clean and orderly environment. Give much attention to the choice of mat and to neatness and precision while matting.*

2. *Mats come in many different colors and textures. Remember, choose a mat that enhances your painting, and does not overpower it.*

3. *A window mat is hinged to a backing so that a painting can be inserted and taped to the backing board.*

2

3

chapter 21

MATTING AND DISPLAYING YOUR WORK

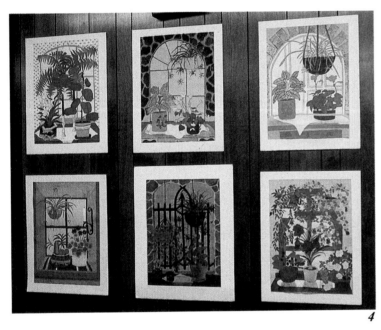

4

5

Matting and framing is a very important part of the total painting process. Many student painters stop short of this final step and never realize how impressive their artwork can be when matted and framed attractively. Besides enhancing the beauty of paintings, matting and framing protects them and separates them from surrounding distractions. Professional artists, concerned with preserving their works, have paintings matted, framed and sealed using prescribed material and methods.

WAYS TO MAT

There are several ways to mat a finished painting. A *window mat* is made by cutting a "window" slightly smaller than the painting in a piece of thick mat board. *Mounting* or *float matting* means glueing a painting on top of a piece of mat board. The method you choose largely depends upon the nature of your painting and the effect you want to create with it. Window mats (especially multiple window mats) can create the illusion of depth and give a paint-

4. *These paintings have been float matted. They are glued onto a piece of mat board or tagboard, and all edges of the paintings are visible.*

5. *A close-up view of the corner of a double-matted painting.*

6. *A middle value gray mat with a white liner for contrast.*

7. *A neutral toned mat that repeats a color found in the painting.*

8. *A completed picture is ready to be cropped or cut down to form a better composition.*

ing crisp, clean edges. The edges of the mat can be beveled (slanted) or straight. Float mats are easier to make than window mats, but are not always appropriate. Some watercolorists prefer to float mat because they want to display the feathery, rough edges (deckles) of heavy watercolor paper. If your work is painted on thin paper, however, glue marks may show through it, and you should probably window mat it instead.

Size and Color

A mat must be the right size to set off a painting to advantage. A mat that is too small crowds the picture; a too-large mat can overwhelm it. Try making the mat the same width on all four sides (say 3″ or 7.5 cm). Or leave a wider margin at the bottom, if you want to provide extra visual support for the painting.

Select the color of your mat board carefully. Many painters prefer to use only white or off-white mats because of their neutrality. If you choose a colored mat, it should echo a color used in the painting and should be a subtle tone that will not overpower or draw attention away from the work itself. An inner mat of white or colored paper or mat board, called a *liner,* may also be used to accent the painting.

Matting can be demanding work. Be precise and neat, no matter what matting method you choose. A crooked or smudged mat will make your painting look crooked and smudged. Take as much care with matting your work as you do with painting it.

9

10

9. A "frame" of paper strips helps you judge the final composition. The painting is now ready to be cut down and matted.

10. After experiments with color value and size, a metallic silver board is chosen as a liner, placed on top of two additional pieces of mat board and glued down.

11. Plastic wrap or acetate may be stretched tight over the painting and taped to the back. Wrapping a painting protects it and enhances its beauty.

11

12

13

12. *A mat cutting machine cuts with accuracy and precision as well as bevels (slants) the edges of the cut surface.*

13. *After float matting this double triptych on two mat boards, it was surrounded by a window mat.*

14. *Larry Webster chose a round mat to instill a sense of unity and circular rhythm in* Fractured Fault, *an acrylic and watercolor painting, 30″ (76 cm) in diameter.*

14

Cutting a Window Mat

You can cut a window mat yourself, with an X-acto knife and a metal ruler, or you can go to a frame shop where they can cut beveled edges with a mat cutter. You may choose to have your painting single- or double-matted. Besides the traditional rectangular shape, you may decide upon a round, oval or divided mat. Remember that you must have the hole cut one-quarter of an inch smaller than the painting on each side.

FRAMING YOUR PAINTING

There are many types of frames to choose from. If your painting is a "standard" size (8 × 10″, for example), you may buy an already assembled frame in wood or metal. Unfinished wooden frames may be stained a soft wood color or painted to blend with the mat — either the same color or a slightly lighter or darker tone. A frame should never overpower the painting by being too heavy or thick, so think carefully about your painting before you frame it. Is your work delicate, detailed, intricate? Do you use bold colors and large shapes? Choose a frame that echoes your style.

Metal frame kits, complete with hardware, are available in many sizes and are easy to assemble. They come in silver, gold, bronze and an assortment of colors. Plastic box frames are also available and are inexpensive and easy to use.

15

16

17

Frame shops have samples of wooden mouldings in different thicknesses, colors and designs. Frames can be made to order from these mouldings.

You may choose to glass your painting without a frame. Clips and elastic cord hold the pieces of glass together. When glassing (glazing) your painting, use regular clear window glass or Plexiglas. Nonreflective glass is waxy in appearance and dulls the painting underneath it.

DISPLAYING YOUR WORK

After your painting has been matted and framed, it is ready to be displayed at home, in school or in public places. The painting process, which began as an idea, continued with sketches and step-by-step painting procedures, ends when the finished, matted painting is finally put up to be seen and enjoyed. The visual communication process is thus completed.

15. *Wooden frames are available ready-made in certain standard sizes. Wooden moulding comes in various finishes, thicknesses and colors for custom framing.*

16. *Nancy Kinne chose a silver metal pre-cut frame for its light appearance and because it echoes a touch of silver metallic paint used in her acrylic painting,* Galaxy #11, *(24 × 38" — 61 × 97 cm). Besides selecting a frame that enhances your painting, keep in mind the setting in which the painting will hang and choose a frame that will look natural there.*

17. *Metal frames in many colors and finishes can be cut and assembled to fit any size painting. Framing kits are available in metallic tones of silver, gold and pewter, and in black. These come in a variety of sizes and are easy to assemble.*

ACKNOWLEDGMENTS

A book such as this cannot be published without the extensive cooperation of many people and institutions. The authors wish to sincerely thank numerous artists who gladly sent slides and transparencies for use in the text. You'll see their names in captions throughout the book. Space alone prevented us from using all the images they sent, but what we included will show young artists the skill and imagination of contemporary American artists.

Museums house many painting treasures which we think are important examples for young people to know and appreciate. Museum staffs from around the world, and particularly in America, have supplied prime examples for use in the book. We also thank them for their generous help and cooperation.

Several American galleries have supplied visual materials for the artists they represent. We wish to thank the directors and staffs of those galleries for their help and cooperation. In addition, we would like to thank NASA for supplying several photographs; Winsor & Newton, Inc. of England for photographs of paint making; and several individuals who sent slides or otherwise supplied information: George Magnan, Phil Orlando, Bob Gino, Robert Miller, Tina Marley, Kevin Rasmussen and Claudine Butcher.

Special thanks to Tony Lefton of Art Hardware in Boulder and Neil Green of Carter Sexton's in North Hollywood for providing materials to be photographed, and to Mike Ward and Bruce Budy for taking photographs for the book. Thanks also to Carol Meyers for her help in typing and proofing the original manuscript, and to The Frame Up in Boulder for help in providing photographs for Chapter 21.

Finally, this book could not have been completed without the cooperation of the teachers who supplied many examples of the work of their talented students.

With such considerate and considerable help, the task of putting an effective book together was made much easier. We thank you!

PHOTOGRAPHIC CREDITS

The many examples of student work shown in this book were supplied by teachers from several excellent schools. Work from the following schools is included (with teachers' names in parentheses): Baltimore City Schools, Maryland (George Horn); Baseline Junior High School, Boulder, Colorado; Emerson Junior High School, Los Angeles, California (Jack Selleck); Gardena High School, Gardena, California (Ted Wessinger); John Marshall High School, Los Angeles, California (Rene Parola); Lutheran High School, Los Angeles, California (Roland Sylwester); Oklahoma City Vocational-Technical District 22, Oklahoma City, Oklahoma (Judy Scott McGee); Putnam City North, Oklahoma City, Oklahoma (Mary Ruth Mayfield); Reseda High School, Reseda, California (Gene Gill); Seoul American High School, Seoul, South Korea (Michael O'Brien); Wagner High School, APO San Francisco, California (Kathy T. Reed); Yokota High School, Yokota Air Base, Japan (William H. Kraiger).

234

WHERE TO FIND MORE INFORMATION

These books, among many others, can help provide background about the art of painting, and show you examples of the work of the world's great artists. Your art department or school library may be able to provide copies for you to study and enjoy.

- Baigell, Matthew. *A Concise History of American Paintings and Sculpture.* New York: Harper and Row, 1984.
- Brommer, Gerald F. *Discovering Art History.* Worcester, MA: Davis Publications, Inc., Revised edition, 1988.
- Goldwater, Robert and Treves, Marco, eds. *Artists on Art.* New York: Pantheon Books, 1974.
- Harris, Ann Sutherland and Nochlin, Linda. *Women Artists: 1550–1950.* New York: Alfred Knopf, Inc., 1977.
- Hartt, Frederick. *Art: A History of Painting, Sculpture, Architecture.* 2 vols, second edition. Englewood Cliffs, NJ: Prentice-Hall Inc., 1985.
- Janson, H.W. *History of Art,* third edition. Englewood Cliffs, NJ: Prentice-Hall, Inc., 1986.
- Janson, H.W. and Janson, Dora, J. *The Story of Painting for Young People.* New York: Harry N. Abrams, Inc., 1962.
- Lewis, Samella S. and Waddy, Ruth G. *Black Artists on Art.* 2 vols, revised edition. Los Angeles, CA: Contemporary Crafts, Inc., 1969–71.
- Ruskin, Ariane and Batterberry, Michael. *Discovering Art* Series, 8 vols, New York: McGraw-Hill Book Co., 1972.
- Wasserman, Burton, *Exploring the Visual Arts.* Worcester, MA: Davis Publications, Inc., 1976.

These books provide information on techniques and subject matter. Some titles help zero in on specific coverage, but most of the books will touch on a variety of subjects. The numbers in parentheses suggest chapters in our text to which these books specifically apply:

- Bowers, Michael, ed. *Painting in Oils.* Cincinnati, OH: North Light Publishers, 1984. (9)
- Brommer, Gerald F. *The Art of Collage.* Worcester, MA: Davis Publications, Inc., 1978. (11)
- Brommer, Gerald F. and Gatto, Joseph. *Careers in Art: An Illustrated Guide.* Worcester, MA: Davis Publications, Inc., 1984. (1)
- Brommer, Gerald F. *Transparent Watercolor: Ideas and Techniques.* Worcester, MA: Davis Publications, Inc., 1973. (7)
- Brommer, Gerald F. *Watercolor and Collage Workshop.* New York: Watson-Guptill Publications, 1985. (5, 7, 11)
- Brommer, Gerald F. *Drawing: Ideas, Materials, Techniques.* Worcester, MA: Davis Publications, Inc., 1978. (4)
- Daly, Thomas Aquinas. *Painting Nature's Quiet Places.* New York: Watson-Guptill Publishers, 1984. (15)
- Fullner, Norman. *Airbrush Painting: Art, Techniques and Projects.* Worcester, MA: Davis Publications, Inc., 1983. (12)
- Greene, Daniel E. *Pastel.* New York: Watson-Guptill Publications, 1985. (10)
- Henning, Fritz. *Concept and Composition.* Cincinnati, OH: North Light Publishers, 1983. (3, 4, 5)
- Hill, Tom. *Color for the Watercolor Painter.* New York: Watson-Guptill Publications, 1982. (2, 7)
- Katchen, Carole. *Figure Drawing Workshop.* New York: Watson-Guptill Publications, 1985. (14)
- Laidman, Hugh. *The Complete Book of Drawing and Painting.* New York: Penguin Books, 1978. (General)
- Leland, Nita. *Exploring Color.* Cincinnati, OH: North Light Publishers, 1985. (2)
- Pike, Joyce. *Painting Floral Still Lifes.* New York: Watson-Guptill Publications, 1984. (13, 16)
- Porter, Albert W. *Expressive Watercolor Techniques.* Worcester, MA: Davis Publications, Inc., 1982. (7)
- Quiller, Stephen and Whipple, Barbara. *Water Media Techniques.* New York: Watson-Guptill Publications, 1983. (7, 8, 12)

- Reid, Charles. *Flower Painting in Watercolor.* New York: Watson-Guptill Publications, 1986. (7, 16)
- Roukes, Nicholas. *Art Synectics.* Worcester, MA: Davis Publications, 1984. (General)
- Shapiro, Irving. *How to Make a Painting.* New York: Watson-Guptill Publications, 1985. (2, 3, 5, 7)
- Sheaks, Barclay. *Painting with Oils.* Worcester, MA: Davis Publications, Inc., 1978. (9)
- Sheaks, Barclay. *Painting with Acrylics: From Start to Finish.* Worcester, MA: Davis Publications, Inc., 1972. (8)
- Sims, Graeme. *Painting and Drawing Animals.* New York: Watson-Guptill Publications, 1983. (19)
- Smith, Stan. *Drawing and Sketching.* Secaucus, NJ: Chartwell Books, Inc., 1982. (4)
- Suffudy, Mary, ed. *Sketching Techniques.* New York: Watson-Guptill Publications, 1985. (4)
- Suffudy, Mary, ed. *Still Life Painting Techniques.* New York: Watson-Guptill Publications, 1985. (3, 7)
- Webb, Frank. *Watercolor Energies.* Cincinnati, OH: North Light Publishers, 1983. (3, 7)
- Woods, Michael. *Perspective in Art.* Cincinnati, OH: North Light Publishers, 1984. (4)

GLOSSARY

abstract art (abstractionism) A style of art that shows objects as simple shapes and lines, often geometrical, with emphasis on design. There is little or no attempt to represent forms or subject matter realistically.

abstract expressionism A twentieth century painting style that features large-scale works and expression of feelings through slashing, active brushstrokes. (Also called **action painting**).

accent color A small amount of contrasting color used against another color; for example, orange accent in a predominantly blue area.

achromatic (ak-ruh-mat-ik) Without color. (White, black and gray are achromatic.)

action painting See Abstract Expressionism.

adjacent colors See Analogous Colors.

aerial perspective (air-ee-ul) Making things seem far away by painting them less clearly and with less color. Also called **atmospheric perspective**.

aesthetic (es-thet-ik) Pertaining to the beautiful, refined, tasteful and artistic. **aesthetics** (es-thet-iks) The study of beauty, art and taste.

airbrush A small precise spray gun attached to an air compressor. Used to create a smooth application of paint or gradations in value and color. Also called an **airgun**.

alkyd paints (al-kid) Artists' paints, similar to oils but with a faster drying time.

analogous colors (an-al-uh-gus) Colors that are closely related, such as blue, blue green and green; three or four colors that are adjacent (touch) on the color wheel.

apex The highest point or summit. In a painting, the topmost part of the subject being shown.

aquarelle (ah-cwah-rel) The French word for transparent watercolor.

art nouveau (art new-voh) A busy, decorative style of art, popular in Europe and America from the 1880's to the 1930's. This style usually shows flowing lines, flat shapes and vines and flowers.

assemblage A piece of art made of parts of objects or materials that were made to be used for some other purpose.

asymmetry (ay-sim-uh-tree); **asymmetrical balance** An informal balance of elements in a painting. The right half of the painting is different from the left half, yet is in balance.

avant garde (ah-vahnt-guard) A term used to describe art that seems to be ahead of its time, unusual and experimental.

background The area farthest away in a landscape or the area around the subject matter in a painting.

backlight Light coming from behind a subject.

balance A principle of design that refers to the visual equalization of elements in a painting. There are three kinds: symmetrical (formal), asymmetrical (informal) and radial.

baroque (bar-oak) A period and style of European art (seventeenth century) which emphasized color and light. The work was large, filled with movement, swirling lines and emotion.

bichromatic (bye-crow-mat-ik) A term describing a painting created with just two colors.

binder An adhesive used to hold particles of pigment together in paint, and to hold color to the ground.

biomorphic shapes (bye-oh-more-fik) A term applied to shapes that resemble the curves of plant and animal life.

bleed Paint or ink that runs into an adjoining area, or up through coats of paint. Usually undesirable. Also refers to fuzzy edges in a painting.

blocking in Placing the major elements of a painting with simple tone, color and line.

brayer A hand roller used to apply color in printmaking or painting.

bright A short, flat brush with a long handle, used mainly for oil, acrylic and alkyd painting.

broken color Two or more colors placed in a painting so that they seem to create a third color, without actually being mixed on the palette.

calligraphy (cuh-**lig**-raf-fee) The art of fine handwriting. Any handwriting-like line work used in a painting.

canvas A fabric (cotton, linen, jute, etc.) prepared as a surface for painting in oil or acrylics.

cartoon A full-scale drawing from which a painting or fresco is made. Also, a simplified humorous drawing.

center of interest The main area of interest in a painting, toward which all visual movement is directed.

charge the brush A term used in watercolor painting, meaning to fill the brush with color.

chiaroscuro (key-ah-ross-**kyoo**-roh) Strong contrast of dark and light values in a painting. A technique for modeling forms in painting, by which the lighted parts seem to stand out from dark areas.

chroma (**krow**-mah) The intensity, strength or saturation of color. A color's brightness or dullness.

cityscape A painting that uses elements of the city (buildings, streets, shops, etc.) as subject matter.

closure The ability of the mind to complete a pattern or picture where only suggestion is shown.

color-field painting An abstract art of the late 1960s using color applied to the surface in flat, uniform shapes.

colorist A painter known for his or her mastery of color.

color scale Colors in a series of steps at regular intervals, based on hue, value or chroma.

color scheme The choice or combination of colors used in a painting, such as monochromatic, analogous, complementary or mixed.

color triad Three colors spaced equally apart on the color wheel, such as orange, green and violet.

color wheel Colors arranged in a circle in the order of the spectrum.

complementary colors Colors directly opposite each other on the color wheel, such as red/green, blue/orange, etc.

contour The outer limit of a figure, form or object.

Contour drawing A line drawing using one line or few lines to render a subject.

contrast A principle of design that refers to differences in values, colors, textures and other elements to create emphasis and interest.

cool colors The hues on one side of the color wheel which contain blue and green.

cropping Cutting a picture down or trimming its size.

Cubism A painting style in which the subject is broken apart and reassembled to the artist's own design, usually in some geometric pattern.

curvilinear Having curved lines.

damping the paper In watercolor, putting water on paper with a brush or sponge before painting.

deckle edge The decorative, ragged edge on some papers.

designer's colors Gouache. A very fine quality of opaque watercolor.

doodle To draw or scribble with little or no conscious thought about the result.

drizzle To drip paint or let it run into a pattern.

dry brush In watercolor painting, a technique in which very little color or water is on the brush, creating a "skipped" effect.

earth colors Pigments made from natural minerals: colors such as yellow ochre, burnt sienna and the umbers.

easel A free-standing structure used to hold a canvas or drawing board while the artist is painting.

edges, hard Sharp lines and forms that do not blend into nearby areas.

edges, soft Allowing a value or color to blend and blur into nearby areas without a definite line.

emotional color Color used for its emotional effect rather than for realism.

emphasis A principle of design by which the artist may use different sizes, shapes, contrasting colors or other means to place greater attention on certain areas, objects or feelings in a painting.

Expressionism Any style of painting in which the artist tries to communicate strong personal and emotional feelings. This style of art began in Germany early in the twentieth century.

extender A substance added to pigment in order to increase its bulk or reduce its color intensity.

fan brush A bristle, sable or synthetic brush made in the shape of a fan. Used to blend colors or to create texture.

Fauvism A style of painting in which the artist communicates emotion through his or her use of color, usually bright and intense. Started in France early in the twentieth century.

feather To blend an edge so that it fades off or softens.

ferrule The metal part of a brush that holds the hairs or bristles.

figurative Representational painting. A painting showing a human figure that is more real than abstract.

filbert A flat brush with an oval-shaped point.

fitch A long, flat lettering brush with a chiseled edge.

fixative A substance sprayed over charcoal or pastel drawings and paintings to make the pigments stay on the paper.

flat A term describing the finish of a painting as lusterless. Also, applying paint without variations in value or color, and no brush marks showing. Also, a brush with oblong hairs and a long handle.

focal point The center of interest in a painting.

foreground The area in a painting that seems to be closest to the viewer.

foreshorten To shorten forms in a painting as they move back from the foreground so that their proportions appear natural to the viewer.

formal balance A composition balanced equally on both sides of the center.

found papers Papers not originally intended for artwork and are not changed before using.

free-form Irregular in shape, not geometric.

frisket A transparent paper or plastic material, with adhesive backing, used as a stencil or to protect parts of paintings from washes or airbrush treatment.

gel A colorless medium that adds gloss and substance to paint.

genre painting (**jhahn**-ruh) A type of painting that portrays a phase of everyday life.

geometric abstraction The use of geometric shapes (lines, squares, triangles, rectangles, circles) to design a composition.

gesso (**jess**-oh) A mixture of finely ground plaster and glue that is often spread on a surface prior to painting.

gestural drawing A way of drawing action or movement, generally of a figure or object in motion. Drawn quickly to express the feeling of movement, not detail.

glaze A transparent (can be seen through) layer of paint, applied over a dry area, allowing the underpainting to show through.

gloss medium An acrylic medium that is used to increase the gloss in pigments, and can be used as a final varnish.

ground The surface on which a painting is done. Also, a base coating of paint or gesso applied to a panel or canvas before the painting is made.

gum arabic A natural gum material from the acacia tree, used as a binder in making transparent watercolor paints.

hard-edge painting See **edges, hard.**

hatching Lines drawn upon lines side by side to create texture and value. When they cross each other, hatching becomes **cross hatching.**

high-key painting The use of light values in a painting, making a pale picture.

highlight A spot of the highest or lightest value on a subject in a painting.

high surface A very smooth surface on paper.

horizon line An imaginary line that runs across a painting from left to right, and shows the place where sky and earth come together.

hue The name of a color, such as red, orange, blue, etc.

illumination The art of illustrating manuscripts with fanciful letters, pictures and designs.

illusionism See **trompe l'oeil**

impasto A thick, heavy application of paint with either brush or knife.

Impressionism A style of painting begun in France about 1875. Impressionist works give a quick, true glimpse of the subject, and often show the momentary effects of light on color.

informal balance The arrangement of elements in a painting without using bilateral symmetry. See **asymmetry.**

intensity The strength, brightness or purity of a color; its chroma.

intermediate colors Colors made by mixing neighboring primary and secondary colors on the color wheel; for example, mixing red and orange to get red-orange.

juicy Describes paint that is thick, succulent and workable. Might also describe the quality of a painted surface.

juxtaposition In painting, the close placement of colors or forms; side by side.

key The dominant tone or value of a painting: high (light), medium, or low (dark).

kid finish Describes a medium-textured paper. Also called **vellum.**

landscape A painting that emphasizes the features of the natural environment (trees, lakes, mountains, etc.)

lay in To apply paint, pastel or other medium roughly to a ground; the first steps of painting.

lift In watercolor, a term for taking out unwanted pigment using dry brush, sponge, tissue, etc.

light source The place that light appears to be coming from in the painting, as shown by cast shadows and highlights.

line An element of design that is a continuous mark made by a pencil, pen or brush, as distinguished from color or shape.

linear Having to do with lines. A painting that contains much line work is said to be linear.

linear perspective A system of painting to create what looks like depth on a flat surface. All parallel lines moving backwards in the distance are drawn to one or more imaginary vanishing points on the horizon.

line of sight In linear perspective, the line that reaches from the viewer's eyes to the picture plane, and perpendicular to the picture plane.

liquid mask A liquid frisket (stencil) used to block out areas in watermedia paintings; can be removed by rubbing with fingers.

local color The color of an object seen in white (natural) light, without reflected colors and shadows.

lost and found A painting quality in which lines and edges fade or blend into others, and then reappear.

low-key painting Using the darker part of the value scale; likely to be subdued and moody.

manila paper A buff-colored paper used for sketches. Very rough manila paper is called **oatmeal paper.**

Mannerism A style of European painting in the late sixteenth century that usually showed emotional distortion and harsh coloring.

masking tape A paper adhesive, pressure-sensitive tape that sticks tighter than **drafting tape**, but can be removed without damaging artwork.

Masonite A trade name for a building material made from pressed wood, used as a painting surface or a mounting board.

mat Heavy paper or cardboard used to frame paintings, usually those which are placed under glass. **mat board** The cardboard used to mat paintings.

matte A dull, lusterless finish. Might also be spelled **mat** or **matt. matte medium** An acrylic medium used to reduce gloss. Can also be used as a final matte finish.

medium Liquid used to thin paints. Also, material used to make paintings, such as oil, watercolor, acrylic, etc.

middle ground The middle area in a painting, between foreground and background.

middle-key The middle values on a value scale (as opposed to high-key and low-key).

miskit See **liquid mask.**

mixed media Two or more media used in one painting, such as gouache and transparent watercolor, or acrylic and pastel.

modular colors A line of acrylic colors already mixed to different values.

monochromatic (mah-no-crow-mat-ic) Refers to artwork done in variations of a single color.

montage A picture made by mounting other pictures, photos and the like onto a flat surface.

motif The main idea or theme in a painting. Also, a repeated design or pattern.

multicolor Having many colors; polychromatic.

mural A wall or ceiling painting, painted directly on the surface or permanently fixed in place.

narrative art Art that tells or suggests a story.

naturalism Realism in painting, not influenced by distortion, personal feelings or romanticism. How things actually look.

negative space The space in a painting not occupied by subject matter, but still used as part of the overall design.

neoclassical A style of art influenced by classical Greek and Roman art. Mainly in eighteenth century Europe.

neutral In pigments, refers to beige, tan, putty, etc.

non-figurative Without figures. Sometimes refers to non-representational.

nonobjective art Art that has no recognizable subject matter. Also called **non-representational art.**

noodling Drawing or painting intricate details; or applying intricate calligraphy in a painting.

oak tag A tough paper used for stencils and mounting.

oatmeal paper See **manila paper.**

objective In painting, showing the subject as it appears. Representational.

oblique Diagonal.

oil pastels Oil colors in stick form; do not require fixative.

one-point perspective Perspective in drawing or painting that has only one vanishing point.

opaque Opposite of transparent; not allowing light to pass through.

op art A style of art in the 1960s in which geometric designs were used to create an illusion of movement.

organic line An uncontrolled line in a drawing or painting that flows and does not outline objects. **Organic shape** Refers to free-form shapes, which look like living things. The opposite of mechanical or geometric shapes.

overlapping planes A perspective technique — the artist places one object in front of another, creating the illusion of depth.

overpainting Color applied on top of an undercoat.

painterly Appearing free in style or technique. The quality of a painting that allows brushstrokes to be seen on the painting's surface.

palette (**pal-**ett) The colors an artist chooses to work with. Also, the flat support on which colors are mixed.

palette cup A small cup, clipped to the palette, and used to hold turpentine, thinner or medium. **palette knife** A type of knife used to mix color on the palette, also used to clean off a palette.

panel In painting, a flat piece of wood, Masonite or other hard board used instead of a stretched canvas.

patina (pah-**tee**-nah) The thin surface covering, caused by oxidation, on old objects. It can be imitated in painting by overglazing.

pattern A principle of design in which shapes, lines or colors are repeated at regular intervals.

perspective A way to show three-dimensional forms on a two-dimensional surface.

photorealism A type of painting in which the objects look so real that the painting looks like a photograph.

pictograph Picture writing that expresses an idea with picture symbols.

picture plane The imaginary plane, like a sheet of glass, at right angles to the viewer's line of vision, on which the image is positioned. It is not the actual surface of the canvas or paper.

pigment The dry, powdered coloring agent in any paint, that is mixed with a medium to form tube colors or sticks.

Pointillism A style of nineteenth century French painting in which colors are applied to canvas in small dots, producing a vibrant surface.

polychrome Several colors, rather than one (monochrome).

Pop Art A style of art in the 1950s that used popular, mass-media symbols and products (Coke, Brillo, etc.) as subject matter.

pop colors Bright chrome colors; high intensity colors.

portfolio A portable case for carrying artwork. Also, the selection of artwork which an artist shows to clients.

portrait A painting of a person, usually three-quarter or full length, but also can be a **bust** — shoulders and head only.

positive space The area containing the principal subject matter in a composition.

Post-Impressionism A style of art (late nineteenth century French) that immediately followed Impressionism. It stressed substantial subjects and a conscious effort to design the painting surface.

post modern art A style of art in the 1980s which featured things of our visible world. A revival of objective painting.

primary colors The hues from which all other spectrum colors can be made: red, yellow and blue.

prime To prepare a canvas or panel for painting by giving it a coat of a glue-like paint, such as gesso.

primer The glue or size (such as gesso) used to prepare a painting surface.

primitive art Paintings produced by an artist who has not had professional training. Also the art of native cultures such as African, Inuit or American Indian.

proportion A comparative size relationship among several objects or between several parts of a single object or person.

quire Twenty-five sheets of paper.

radial balance Composition based on a circle, with the elements coming from a central point.

rag Paper made only from cloth fragments.

raw color Color straight from the tube.

realism Painting things just the way they are.

receding colors Cool colors (blue, green and violet) which seem to move back in a painting. Warm colors move forward.

rectilinear Made of straight lines.

Renaissance art A period of art in Europe (1400–1600) during which cultural awareness and learning were reborn. An emphasis was placed on humanism and science, and on classic design.

render To make a detailed and accurate drawing. Also, to draw or paint a given subject.

representational art Art in which the artist wishes to show what he or she sees. Also called **objective art**.

reproduction A copy of an original work of art, made by someone other than the artist, usually by mechanical processes.

resist A painting technique that relies on the fact that wax or oil will resist water, causing watermedia to puddle in clean areas.

rhythm A principle of design that relates to a type of movement in a painting or design, often created by repeated shapes or colors.

rice papers Japanese handmade papers of different textures, sizes, weights and colors. Used for printmaking, watercolor and collage.

rigger A long, pointed brush used to paint fine lines and details.

Rococo A style of art (1700s) which featured decorative and elegant themes and styles.

Romanticism A style of painting (mid-nineteenth century) that featured adventure, action, imagination and an interest in exotic places and people.

rough A quick, incomplete sketch, used to explore ideas.

round A pointed brush (sable, synthetic, hair or bristle).

sabeline brush A dyed ox-hair brush used as an inexpensive substitute for sable.

sable brush A brush made of kolinsky, a Siberian mink. The brush is expensive, has good "spring" and comes to a fine point.

saturation Also called **intensity** or **chroma**. The measure of the brilliance and purity of a color.

scrubbing Applying paint with a brush in a scrubbing motion.

scruffing Roughing up a surface area in a painting. Dry brushing color over a rough surface, allowing the underpainting to show.

scumble To place a neutral color over another color, and blend the two together to make the first color less intense. Usually done with a dry brush, rag, stiff brush or finger.

seascape A painting that features some part of the sea as subject.

secondary colors Orange, green and violet. Made by mixing two of the primaries in equal amounts.

shade A low-valued color, made by adding black to a hue.

shape An element of design that is an enclosed space, having only two dimensions. Can be geometric or organic.

shaped canvas A painting technique in which the canvas (surface) is not flat, but has objects placed behind it to produce a relief surface.

sighting A way of seeing and mentally measuring the things to be drawn or painted, without using mechanical means.

silhouette A flat shape in profile, usually of one value.

simultaneous representation Showing a thing or person in more than one view — from several eye levels — at the same time.

size A gel used to seal the surfaces of papers, panels or canvas. Also called **sizing**.

social realism Twentieth century art movement, dealing with social, political and economic subjects.

space An element of design that indicates areas in a painting (positive and negative). Also, the feeling of depth in a two-dimensional work of art.

spectrum Bands of colored light created when white light is passed through a prism. Also, the full range of colors.

split complement A color harmony using three colors: one color and the two colors on each side of its complement.

stencil Any material that masks certain areas and allows color to be applied to the open areas.

stipple A texture made of tiny dots. Also, the act of making such a texture.

stretched canvas Canvas that is fastened to stretcher bars (strips) and ready to prepare for painting.

study A drawing or painting of a section or of a whole composition, usually more detailed than a sketch.

stump A small roll of heavy paper, used to smudge and refine pencil, charcoal and pastel drawings.

stylize To modify natural forms and make a representation in a certain predetermined manner or style.

subjective color Color the artist chooses to use, without regard to the actual color of the objects being painted.

Sumi-E Japanese brush painting with ink or watercolor.

superrealism A style of painting that emphasizes photographic realism. Often the paintings are much larger in scale than the original subjects.

support The foundation on which a painting is made (canvas, paper, panel, etc.).

surrealism A style of twentieth century painting in which artists show their inner thoughts. Often the paintings contain realistic objects in unnatural settings.

symmetrical Formal balance, in which the right half is similar to the left half.

tabouret (tab-oh-**ray**) A stand to hold an artist's palette, paints and brushes.

tactile Having to do with the sense of touch.

temperature In painting, refers to the relative "warmth" or "coolness" of colors.

tension In composition, the visual sensation of strain or pull; the dynamic relationship between any of the visual elements.

tertiary colors (**tersh**-uh-ree) Intermediate colors made by mixing a primary (red, yellow or blue) and a neighboring secondary color (such as red-orange). Originally, tertiary colors were those created by mixing two secondary colors (green with orange, for example).

tetrads Color harmonies based on four colors — every fourth color on a 16-unit color wheel. For example, one tetrad contains red-orange, violet, blue-green and yellow.

texture The element of design that refers to the quality of a surface, both tactile and visual.

thin A term describing oil paint diluted with turpentine rather than with medium.

thumbnail A very small, rough sketch.

tight The quality of a painting that is exact, carefully detailed and usually made with small brushes.

tint A light value of a hue, made by adding white to the original color.

tondo A painting done in circular form.

tone Modifying a color by adding neutrals to it. Also, the relative lightness or darkness in a painting.

toned ground A thin glaze or wash put over a painting surface prior to painting.

tooth The texture of paper, canvas or other ground.

translucent Allowing light to pass through, but not transparent (a quality of paper, for example).

transparent Able to be seen through.

triad See **color triad**.

triptych (**trip**-tik) A painting in three separate parts.

trompe l'oeil (tromp **loy**) A painting rendered so realistically that it can fool the viewer into thinking the subjects are real rather than painted. French words for "fool the eye." Also called **illusionism**.

two-dimensional Flat. Having only two dimensions: height and width.

two-point perspective The type of perspective in which objects are at an angle to the viewer, and will each have two vanishing points. Also called **angular perspective.**

underpainting The first paint applied to a painting surface, to be overpainted with other colors or glazes.

undertint A transparent undercoat over a white ground. See **toned ground**.

unity A principle of design that relates to the sense of oneness or wholeness in a painting.

unprimed canvas Raw canvas that has no primer on it.

unsized Refers to paper without any sizing or filler.

value An element of design that relates to the lightness and darkness of a color or tone.

value scale The range from light to dark, including white, grays and black. Colors can also be evaluated on this scale. Value scales are usually constructed so that black = 0, and white = 10. Some scales, however, reverse these numerical designations.

vanishing point In perspective, a point or points on the horizon at which parallel lines seem to converge.

vehicle The liquid that is ground with dry pigment, and which holds it in suspension, making it paintable.

viewfinder A small cardboard frame used to isolate or frame a scene. It helps to locate a desired composition. Also called a **finder**.

vignette (vin-**yet**) A painting with an irregular outer shape, placed on a conventional, rectangular ground, leaving negative space around it.

viscosity (viss-**cahs**-i-tee) The degree of thickness in paint.

warm colors Colors in which red, orange and yellow predominate.

wash A thin, liquid application of paint. A **graded wash** varies in color or value from dark to light, or light to dark. When applied over dry underpainting, a wash is often called a **glaze**.

wash out To remove a painted area of a painting by applying water and washing out the color as much as possible with spray, brush or sponge.

watermedia Any paint which uses water as its medium.

wet-into-wet Painting additional color into a wet area, creating a soft effect; usually refers to watermedia techniques.

worm's-eye view A painting with a very low eye level, with the horizon at the bottom of the picture or below it. Looking up at the world.

yamato-e Traditional Japanese painting style.

INDEX